SMASH
CUT

SMASH
CUT

A MEMOIR OF HOWARD & ART
& THE '70S & THE '80S

BRAD
GOOCH

HARPER

An Imprint of HarperCollins*Publishers*

HarperCollins books may be purchased for educational, business, or sales promotional use. For information, please e-mail the Special Markets Department at SPsales@harpercollins.com.

FIRST EDITION

Designed by Fritz Metsch
Jacket photograph © Paula Court

Library of Congress Cataloging-in-Publication Data has been applied for.

ISBN: 978-0-06-235495-2

15 16 17 18 19 OV/RRD 10 9 8 7 6 5 4 3 2 1

For Aaron Brookner

CONTENTS

———

SMASH
CUT

PROLOGUE

———

I'M SITTING ALONE, TAKING A BREAK FROM THE FILM crew. Howard's nephew Aaron is in town making a very handheld documentary, seeking to discover more of the life of his uncle. He's set up establishing shots in my office, where I've been writing about Howard, about our lives together, and our times together and apart, in the seventies and eighties. As I talk into the microphone that he taped inside my black T-shirt, my voice becomes foggy, mumbled, and congested. While he and his crew discuss cutaways and finishing the scanning shots of the bookshelves, where some photographs of Howard stare back, I focus, inappropriately, like a perplexed kid, on a mourning dove on the fire escape.

And then they're gone. But they brought with them a pang that had not been there when I'd been writing by myself, for several months, trying to recall the past, as if it were a dream that I was recording, like a novel, with these characters Brad and Howard, and some other more famous characters like Andy or Bill or Madonna, names that felt italicized as I typed them out. When I was in the

eighth grade I won a contest for memorizing and speaking in dramatic German a poem by Heinrich Heine that included lines about a sad song from olden times that the poet just couldn't get out of his head—*Das kommt mir nicht aus dem Sinn*. Aaron's crew brought with them that caliber of queasy sensation, and it hurt more than expected and I couldn't shake it. Now I remember. The first lines were, "I don't know what it means that I'm so sad," so *traurig*.

Why? It must have been the equipment. Howard was a film director, whose career was just taking off when we met, and kept on the ascent from then on. The night that I first saw him, at a gay bar called the Ninth Circle, in 1978, he'd arrived with his crew. They were working on his student thesis film on William Burroughs for the NYU film school. Howard and I stumbled into the back after we'd met for him to write down his number, and there they were, a bunch of straight guys, sitting at a table, drinking beers from little glasses that looked almost dainty in their hands. Stacked on the table, and on chairs, were boom mikes, and tripods, and silver gaffer tape, and a big—I guess—video camera. (I didn't know then and I don't know now.) They were with us, from then on—not those same guys, but always some gaffer, and some sound guy, and a lighting technician. And here they were again: his nephew, seven when Howard died, now the father of Dylan, living in London; a guy with nerdy glasses, from Brooklyn; and a German, with wavy brown hair, aloof, who went off to roll his own cigarettes and obliviously smoke.

I can't blame them. Nor are they the only bringers of eerie vibes. I bring them on myself all the time. Not when I'm trying to write things down—the cure—but the rest of the time, in between. From my apartment, I catch sight across Twenty-third Street of the top-

floor dormers and ivy-covered brick chimneys and steeple towers of the Chelsea Hotel, sometimes through a bedroom window, sometimes a kitchen window, sometimes reflected in a bathroom-door mirror, or sun-dappled in the late afternoon, ricocheting off my office door. Howard and I lived at the Chelsea for three years. When I walk by each morning on my way to the gym, I always clock our fifth-floor front room, with French doors and balcony. I see the "O" in the "Hotel" sign, and remember it looming in black-and-white photographs of my thirtieth-birthday party. The little guitar store was briefly a photocopy shop that we ran. Now, like a metaphor of demolition and expropriation, the hotel has been vacated, its walls stripped, wiring replaced, our old windows boarded up, the place being revamped as a serious luxury hotel rather than a bohemian folly.

You can't get there from here. Nor would I want to. I'm not nostalgic, just shocked. Shocked at the difference between then and now. It's not simply a pleasant reverie to think back on those times, no recollecting in tranquility. It's more like a smash cut, that editing option so favored by Howard and other film-school students during the seventies: splicing one image or event up against another totally unrelated image or event. I'm looking out at Memory Hotel from the bedroom of the apartment in a co-op that I share with my husband, Paul. *Husband*. Now, that is a smash cut. When Howard and I were together in a complex fandango that included living together, and living separately, and being monogamous, and pursuing three-ways, or separate boyfriends, the option of two men having a legal marriage, recognized under state law, did not even remotely exist. We were boyfriends, or lovers, or friends with a capital F, but not husbands, or even partners. No event horizon for such a life choice was at all visible. Paul and I have been together eleven years,

3

married for one. We have matching gold wedding bands that we bought together at Tiffany's. The two married gay guys downstairs have a baby girl they wheel up and down Twenty-fourth Street in a stylish baby carriage. Sometimes Paul and I, too, talk about surrogates, and egg donors, and adoption, and sperm-count analysis.

When I started writing down my memories, I was contemplating recording the fabulous times of my youth, the golden age of promiscuity, when I came to New York and everything was sex and poetry and *La Bohème* for suburban American kids arriving to create their identities, and do drugs, and get laid. In a way, it was a response to the curiosity of young gay guys, who often ask me some version of, "Oh, tell us what it was like in the seventies." Again, because this present for them seems so smashed up against that past. "Well . . ." I begin, in a portentous tone, "back in the day, there were no cell phones. To make a call you dropped a dime in the phone booth at the corner. No online hookup sites, either, just bars. New clubs were always opening in abandoned warehouses, or down a flight of steps into a cellar, or up a freight elevator. No one seemed to have a job. . . ." Eventually I get around to telling more of the good stuff.

Frank O'Hara was a big figure for me, for us. Lots of us read his poetry in small towns in America, and came to Manhattan, as I did, in 1971, to become poets like Frank O'Hara, or painters, or anything to do with art, and creativity, and politics, too. O'Hara once wrote, of politics, that "the only truth is face to face." I discovered while trying to write this handheld narrative of those lost years that when the heady buzz subsided, and the sun came up, as it did every morning in those decades, too, I would picture Howard Brookner's alert face. History is face-to-face, too. There is no way for me to separate out the story of the fabulousness and horror of the

years from 1978 to 1989, and a little before and a little after, from Howard—my lover, or my boyfriend, or Friend, or whatever we were to each other. Writing down my own lyrics to that song that I can't get out of my head, I wind up coming back to Howard, as that era for me always meant coming home to Howard, whatever "home" meant for us. If I were forced to choose one trait that defined us, and our generation, and those times, I'd have to say that we were romantics. It was a romantic time. The history I'm left with turns out to be of Howard and Brad, face-to-face, with some very interesting, very lively action going on in the deep background.

PART I

DOWNTOWN

AROUND THE TIME I MET HOWARD I NEVER WROTE anything without help. I would sit on the floor in my studio apartment on a top floor on Perry Street in the West Village in Manhattan in 1978 with a pale-blue lap-size Olivetti typewriter, then reach for a cigarette and take deep drags until my throat burned. When I started to feel sick and dizzy, a few words would come, a thought-balloon. I was helped by cigarettes. Tareytons. Tareyton Lights. I smoked fancy cigarettes, too: joints. I kept a small, plastic Jiffy bag full of pungent flecks of grass. But they were for the rest of the time, not writing time, which was daylight and harsh nicotine, and a bottle of Astor Place vodka in the mostly empty, rust-stained refrigerator. When I was roiled enough from the Tareytons that I no longer could think straight, I felt I was no longer "myself," and could write. When I got sufficiently high from the joints that I could not formulate any more words, I felt I was not "myself" enough to go for a walk in the neighborhood. When I drank in bars at night, a *ding* of joy went off, signaling that I was no longer "myself" and could meet someone.

That night, I definitely was not "myself." It was May 1978. It was a night when steam exploded from manhole covers into pointillistic, grainy air on streets that were lit a dingy amber from sketchy streetlamps, made all the more intense by the ever-present faint smell of acrid dog shit. That is: a pretty standard summer's night for the neighborhood, the West Village, at that time, near that place. The place: the Ninth Circle, half sawdust pool hall (downstairs), half gay bar with a jukebox and tables in the rear (upstairs) on West Tenth Street near Sixth Avenue, a block from New York's oldest extant gay bar at the time, Julius. I had been coming to the Ninth Circle since 1971, when I was an undergrad at Columbia, way uptown. Then it was an almost "preppy" bar (though we didn't use that word yet), collegiate, young. "Chicken hawks," who liked young guys, went there. (I couldn't imagine why, as I had a fetish, in college, for thirty-year-olds with jobs. A nine-to-five job, to me, was the most exotic of aphrodisiacs, better than poppers.)

On that ordinary evening, a poster of Mark Spitz was glued to a far wall of the bar. I know because, for a long while, I stared deeply into it. I remember his skin, so dark and deeply tanned—he was wearing a pair of American-flag swim trunks, with red and blue stripes, and pointy white stars at the crotch. His several gold medals hung heavily about his neck, forming a magic talisman that I imagined was casting a spell on me, glittering like a disco ball. I pondered whether Spitz was an icon in a gay bar because he was a buff, desirable athlete—a "jock"— or because he was overly wishfully rumored to be secretly gay.

Some friends had been with me earlier. The poet Tim Dlugos was definitely among them. Tim wore big glasses with transparent frames and usually a striped tie and jacket, chinos with creases, shiny loafers, very collegiate, though I was now twenty-six and he twenty-seven.

(I thought of him as a twenty-seven-year-old "chicken hawk.") Was Dennis Cooper there yet or was that later? Richard Elovich was. Richard worked as what we liked to call an "amanuensis"—for the sheer Victorian rollout of the word—to more famous artists such as Jasper Johns and Allen Ginsberg. He was a friend of Howard's and would have a part to play in the coming hour or so. Already probably obvious: it was an arty, literary bar, or lots of us had arty, literary pretensions. Actually I had been introduced, at this very bar, five years earlier, by the poet John Ashbery—who during the seventies often sported his own dark Mark Spitz mustache—to my first boyfriend, J. J. Mitchell, Frank O'Hara's last boyfriend in life. Lightning could seemingly strike twice, or thrice, or innumerable times at this very same spot.

An invisible finger had just pressed down on the switch in my brain that I believed turned off "myself." I could tell because, rather than looking around hopefully for Tim or Richard, I felt relieved that they and anyone else with a name or specific identity I knew was blurred. Not to sound too much like a disco lyric, but it was just me and the music. I won't pretend to remember the name of the song that was playing, but I can remember the pastel greens, yellows, pinks, and purples of the rocket ship of a jukebox flashing, and I know its ambient notes were being registered on some neural receptor so that I felt them pleasantly numbing the top of my head, and there was Howard. I didn't know his name yet, of course. He was just part of the nameless and undefined, more aural, waves of rhythm that the bar was becoming as I was sliding, and then, a sudden stop. I was seeing this light like a warm, soft aura around this guy just *as* I was seeing him.

Let me back up. We didn't speak. Howard had been sitting with his film crew at one or two of the cramped wooden tables in the rear.

He'd snuck away for a minute and held a dark green bottle of beer, probably a Heineken, leaning inches to the right, and down on a diagonal from the poster, into the shadows, crammed in: about five-nine, curly dark brown hair, bantam weight, toned body tanned, almost Middle Eastern–looking. He was wearing a T-shirt, faded brown corduroys, and the beat-up blue sneakers with Z's on the sides that he always wore back then. I felt his dark-brown eyes staring sharply into mine as I was staring into his. Then it stopped. Scuffing and shuffling interfered with sight lines and erased him like a squad of human erasers and I saw only his back, his damp reddish-orange painterly T-shirt, and I think I caught a musky smell, as well.

Quick, pick up the string, keep it going. Here comes Richard Elovich, five, ten minutes later. "You should meet my friend Howard." Richard always had a sly way of saying everything as if it were a joke that only he and you and some other higher intelligences would get. I never did find out if words had been exchanged, or if this was co-incidental, fated. Richard led me back to a table where Howard was sitting with his film crew. I'd never seen a film crew. But there they were, the NYU Film School students. I don't recall, either, whatever urgent words we exchanged. But soon Howard was writing down his number for me on a chopsticks wrapper from a Japanese restaurant. On one side was the name of the restaurant, "Taste of Tokyo," with step-by-step instructions and a line drawing showing how to use chop-sticks, as Japanese restaurants were still very foreign. He wrote out his name, HOWARD BROOKNER, went back and doubled the letters of "HOWARD," adding zigzags and squiggles so that it looked like the scarifying titling of a horror movie, leaving the "BROOKNER" normal. And his number. I traded mine. He said that he was going to visit his parents in Miami and would call when he got back.

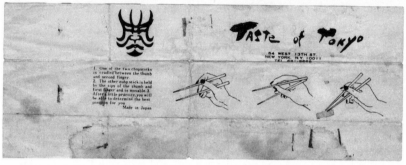

I had a few quick first impressions of Howard that out-of-focus, tender evening that never changed. He possessed an insouciant charm entirely his own, like an original musician, more Tom Waits than Billy Joel, and could direct the full force of this charm on someone, while maintaining a noncommittal demeanor. He wasn't tall, and in his medium-ness was most directorial. He was very sexy and very sexual and very intelligent about his sexiness so that its force was subliminal. He was a Mexican jumping bean—popular when I was a kid, you put them in the palm of your hand and they didn't stop popping. Neither did he, between the gaffer and the sound guy and Richard and the bartender and me. He was not too fazed by being gay. Witnessing the Stonewall riots (just a block over from the Ninth Circle), eight years earlier, Allen Ginsberg told a *Village Voice* reporter, "They've lost that wounded look that fags all had ten years ago." That was Howard: instead of a wounded look, a conspiratorial twinkle.

The phone did ring one afternoon in the middle of June. Howard was back. His voice was alluring on the other end, playful. He was twenty-four, two years younger than I was (I'd asked his age on that call) and working as an usher at the Met. He was inviting me to a Cuban dance troupe, filler during a slow week at the opera house. He'd scored free tickets. Somehow, remarkably, I hesitated, and made a lame answer along the lines of, "I don't like folk dancers . . . or Spanish guitar." I have no idea what I thought I was saying, but obviously I wasn't given to much self-knowledge. I apparently had strict aesthetic standards that Cuban dancers somehow did not meet. Providentially, for the course of our lives, Howard tried again. His friend Brad was the lead singer in a punk-rock band and they had a gig at a basement club on Eighth Street Saturday night. The offer finally right, I said yes.

At some designated hour, Howard showed up, sweaty from having run down by the river. I forget how we decided that he would come by for dinner first, or that my apartment would be the terminus of his run. But I opened the door and there he was, tanner from Miami, the same electricity subtly activated. He was in shorts, a gray Exeter T-shirt—his prep school—the sneakers with Z's, holding a paper bag with a fresh T-shirt to change into after the shower he asked to take. I returned to sit on two brown, corduroy pillows stacked next to my window for looking through the fire escape at a tender-blue, or pink, or gray sky. The time was early sunset. I was reading, or pretending to read, a red hardback translation of something by Jacques Derrida. I was a lit major in grad school at Columbia at the time, though not the kind of student to whom Derrida made much sense.

Howard emerged from the teeny bathroom wrapped in my

cheap white towel stitched with the blue letters "YMCA," still wet. Now the two of us were pretending to be nonchalant in a very chalant (a word?) situation. The door shut and opened again and he was fully dressed, the same, but with a worn black T-shirt, intended, no doubt, for the punk concert later. By then I'd made my way across the six feet of available space to the refrigerator, where I took out a lump of red hamburger meat wrapped pretentiously in sheets of French newspaper. I worked, too, as an "amanuensis"—for the poet Kenward Elmslie. Born into the Pulitzer family, Kenward lived in a townhouse on Greenwich Avenue, and for lunch he liked to prepare *beefsteak tartare*. He would send me to a nearby French butcher, who wore bloody aprons, and then he would add his own egg yolk and capers.

So I added *my* own yolk and capers. "What are you *doing?*" Howard asked. I told him and he made a negative, mistrustful sound. It wasn't the sound of an American dubious of all things French. Howard had lived in Paris for a year after college. He went to college at Columbia, too, two years after me, though we'd never met there. In Paris, he knew a very funny, highly theatrical girl, Melinda Patton, who soon would have a part to play in one year of our lives. Back then she was a waitress, and he a dishwasher, at Le Petit Robert, near Place Blanche. I, too, had lived in Paris, gone to the Sorbonne, my first year out of college. We had yet to discuss our overlapping adventures in Paris. Yet the *beefsteak tartare* did not lead, as might be expected, to a natural segue. I usually ate on plastic milk crates, so I set a red one down for Howard, by my bed (meaning my thin mattress on the floor), and a yellow one for me, by the brown pillows. But after looking for a few seconds at the mound of uncooked meat set before him, he balked.

"Umm, do you have a pan? I want to cook mine. Want me to cook yours?"

"Sure," I answered, almost meekly, swallowing a clump of hurt and surprise.

Howard quickly scoped out my battered little kitchen. Within minutes he was pouring vegetable oil from an opaque plastic bottle into a huge and heavy metal skillet. Steam rose, meat crackled, and soon enough, the tables turned, figuratively, and he returned, putting down his own plate, and a plate for me of cooked ground meat, crispy brown, pungent, with no bun. The jar of Grey Poupon mustard intended for the *tartare* still out, we took turns relishing our now-hamburgers. Somehow we were already finding our way to our independent, occasionally insensitive, copilot rapport.

A joint was shared and we were out on the street. The walk was summery and crepuscular—a violet sky, a first star—as we made our way across the Village to the entrance of the basement club on Eighth Street, a few doors down from Sixth Avenue. A tall Frankenstein's monster look-alike wearing some article of leather, a vest perhaps, held a clipboard and checked our names. We clattered down and took seats in the first row of folding chairs in a basement hall. The gawky band appeared. Brad was nearly David Bowie. He was tall, blond, bony, and narcissistic, in tight black pants, white shirt open on marble skin. Their music was garage-band rapid patter. Punk in its beginnings included lots of quick suburban highschool echoes, and a nerdy look, built on button-down white shirts and short haircuts, indicating a move away from more voluptuous hippie rock.

Brad was also gay, not just glam rock or crypto bisexual, and so he was adding something incrementally new to the developing

musical style, as I understood it, anyway. "Brad, meet Brad," Howard joked when he took me over afterwards to meet the rocker, or simulation of a rocker. Howard made some flirty reference about Brad resembling Jim Morrison of the Doors, and Brad, moth to candle, was drawn into the obvious amber flame. Howard loved beauty, and open-ended flirting, and I already saw him, just a few hours in, seducing someone as a kind of magic act. Turning back to me, he joked insecurely, it seemed to me, something about his "creep collection" of friends. "Do you want to go to my place?" he asked suddenly, sort of interrupting himself. "Sure."

We exited back up into the fragrant air and honking noise. Across the street the clock tower of Jefferson Library beamed the time as after ten. We walked past the Eighth Street Playhouse, where, on weekends, it was always Halloween, as crowds lined up early for the midnight showing of *The Rocky Horror Picture Show*, dressed as the various characters. They were preparing to pop up during the screening to act out songs, like early karaoke. Just off the curb we walked over was stamped or painted in the street a warning that had been proliferating recently: "CLONES GO HOME." We were descending now into the East Village, where what seemed like an achingly important stylistic battle was being signaled between the more punk East Village gays and the "clones" of the West Village— the first iteration of "gay lib," supposedly identifiable by their leather jackets, flannel shirts, biker boots, beards, and sideburns. Howard and I only vaguely fit either type, and so were poor candidates for a Romeo–Juliet clash. Later there appeared the acronym FAFH (Fags Against Facial Hair), which was, likewise, very East Village.

"You'd better go home," Howard cracked, since I lived in the maligned West Village.

I shrugged off the street stamps.

Eventually we arrived at his block, the last on Prince Street before Bowery—a burnt-out district, full of inky-purple shadows tinged with even more of a sickly yellow cast than the West Village, and a smell of gas, rather than dog shit, in the air. Few lived around here, except the street people, occupying empty eye sockets of windowless apartments across the street; the only business, a pizza shop one corner away. Howard's loft was on the second floor of a fallow industrial building. I was impressed by his pioneer edginess as we pushed our way through a gray metal front door. Another friend of mine was living in what later was called "Tribeca." He, too, was a pioneer, inhabiting a space in an old warehouse, installing plumbing, tearing up the flooring, breaking through an exterior brick wall to make a window through which he could see the World Trade Towers, like silver stereo speakers. By contrast, we were mere Hobbits in the West Village. Creaking upstairs in the dark, Howard said that he was paying $100 a month, $80 less than I was.

As we walked in, he clicked on a metal light clipped to gray industrial shelves near the door. I blinked into view one vast, rickety, undivided loft taking up an entire floor, from the tall front windows in green frames looking out on the bombed-out destruction across the street, toward the back, still mostly dark. The hangar space was subdivided by function, and by quirky, eye-catching items. Here a reproduction of the Apollo Belvedere on a white plaster column, there the red IBM Selectric typewriter from Kubrick's *A Clockwork Orange*, set on a gray metal typing table with adjustable flaps. The middle segment was a kitchen with a gray Formica-topped table covered with scattered knives and forks. In the rear I could make out a giant king-size bed and a padlocked shutter. I followed Howard in a vague

curve back to the refrigerator. Without asking, he pulled out a bottle of Gordon's vodka, and poured two tall cold ones in smudgy glasses.

He then made his way straight to a red leather couch next to a white rotary phone on a little table—he owned an answering machine, I didn't—while I slumped into a dowdy brown armchair with copper stripes. "That was my grandmother's," he told me. Howard used to visit his grandmother every Friday night in the Bronx, for "Shabbat," he explained. I hadn't really thought about his religion, but now I knew. He told me she was crazy, and he was afraid he'd go crazy, but he said it with a, well, crazy grin. "My cousin in California was Moe Howard, of the Three Stooges. I was named after him," he added, the missing link perhaps being that madcap followed from crazy. Then he stood up and dropped the needle on a record on a high-tech German turntable connected to gigantic speakers. "It's Bruce," he said. "You know him?" "No," I answered as the room was filled with loud guitar and drum that I associated with straight boys' dorm rooms. He handed me the empty sleeve for *Darkness on the Edge of Town*. I examined Springsteen's red-tinted rugged face.

He told me about Kevin Goldfarb, a friend from Great Neck, on Long Island, his hometown. I sensed that he had an unrequited crush on Kevin. That maybe the fascination with Bruce Springsteen was really a fascination with Kevin. "Candy's Room" blaring, he told me that just the week before, Kevin was walking down Eighth Street and saw "Bruce." Kevin caught up to say that he admired "Adam Raised a Cain," and Bruce invited him to have a coffee. Earlier in the summer, Howard saw Springsteen play the Academy of Music, the old opera house on East Fourteenth Street. We also discovered we both, unpredictably, loved Donna Summer's easy summer disco hit, "Last Dance."

"Do you want another?" he said, taking my glass, without waiting for an answer.

The first sip of the second bracing glass of vodka, no ice this time, burned my throat going down. But I finally lifted off, and I could tell, by looking, that Howard—stretched out on the couch—had lifted off as well. We didn't make out yet. Instead we talked and, in that stretch of two, three hours, ran through many of the topics that would remain high on our list for the entire time we knew each other. Howard thought that film (which he was doing) was going to become the universal language, the Latin of our times, because it was visual and so could be understood by everyone. I argued that poetry (which I was doing) was the ultimate, the only way to hit the gong, and was bound to become the form for the shiny future now that the novel was finished. Howard, weirdly, I thought, argued in favor of the State of Israel, I, for a Palestinian state, both of us ignoring the compromise of the two-state solution for our hot controversy. We also talked about nuclear bombs, Kraftwerk, the movies of Nicholas Ray, death, extinction, and the use of hypnosis games in sexual seduction back when we were both suburban teenage boys.

All this talk was, of course, foreplay. But an even bigger thrill was that I was now feeling the insulated, contrived ecstasy of not being "myself," but with someone else who was also obviously not "himself," both of us highly stimulated in an intimate pod that felt both natural and miraculous. Another way of saying the same thing: I fell in love with Howard during that first animated, abstract, improvisatory jazz piece of a conversation in his front room. "I'll show you the back deck," he said, springing up, his body wiry. As we walked to the rear, Howard yanking down the metal pull chains of ceiling light fixtures along the way, I quickly eyed the waiting

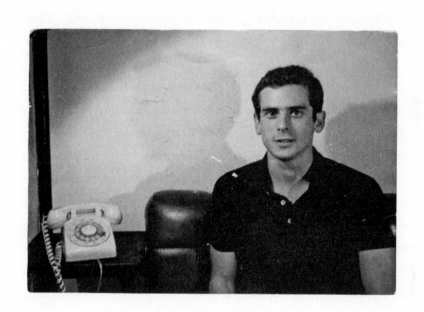

big bed, towered over by a precariously leaning balsa-wood bookshelf. Howard undid a metal contraption to open the door and we stepped onto a tar-covered back porch, actually the roof of the floor below, into the sticky summer heat made more intense by the tar. "I kill plants," he said, pointing toward some brown stalks in big pots. Then we sat on the ledge, identifying Greek-named constellations in the sky.

I think Howard leaned over and kissed me. Or I leaned over and kissed him. Or we both leaned over; very innocent stuff. Then we returned inside and we were soon embracing inside his big boat of a bed. I remember the musky smell of Howard's body—again, something I associate with the Middle East, an oily mixture, some (is it possible?) saffron. He complained that I was a "bad kisser." (Like turning my *tartare* into a hamburger, his comment was impolite, but as intimate as trust.) The lights were off now and his dark tan made his eyes burn even more intently in the shadows. I don't remember any details, other than smell, and the touch of his almost hairless skin, but I do remember a sensation of being a mere composite of iron filings pulled in by the life-size magnet of Howard's body. We made a big physical impression on each other that smoothed the sharp angles left from all of the heady talk earlier. We were both reeling drunk, and stoned, and lost in a cloud of sheets, and then the phone was ringing. It was morning.

It was Sunday. Gay Pride Day.

"I'm having a cookout," Howard announced, standing in white Fruit of the Loom skivvies, his palm clamped over the enormous handset of the phone. "Can you stay?"

"Sure," I managed to say, throat raw from the cigarettes and sex the night before.

I actually felt a bit of a downbeat, accented with shy apprehension and disappointment, to be meeting Howard's friends, before I'd even seen him alone (and sober) in the daytime. When he wasn't being indolent and shockingly unproductive, Howard could be extremely animated and daring, "stirring up mise-en-scène," as he liked to say. It was dynamic of him to be having a holiday barbecue, I thought, but then the party hadn't been planned with me in mind. I was stepping late onto an already moving train.

While Howard peed in the narrow bathroom opposite, I stood on the bed in *my* white Fruit of the Loom skivvies to survey the bookshelf. When I really took in its height, and its threatening tilt forward, some books already edging over, I wondered whether I would ever be able to sleep there again. The collection might easily have been mine, filled with the same classics from the Columbia College Humanities "Great Books" course, the same line of little metallic paperback Greek tragedies. I reached for a brick of a volume that I did not own, *The Complete Poems of D. H. Lawrence*, and toted it with me. Howard exited, and I passed him, distracted, as if we were already living together. Sitting on the toilet, I read "Snake": "A snake came to my water-trough / On a hot, hot day, and I in pajamas for the heat / To drink there." I cleverly made the connection between Howard's penis and my reading this poem. I was feeling very limber.

By the time I left the closet of a bathroom, Kevin had arrived. I quickly figured out that he wasn't Kevin from Great Neck, the Springsteen-loving straight boy, but rather a gay Kevin, Kevin Dowd, a self-defined "pervert," and proudly so. Unloading an Acme

shopping bag filled with chips and gigantic plastic bottles of sodas, he was gangly, with glasses, an unassuming short-sleeved plaid suburban cotton shirt, a beard cut as sharply as the Sheriff of Nottingham's from *Robin Hood* of the fifties TV series, and an unctuous, monotone way of speaking with his jaw clenched. His perversion was detectable as a lilt in the eyes. He had placed an ad recently in the pink "Personals" pages of the national gay newspaper *The Advocate*, soliciting East Village punks and offering to service them in broad daylight on Second Avenue. Kevin was working as a grip on Howard's documentary, and they were collaborating on a screenplay for a film titled *Gang*, about street gangs in Chinatown. If Howard was the more infatuated one in his friendship with the first Great Neck Kevin, I quickly understood that this Kevin, the early-morning shopper, was the more infatuated vis-à-vis Howard.

"Do you want these in here, Howard?" he asked in a near whisper.

Around one or two, others began showing up. I already sort of knew one of them, Darryl Pinckney. I had been aware of Darryl from afar at Columbia as a black writer—in Howard's class, not mine—who'd won an important prize and was cool in a brainy rather than posing way. A crucial distinction was that he had been a writing student of Elizabeth Hardwick (prose), across Broadway at Barnard, rather than of Kenneth Koch (poetry), like me. Howard and Darryl had been roommates, and had worked together as interns at the *New York Review of Books*. They had lots of funny literary-style anecdotes. Howard Moss, poetry editor of *The New Yorker*, made a pass at Howard at a party. Howard came home and said to Darryl, "A rolling Brookner gathers no moss." Repeating this jibe cut them up. Darryl liked to tell the story of quoting a re-

mark of Elizabeth Hardwick's to someone at a dinner while she was present and her reprimanding him, "Darryl, you are not T. S. Eliot, and I am not the Greeks!" I heard both these witticisms for the first time—though not the last—at that urban barbecue on the black tarpaper-roof in the noonday sun.

Most of Howard's friends wound up playing zany parts in his student films, shorts on yellow spools of celluloid he showed at least once in a film school screening room. I remember Darryl played a cabdriver spouting a line from Flannery O'Connor's *Wise Blood*, "Jesus is a trick on niggers." The next friend to show up for the barbecue was Joe Krenusz, head usher at the Met, a Hungarian with a thick accent and a love of Eastern European opera divas. Joe lived in the Bronx. When Howard wasn't visiting his grandmother, he was just as often visiting Joe, returning home late on the IRT train loaded down with boxed-set recordings of Berlioz and Janáček operas. I believe that Joe wore a brown toupee, or I have retrospectively invested him with one, as it would have fit. Joe had a nephew along that day, Istvan, living with him, with an equally powerful accent. Joe liked to have parties where young guys got drunk on licorice liquors. In his cameo in one of Howard's movies he was Count Krenusz. The joke line, delivered in high camp, trilled bitchy fashion by Melinda, of Paris, was: "He's not a count, he's a discount."

We were all seated in a haphazard configuration at a wooden picnic table, our legs half in and half out, with Howard making clouds of smoke, much as he had the night before in my kitchen, while cooking hot dogs and hamburgers on a sturdy grill. Kevin, twinkling eyes cast down, was sous-chef. Suddenly a most unlikely friend of Howard's appeared, his head popping up from the low wall of the ruins of the roof next door. It was Jimmy, or "Jimmy

the Bum," as Howard called him. We would now describe him as "homeless." His head was a round bowling ball, like a Jimmy Cagney head, and he handed Howard a bottle of vodka. He was full of good cheer. Howard was like the kid who made a fortune with his neighborhood lemonade stand. He had lots of gigs and angles. One of them was working for the Bari brothers, who ran a restaurant supply store on Bowery and owned most of the real estate on the block. Howard found them tenants, and in exchange got his loft at low rent. In return, he also convinced them to let the "bums" sleep in the buildings. Jimmy was thanking him for the effort. He, too, had a walk-on or more of a stroll-on or roar-on cameo in one of Howard's screwball shorts.

By late afternoon it was decided that we would head over to a Gay Pride celebration on Christopher Street. We walked across town into the crowds: guys in cutoffs, white Adidas sneakers, scruff, kissing. Christopher Street was blocked off, with a line at Village Cigars at the corner of Seventh Avenue waiting to buy rolling papers. I remember a lesbian with a T-shirt, "Anita Dear, Shove It," the big issue that year having been Anita Bryant's anti-gay campaign in Florida. At sunset there would be fireworks over the Hudson River, by the dilapidated wooden piers, several stories high, where cruising went on all day and all night, and where boys and men disappeared with one another into little rooms pungent with the sweet smell of poppers and the bitter smell of urine. At the corner of Hudson and Christopher a wooden stage was set up. Camille O'Grady was singing. As Black Irish as her name, a Jersey girl much like Patti Smith, tall, in leather vest, boots, and all manner of bracelets and amulets, she belted out her new anthem, "Toilet Kiss, Porcelain Piss."

"I know her," I bragged to Howard.

By the time Howard and I, and our group, arrived at West Street, clocking from the time we met at my apartment just about twenty-four hours before, though it seemed weeks ago, we had filled each other in scattershot on our romantic pasts and present—what my therapist, an Episcopal nun, Sister Mary Michael, her tower office at the Cathedral of St. John the Divine, called a "relationship history." One of *my* episodes had been falling in love with Shipen, the head of an experimental hippie monastic community of men and women affiliated with the Cathedral. I joined the community, against the advice of its advisor, Canon Edward Nason West, who told the group, "Beware of Greek boys," referring to me. He was right. My presence caused tension. Shipen tried to gas himself in the community bus named "Athanasius," and Sister Mary Michael stepped in to help, leading to my exit. Next I was involved with the painter Frank Moore. He lived in Paris on a grant at Cité des Arts, where we created a collaborative book of poems and etchings. But the distance had grown longer recently, and soon a French poet friend of ours, Pierre Martory, would inform him that "Brad met someone." News of love was a priority and traveled quickly.

Howard's "relationship history" was not as meandering as mine—equally convoluted, but more compressed. He was recovering from a "relationship" with a straight boy, Rick, who had also been at Columbia. Rick had a girlfriend, and Howard was obsessed with tracking their movements, excruciating as that tracking was for him. One episode involved watching the couple through the plate-glass windows of Phebe's restaurant on the Bowery. A student film of Howard's from this period, *Wires*, was filled with imagery that reeked of romantic espionage. For a time Rick was Howard's

roommate in the loft. This may have been the subtext of the talk the night before of fear of madness running in the family, for Howard wound up on a prescription antidepressant. He described watching Rick and girlfriend making love in the apartment, insulated by the soft drug, which he craved, observing dispassionately, as if through the wrong end of a telescope. We both presented ourselves as more available than we probably were. Frank and I had never officially discussed closure. Howard was still obsessed with Rick. But things moved fast in those days. So we just rearranged.

The next month is a blur. We both had previous lives continuing. Most of Howard's was still taking place out of my view. We were a split screen. But weirdly significant shifts happened in both our lives at just that time, on that cusp. I had been feeling anxious about writing stories rather than poems on my clunky little type-writer. Then I hit on writing stories in the present tense in movie-script format, which became my style for the next decade. Was it the influence of having met a filmmaker? Another plot point: Walking down lower Seventh Avenue near my apartment one af-ternoon I was caught up to by a cheerful Paul Rackley, who said he was something called a "booker" for a modeling agency, Elite. He said I should try it and handed me his card. That card began to itch and buzz, like a fluorescent fly, in a corner of my brain. On Howard's side, I remember having brunch with him and James Grauerholz—a tall, blond, Nordic midwesterner, Howard's age, who was William Burroughs's assistant and intimate—in a greasy spoon on Prince or Spring Street. James had arranged for Howard to shoot William for his student film short, and the talk now was

of going big with the project and Howard making a full-fledged documentary. So we were both expanding.

But that insight is hindsight. We did meet and we did make some right turns. But it was still the Roaring Seventies and mostly, at least for several weeks, I lived, by virtue of inertia, or habit, the life I had been living, not aware of any pattern-interrupt. That life wasn't defined by work or school but by wandering the streets, beginning in late afternoon, and often going into the late night, early morning. A marker along the way, a signpost showing where things were heading, appearing sometime mid-decade, had been the Toilet, on West Fourteenth Street. You rode a dicey freight elevator up from the street. Half the club was borrowed from the recent past: a disco dance floor where poppers were sniffed, tambourines banged on butts, while shouting and gyrating emphatically to Sylvester's "You Make Me Feel (Mighty Real)." The other half was a first glimpse of the near future: a transgressive line of dirty-theme toilets (on message with Camille O'Grady's song) and sex-scene raunchy orgies that you could either watch or take part in.

The logic set in motion by the Toilet actually did arrive at a bottom line, a finding of limits, like a crash test, at what I definitely thought of as *my* bar that summer of 1978, the Mineshaft, at the corner of Washington Street and Little West Twelfth. I believe I was there on its first night, or one of its first nights, in the fall of 1976. On my way nowhere special, I saw two shadows dart into a door I didn't know, probably on my way to the Toilet, which was practically around the corner. It was early, say ten p.m. I followed them, and found myself in a single room of what became a downstairs den of the full-blown club, with just a few other shadows drinking silver cans of beer. When I returned a week or so later, an adjacent door

now led to stairs, and a dress code was in effect, posted, with a guard in place to enforce: no colognes, no "designer sweaters," no "rugby styled shirts or disco drag." If you wore any offending clothing you had to strip it off at the "coat check" and put it in a plastic bag to be checked. Some guys in proscribed khakis or dress pants stripped in the glare at the door and walked about in briefs. Sneakers were forbidden too, and some walked barefoot on the iffy floors. "Jock straps" were approved, "& sweat." Seemingly every week a new vanishing point was introduced: a sling where fist fuckers fisted; a scaffold for whipping willing victims; a bathtub for those desiring "golden showers."

I moved through the Mineshaft in a kind of trance, like a zombie, or sleepwalker. Most others were in a trance, too. I saw Kevin, Howard's grip, there soon after we met and he had the same inability to say a word to me that I had to him. It was as if we were all shot up with some anesthetizing drug before we walked in. "Feeling no pain" was an important motivator. Drugs were in the air everyone breathed. I saw my doctor, who had a mostly gay practice on the Upper East Side, splayed on the pool table in the main room with poppers held to his nose and things being done to him. He was the brains behind giving antibiotics to all of us patients to take *before* going out, as a prophylactic measure against exposure to venereal diseases. Of course, the shortsighted tactic backfired within the petri dish of the Mineshaft as subcommunities became hosts to infections that soon developed resistances to the antibiotics and needed more and more powerful prescriptions. The place obviously had a risky edge. The doorman, a French furniture curator by day, purportedly threw someone down the steps and broke his arm in a rage over a misplaced handkerchief or inappropriate blazer or preppy loafers. I remember

thinking that this was Satanism lite—or "fascinating fascism," to borrow Susan Sontag's phrase; something had to give.

But the two-storey dream box, full of floor hatches and shoeshine stands, torture devices and pillories out of Puritan Salem, also had an extraordinarily dark lustrous glamor, a cosmopolitan dandyism that must have rivaled the Hellfire Club of eighteenth-century London. Comparisons to the vertiginous latter days of the Roman Empire, or to Weimar Berlin, were always being made. I was infatuated with the films of Rainer Werner Fassbinder, and had written a story, "Jailbait," as homage to an early film of his. J. J. Mitchell presented Fassbinder with a typescript copy at the bar of the Mineshaft. Susan Sontag and some other women were rumored to have snuck in disguised as men to participate in its democratic voyeurism. I was mesmerized with one regular, a charismatic Jersey-seeming young guy always dressed in slick leather with every color handkerchief lined up in orderly fashion in his rear black leather pants pocket, who marched through the place like a martinet. One night a mutual friend, an art dealer, introduced us. He was Robert Mapplethorpe, and we had a polite conversation. A few days later he sent me a postcard with one of his photographs—a large uncut hose of a cock flaccid across skin inked with a pentagram. The message: if I ever needed a photograph for a project, perhaps we might collaborate. I felt a prissy clutch of embarrassment knowing that the proletarian mailman had seen the startling image of the tattooed skin and penis.

Howard had his own clubs, from the other side of the dotted aesthetic divide. He went to Paradise Garage, a members-only dance club in a converted garage on King Street in the lower West Village. He was very proud of his laminated black-and-white membership card and held on to it for years in the same way that I

held on to a precious, tattered copy of the Mineshaft "dress code" posting that I had charmed out of someone, maybe the doorman. Paradise Garage was alcohol-free, meaning that it was purely a druggie club. I went once with Howard, and remember a side ramp going up to a dance floor filled with mostly Latin and black kids. The bar was a regular hangout of Keith Haring, who had arrived in town the year before. (I later found out that Keith was the culprit writing "CLONES GO HOME" on the street, and that he had founded FAFH.) Howard's other favorite was Mudd Club, which opened that fall on White Street below Canal. As it was more of a punk-rock club, I only went there a few times, and only with Howard. A joke on Studio 54, the club had a black-leather, instead of red-velvet, rope strung outside. As at the Mineshaft, only more so, fucking was taking place against the walls, and in the bathrooms, but mostly boy on girl. At the Mineshaft you heard trippy Terry Riley or Brian Eno electronic "head music." At the Mudd Club you heard David Bowie or Iggy Pop or Lou Reed. Both spots were vehement enemies of 54 and disco.

Howard and I had the good sense, without discussing the issue, to know that if we wanted to get to know each other we would need to spring free of our routines, erratic as they were. Or maybe we both just wanted to get to the beach. It was August, and New York seemed hotter and more humid then than now. Howard, unlike me, *did* have an air conditioner, an appliance as gigantic as a washing machine, set in one of his front windows, though he complained that it only cooled three square feet of the loft. Howard was usually the more capable, get-things-done one. Pretty soon he took to describing me as a "luxury item." For example, as part of his barter with the Bari brothers (who yelled out "Howie" every time they

saw him walking down the Bowery, as if he were some kind of pet or mascot) he was now mostly renting out their apartments to fellow film school students. He rented one particularly shadowy little place to Jim Jarmusch and his girlfriend Sara Driver. Jim had been a poet at Columbia, another Kenneth Koch student, who advanced farther into the future by deciding to be a poetic filmmaker. At NYU, he was a teaching assistant to Nick Ray, the wizened (at least in my memory) director of *Rebel Without a Cause*. That apartment turned out to be haunted, furnished in heavy wooden pieces left by the haunter or his wife—I forget the details of its horrific backstory.

So, naturally, Howard was the one to find our scam of a shack on Fire Island. I had been there two summers earlier, to the Pines, which was basically the West Village loaded onto the Long Island Railroad, then transferred to a ferry, then plunked down intact on this beautiful barrier reef island in the Atlantic Ocean. The Pines was filthy with money, young white males, angled beach-wood high-modern homes built to be flimsy, with the kinds of pools David Hockney was painting in southern California, a pervasive smell of coconut suntan lotion, and a loud persistent rumbling disco beat every night. Fantasies ran high. On my previous trip, the summer before—I was writing copy for a L'Oréal hair-care catalog, a job I scored by sleeping with the beach house–owning art director. I'd gone to the early-evening dance party, Tea Dance, where someone dressed as Batman, with a French accent, led by leash a Filipino boy dressed as Robin. The next day in the high sun Robin laid out fluffy beach towels for Batman. Calvin Klein had a one-lane lap pool where exaggeratedly lithe guys did butterfly strokes.

But that was the Pines. We weren't going to the Pines. We were going to "Skunk Hollow." We giggled at the name, and indeed the

place fit the name. But the place also fit us, and our relationship, and allowed a kind of orchid of intimacy—or stinkweed tree of intimacy—to grow and flourish, which the glossier Pines might not have done. Skunk Hollow was seven miles up the beach from the Pines. Howard knew some film school friends who rented a cabin there for the summer but made an early, unexplained, suspicious exit, and we paid them next to nothing to take over. The hitch (there often was one with these schemes of Howard's) was that Skunk Hollow was condemned, or zoned off-limits for vacation homes, as part of a government dunes-reclamation program. Cabins were still standing but they were meant to be taken down, or bulldozed, or naturally obliterated by the severe winter weather. We were technically illegal squatters. Howard had found the equivalent situation in real estate in a wilderness area of beach that he had gravitated toward on the edge of the East Village. It was also a fantastically beautiful, magically surrealist dream of a hidden spot.

For days we holed up in the cabin. Besides falling stars, the other major natural phenomenon that year was jellyfish, little vermillion globs that washed up on shore and which we counted, scared now of going into the water. We took turns showering by emptying on each other buckets of water cranked from a pump. Howard brought along a Polaroid camera, and we made lots of purple-tinted photos that we scattered on the back porch. Our only neighbor was a hippie nudist with a big untamed gray beard who sat on his slanted shingle roof and stared. We never exchanged a word, but did joke that he was the spirit of Gay Love, watching over us. At night we drank acidic Astor Place red wine we'd lugged out, and ate hot dogs, pinto beans, and Spam. Having filled in our negligible romantic pasts for each other, we'd begun trading more detailed background informa-

tion. Howard told me about having been on the wrestling team in junior high school in Great Neck. He had recently, awkwardly, run into his coach at Cowboys, a hustler bar on the East Side. I found it sexy that he had been a wrestler and leeringly fantasized some.

Skunk Hollow clinched our deal. This really was first love for me. I'd had crushes, as had Howard, on straight boys, or assumed straight boys, all through high school and college. I think for gay guys, at least of that generation, the adolescent spring of first love, the pang often described in short stories, was invariably arrested. I suppose we *were* still recovering from fifties' childhoods in a repressive society, where there was no such thing as "gay" or "coming out." Most of us experienced our first love in our mid-twenties, in the seventies. And even though the smell and pitch of fast sex was palpable on every street downtown, so, too, were aching hearts and love-tossed looks. The seventies had a romantic aura because of so much first love among grown men. Howard and I said "I love you" for the first time in that cabin, and the tenor was far more resonant than anything I'd experienced with boyfriends I'd been dating until then. I forget who went first. But we didn't do much talking about issues beyond that. I woke up the last morning with a choke of a cry, surprising myself, not telling Howard. From then on, we made an effort every summer to re-create that time together, the axis on which our world revolved, ever faster. Our bond was sealed with a look, the look I first got from Howard at the Ninth Circle, and again there, that last day on the beach.

The next year involved lots of walking. Either I walked to Howard's gigantic loft in the East Village, or he to my little shoebox

in the West. That walk is bookmarked in my mind along with a gas station on Prince Street, lonely, moonlit Prince Street. When I saw that incongruous gas station, never open, its solitary Edward Hopper pump always seeming as if it belonged in a small American town of the 1920s, I knew that I was getting close. I was always walking to Howard's place in the dark, after I finished my "homework" (I was back in graduate school, taking one more year of classes). Even closer was St. Patrick's Old Cathedral at Prince and Mott. If we walked by together, Howard would reiterate that Martin Scorsese had gone to that church as a little boy and been inspired to moviemaking by its stained-glass windows and the stories they told. I would only make the reverse commute during daylight hours. My mental bookmark for remembering the reverse walk was turning down a decrepit cobblestone alley, around noon, after having brunch, and hearing Deborah Harry's wailing "Heart of Glass" from a passing car radio—a one-time event—accompanied by a quick, fleeting flash of the awareness of being alive.

We had a poetic kick-off season. I know because some of the poems and letters that we wrote to each other have survived in this or that file or storage bin. I also know, reading back through the worn pages, that we were both already a bit sliced up by life, and that all was not smooth, could never be smooth. Yet the basic tenor was poetic, sexy. One day I ripped a pale-pink page from a collegiate notebook and wrote Howard a poem-letter, leaving every other line blank. A pulse of sexiness beats between those lines. I then made that half-hour walk, the mortar-brick-by-layer-of-brick of our relationship, to drop the page off and return home, a surprise for him to find on returning: "My running over here to leave this note is probably the kind of thing to make you look at me—after

DEAR HOWARD

I JUST HAD AN ATTACK OF 'HELLO!'
LAST NIGHT WHEN I TALKED TO YOU
I WAS STILL IN CAUTIOUS STATE, NOT
GETTING MY HOPES UP, IN CASE YOU MIGHT NOT
BE BACK UNTIL MONDAY. SINCE LAST NIGHT
HAVE LET MYSELF GET ALL EXCITED AGAIN.
THERE'S NOTHIN I'D RATHER DO THAN BE HERE
NOW IN 3-D AND SLEEP HOLOGRAPHIC
SLEEP AVEC TOI. TOMORROW I WILL SEE YOU,
YOU WILL BE SO GLAD TO SEE ME. (?) I
WILL STILL BE IN THIS THUMP—THUMP
MOOD. (?). IT WAS A RELAXING WEEK BUT
NOW I AM STARTING TO BURN DOWN AGAIN
W/ FAMILIAR FIRE. MY RUNNING OVER HERE
TO LEAVE THIS NOTE IS PROBABLY THE KIND
OF THING TO MAKE YOU LOOK AT ME —

all a 26 yr. old man—and say, 'You're crazy,' Well, yes and no. But these kinds of feelings can only go like arrow to tree (O hot cock!) The way when I'm feeling good I go straight in mind to you (O hot cock!). This is a romantic note. Truth wears lipstick, carries KY in hip pocket of Levis 501 button down jeans with white Fruit of Loom Woolworth's Kresge's underwear. There is no place I'd rather be now than here. XXX Brad."

Howard also began writing a poem a day. I seemed to bring out the writer in him—one of his upcoming gigs was churning out a series of paperback porn novels for a heterosexual porn publishing house. He was able to stay up all night (with artificial stimulants) and concoct tales of coed nurses, horny cheerleaders, and hot wives, with surprising success. When he was late once, William Burroughs helped out by typing a few spontaneous pages of filler porn. He also turned out to have a talent for pulp romances. Howard was paid a couple hundred dollars in cash for each one, with cloying titles like *Whispers on the Wind*. The flip side of this talent was exhibited in his poetry. Actually I can't distinguish many of his lines from my own. They were partly parody. A bit of one went: "Today, in your honor, I promised to write / a poem every day. I didn't promise to type / well, punctuate, or proofread. My poem today is as follows: / The sun on Fire Island spreads itself evenly over my body. / Today you are the sun and tomorrow the smell of sex will be your calling card." Its finale showcases the casual honesty that kept us ever alert, like some edgy party game of truth-or-dare that never stopped—"I don't think I'd ever return to Rick, if he should return / to me. But I know I'll never feel the same passion. / At certain spaced moments of passion, you erase his memory. / At others, you emphasize his absence. A terrible line, a terrible truth." The humor, opening with

a cheap joke line, is Howard's, as well as the peep show of his own depth psychology.

Howard had trouble giving Rick up—mostly a fantasy figure from the mise-en-scène he admitted to stirring up, as much a figment as a relationship Sister Mary Michael might call "real." Sometimes, though, these figments took revenge on him, sorcerer's-apprentice style, distancing him from felt life. I likewise had trouble giving up my own figments—the sexy boys at the bars and baths and the Trucks, a line of parked trucks in the West Village mysteriously left open nights and full of others like me doing nasty things to each other. My concession, more etiquette than morality, was that I started going to bathhouses so that I would be around at bedtime in case Howard called. The baths went on all hours of day and night, and lots of other sneaky types were hiding out there. The narrow cubicles were confessionals. After having sex with a stranger you would sit and talk about your lives, or hear a baritone and a bass next door talking about theirs. At the Everard, on West Twenty-eighth Street, Hasidim would hang around the edges of the cave of a steam room during the afternoons, bellies wrapped in towels, with long scraggly hair and thickets of beards, and wedding rings. Alternatives were the Continental Baths, on the Upper West Side, where I first went while in college, and where Barry Manilow and Bette Midler performed; and Man's Country, in the Village, a tame playground, with a plastic model of an actual-size transport truck, along with a fake jungle gym prison cell of rubber bars.

Our warped lives, our shared predilection for the "far out," was a bond between Howard and me, as well as between us and our peers. We were all trying strenuously to walk on the wild side. But the two of us were also drawn to each other's conventional-

ity. Each of us had a family, and our connection to our families kept us trying to assimilate these weird daily experiences back into what we had known. At the time, living arty lives in Manhattan, and coming out in an increasingly bold and expressionist phase of gay culture seemed by far the more interesting half. In retrospect, maybe our attempts to build on some foundation, a shared instinct for something recognizable, was our more ambitious and interesting half. Early on, Howard talked of having children, long before even adoption was standard practice. He attributed his desire to being Jewish. And he was the first to bring up living together, in one of his autumn poems: "I think of the loft we are going to move into. / Strictly in my imagination you understand, I've / never discussed it with you; but I think of the / rooms, Bedroom, workroom—set off, sound proofed / with separate entrances. Rooms for being alone at night / Rooms for exorcising those private ghosts we both carry / Rooms to create sarcophagi, rooms to protect us from / each other."

Howard liked to talk about how his grandmother bragged that she and his grandfather had never slept apart one night of their married lives together. I can't say that we were yet sleeping together every night. But we were at least in the same town every night, which in itself seemed a remarkable intimacy. Enough so that I remember Howard's first trip *out* of town, to film Burroughs in Boulder, Colorado, while staying in the Eldora cabin of one of William's young disciples, Steven Lowe. When I was in grade school I knew a tall, pale, creepy but sympathetic boy who used to devour books about the Third Reich. Steven was of that ilk, with redder hair, but equally spooky. The filming was of

William shooting his beloved guns. In keeping with the spooky style, Howard sent me a postcard featuring Alfred Packer, a local cannibal who had killed and devoured a party of miners in the 1870s. Howard's message didn't quite fit the medium: "Fri night, wish you were under me. Mysteries here in the mountains. Every mystery, every change I think of you. Sleeping alone is painful. I don't dream and hear strange sounds in the night."

Getting to know Howard meant getting to know William Burroughs, or not exactly getting to know him, but being around him, or in his den. I remained the suspect and never-entirely-comfortable onlooker. I adored *Naked Lunch*, which I'd read in high school, feeling inchoately aroused by its scenes of hanging boys with snapping erections. But among the important aesthetic divides of the times was that between the Beat writers (many gay: Bowles, Burroughs, Ginsberg),

and the New York School writers (also many gay: O'Hara, Ashbery, Schuyler). A letter from Burroughs, written in the mid-sixties, surfaced that included the chilly line: "On the credit side of ledger Frank O'Hara was hit and killed by car." O'Hara would have been considered too French, too soigné, too campy, and, finally, too expansively humanistic for someone like Burroughs. I was already covered in that O'Hara French-school pastel paint. Grauerholz, though, liked some stories I was writing, and mentioned them to William as being "like Jane Bowles," and so I was cut some slack. In any case, I would have gotten to tag along because of Howard, with whom William was unusually supportive, even gay-uncle-like. As Howard had written on that postcard from Colorado: "William is very cooperative in the filming, though I am very uncomfortable; but he's trying to put me at ease."

Burroughs lived in what he called "The Bunker," with its punkish Hitlerian resonance (the same resonance evoked in the Eagle's Nest leather bar, named after Hitler's Alpine retreat). His "bunker" was the basement of a former YMCA on the Bowery, a half block from Howard's loft. William liked it because there were no windows. The original graffiti were still sprawled on the concrete walls of the bathroom, with stalls, and a tall porcelain urinal. William enjoyed its soundproofed solitude. He could write at his old-fashioned imposing typewriter on a metal office desk facing a blank wall. At night he started drinking vodka, and there would be dinners with everyone sitting around a long table in orange padded chairs as if we were at a board meeting—but a board meeting out of *A Clockwork Orange*. William had some favorite routines, like the one about the drag queen in St. Louis who advised him, "Honey, some people are just shits." If he was in a good mood,

he would show off his collection of rifles, or a switchblade, or a gleaming machete from the jungles of South Africa. When William was away, Howard and I sometimes slept in his bedroom—a black hardcover copy of a book of dark spells, the *Necronomicon*, set on the dresser nearby—beneath an abstract reddish painting by Brion Gysin. I had some of the most vivid nightmares of my life in that room, about voodoo, and being buried alive.

Attempting to keep the books of his psyche balanced that season, Howard went to visit his parents in Miami, a second separation for us. The trip was traumatic for Howard. Even though he had not clued them in on our relationship, they decided to try to address, on that visit, what his mother termed his "big problem," meaning his homosexuality. Howard's father, Lester, was vice president of a

community college, Miami Dade, where he was semiretired, after having been president of Long Island University, and moving to Florida, for the pace and the weather, with wife Elaine. His parents actually turned out—when I met them the following year— to be more sophisticated than they sounded, on the gay issue; but that was then. I was entirely "Don't ask, don't tell" with my own WASP parents, whom Howard claimed to prefer because of their more checked-out, blank refusal to wade into his (and our) fraught personal lives. Howard was the middle of three brothers, and there would be some hint later that he had been his mother's favorite. The family had lived in Turkey, when Lester was at the American University, but mostly in Great Neck, Long Island, and generally fit into whatever suburban image the place evoked.

The ambush of a conversation took place at an Italian restaurant, and, typically, for all its pain, Howard wrote me a hilarious, deadpan account of his discomfort: "It was in this atmosphere that my parents decided to embark on a discussion of my mental state, complete with a heart-rending and completely sadistic speech by my mother on the subject of my happiness; my ability to lead a 'normal' life with a 'woman'; to choose my own lifestyle, not influenced by 'others' (read 'deviants')." They apparently had been clued in by Howard's boyhood rabbi about some incriminating signs. But Howard must have turned up the heat as Elaine knew enough to bring up his more recent romantic car wreck with Rick: "She also asked me whether I was still depressed about the bad love affair I'd had with 'this person last winter' (lack of gender can mean only one thing—or am I just nervous). Anyway, Brad, this was a most uncomfortable Scungilli dinner for your humble narrator. I grinned a lot (a mother

can see right through a nervous grin), and promised to see a psychotherapist twice a week for the rest of my unnatural life." I was reminded of the Frank O'Hara line, "All things are tragic when a mother watches!"

His parents went to bed, but Howard stayed up reading all the magazines he'd bought at the airport, watched *Guess Who's Coming to Dinner* on TV, and then sat down by the lake until after four a.m. The Brookners lived in a development, in a kind of Fire Island—modern glass house on a little manmade lake, which eventually became a favorite location of ours, though not yet. He had a Miami boyfriend, Steven, and had seen him, but spent a paragraph bragging about his decision not to have sex with him, because of me, stressing, "This does not imply you have any responsibility reciprocal, or otherwise." As the horizon grew brighter toward dawn, he went on: "Yes I think of you every time I look at the ocean horizon (a certain two-toned part of your face). Yes I think of you when I look at myself in the mirror after a shower, and when I stretch out on the couch late at night with my shirt off, my reflections in the glass wall. Surprisingly, I can't remember a dream about you; not surprisingly you are my prime j.o. phantasy. I hope I can be open enough to be vulnerable to you. Clearly this letter is petering out. And so, to sleep."

Soon enough Howard met *my* parents. I hated going to Wilkes-Barre, Pennsylvania, hated visiting my family, even though I was an only child, and kept to a strict regimen of three visits a year. Howard went with me that year, and from then on. Always, when telling anyone about our relationship, he stressed that he

went every year at Christmas "to see the Gooches." Actually, that Christmas Eve we stayed on Perry Street, going first to Macy's to buy presents to take the next day. At seven in the evening we were riding escalators in the nearly empty department store, feeling like two Charlie Chaplins in *Modern Times*, as if we were getting away with something. I don't remember what token gift we found for my parents. For ourselves, we bought a portable black-and-white television and brought it back to set on a shelf in my apartment and, cornily, watched *Miracle on Thirty-fourth Street*. TVs counted as high technology in those days. Howard already had one. The first time I walked the West Village streets, while still a college student, I remarked at all the color sets visible in ground-level windows and, from that consumerism, registered the middle-class privilege, the entitlement, of this "first wave" of "out" gays.

From Port Authority we took a Martz bus, my usual transport, to Wilkes-Barre. The bus was crowded, so we had to sit on the long banquette in the rear. We didn't get to see much of the Delaware Water Gap, and the rumbling of the motor was loud and disruptive, but our shared idea of lucky fun was met because of our fellow passenger—a straight, crew-cut Marine on holiday leave, going home. Howard flirted and interviewed him most of the way, while I looked on, getting my kicks vicariously. Whatever erotic charge Walt Whitman took from stage drivers, and Union soldiers, and "greasy or pimpled" day laborers, we took from, well, bus drivers and Marines and blue-collar-type guys. An element of Howard's willingness to regularly visit what I thought of as a mind-numbing corner of northeastern Pennsylvania was this brush with white-bread folks and places out of his ken. My parents were shorter than I was. John Glenn Gooch, the president of a utility company, was five feet and some inches, Bette

Gooch, housewife, a couple inches shorter. Yet when Howard took to describing them to me, and others, as "the little people," he didn't mean physical leprechauns, but something closer to what Richard Nixon—even in disgrace, my father's political, and styling, hero— meant by "the silent majority."

The ranch house where I'd been a teen had been washed away by flooding from Hurricane Agnes in 1972. I was home from college that summer, and we wound up refugees in the home of my fundamentalist Aunt Lena, who threatened to throw my typewriter out the window. (Had she read pages I left lying about?) With fitting architectural feng shui, they now lived in another ranch house, turned sideways with an entrance through a garage annex. The suburban development was named after a TV sitcom, *Green Acres*, rather than, like *Beverly Hills, 90210*, having a show named after it. I wrote a story around this time, "Spring," published a couple years later in *Christopher Street* magazine, in which my parents made a cameo appearance—my father, an accountant, driving his burgundy Ford Galaxie; my mother staying "pretty much at home." I fit in a description of her going-out clothes: "a red tissue papery dress that tutus out . . . a box-shaped purse made out of glass." Far more interesting to readers was its true-story ending, where I ate pineapple rings and whipped cream off the cock of Bobby, who lived down the street and was my training wheels of a boyfriend, when I was thirteen, and he twelve.

We all got along pretty well. My mother made up the convertible couch in the third bedroom, which was set off as a virtual bedroom for me—I never lived there, and never would—containing relics like high school yearbooks, and a ship-in-a-bottle that never belonged to me but seemed to belong

to some generic boy, some boy who *would* have lived in a community named after a TV sitcom, and embarrassing teen pictures of me looking vaguely Persian. Significantly, Mom arranged the bed as a double for the two of us, and there we slept together in a muffled cocoon from then on. My father enjoyed the role of tour leader. He was born in Wales, having come to America when he was seven and his coal-miner father emigrated to find work. Whenever relatives with impossible names like Gwilym came to visit, he would take them on exhausting day trips to the Liberty Bell in Philadelphia and everything else in between. Howard was subject to just such a tour of the very ordinary Christmas lighting on the porches and eaves of our borough of Kingston, with special attention to the far more exceptional corner house of a local living-in-plain-sight Mafia don. They gave us matching acid-rust and blue-orange itchy sweaters. I was mortified by all the well-meaning but decidedly unbohemian taste on display from my parents, fearing that Howard would break up with me the next week. To my surprise, he liked the nervous vulnerability that this awkward situation brought out in me, and grinned more than usual.

Howard seemed to have special powers. He could be a little minx, or a wizard . . . "fox" might work. Sara Driver, admiringly, described him as a "weasel." But more than that: he was someone in whose hands the cornball spells in the *Necronomicon* might actually work. The example I think of now is the poem he wrote describing our future apartment. Of course we were going to move

in together. We knew that much the first night we slept together. But he eerily conjured up the place we wound up subletting, Steven Lowe's apartment at 4 Bleecker Street, a few doors up from the Bowery, on the top floor, above Yippie A. J. Weberman, who was famous for going through Bob Dylan's trash, becoming what *Rolling Stone* labeled "the king of all Dylan nuts." (The leftist-socialist Yippies—young Marxists with Marx Brothers humor—maintained a headquarters across the street.) Howard forecast its layout in his poem—the former sewing factory with several families of Asians working and sleeping, taking up an entire top floor, was a maze of little rooms, leading into each other, or branching out from each other. Actually two apartments were joined, and you got from one to the other by climbing through a hole smashed in a brick wall, jagged bricks sticking out like teeth so you felt as if you were going into the mouth of a killer shark, or entering a circus House of Horrors. Howard not only predicted the puzzle of many rooms but also its haunted feel, its "sarcophagi" and "private ghosts." We loved its dark, giddy, menacing romance.

The trigger for getting us to give up our long nightly walks back and forth, and take the bigger step of moving in together, was a fight, one of those fights young love depends on. We always said that we never fought. And that was true, too. But we did have—what to call them?—moments of intense, shared discomfort, perhaps simply because nothing that involved sex and emotion had ever been smooth for either of us, so why should this be. These were less fights than tests. This particular test was an invite from my friend Marc Lancaster, an English painter, and "private secretary" to Jasper Johns, for me to go with him for a few days to

Johns's house on St. Martin. I went (deserted beaches, twittering birds pecking sugar packets from the tables of La Samanna restaurant, Roy and Dorothy Lichtenstein over for lunch), but Howard wasn't invited. I remember Howard complaining that Marc was never friendly to him except to plug for details about me. As soon as the plane took off I knew that I wasn't going to enjoy myself. On my return that Sunday night I went straight to Howard's loft, where there was a message that he was in Bellevue Hospital. Drugs were involved—I've erased which, or why. From that ugly neurotic knot, rather than from anything light and positive, came our decision to live together. We discovered we cared enough to get under each other's skins.

The apartment was far from ordinary. Howard brokered the sublet deal with Steven, who mostly lived in his Colorado cabin. I believe the last tenant at 4 Bleecker Street had been the poet Mei-Mei Berssenbrugge, though she was already married to the artist Richard Tuttle and lived mostly in New Mexico. I found a poem or two of hers in a cranny. She won the 1980 National Book Award for Poetry the next year. Either Mei-Mei wasn't bothered by fearsome gods, or Steven had been in residence again, because when we moved in, the apartment was punctuated at crucial turns with shrines to wooden Caribbean deities decked out in war paint and weaponry. They were can't-live-with-them-can't-live-without-them statues. To stash them away seemed a living burial that was sure to bring malevolence, but leaving them in view meant living with a shadow of evil, a kind of kitsch demonism. We finally dared to put them all in cardboard cartons that we stuck on a top kitchen shelf, a spear peeking up from one corner. Then we scattered curse-breaking salt.

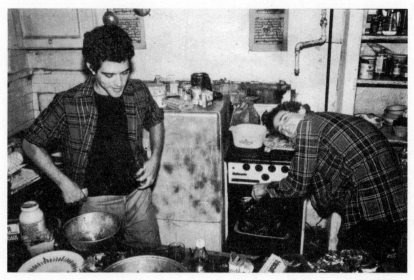

Paula Court

In a photograph Paula Court took of the two of us in the kitchen soon after we moved in, we look like each other's doppelgänger, both in flannel shirts, and matching curly locks, Howard smiling gleamingly while poking with a knife at a turkey in the oven in the dirtiest kitchen imaginable (for Thanksgiving, 1979), me smirking, looking down, overwhelmed, at a counter strewn with a dirty jar of mayonnaise, a dirty black pepper tin, a dirty Triscuit box. On the wall above the refrigerator hung two banners covered in Sanskrit script. The exceedingly bohemian kitchen, done in twenty shades of grime, was at the far end of a long room that extended to front windows covered in sheets of plastic for keeping in heat in winter, helped by a gas heater with blue flame. A flimsy mattress, on the floor, where we slept together each night, was pushed against one wall. After passing through the smash in the brick wall, an entry vestibule of some dead space led into one room with a teacher's desk, where I disciplined myself to write stories, or read the stories of Flannery O'Connor to get my-

self stoked. Beyond, through "Clue"-board-era glass drawing-room doors was the living room, with Howard's chairs from his loft and a working fireplace. Someone left behind a slim volume—Proust's *On Reading*—that I avidly absorbed. An elbow away was a makeshift workroom where Howard crammed his Steenbeck flatbed editing machine, which droned on, day and night, with disembodied voices starting, stopping, starting again, while shadows flickered on a hanging sheet separation.

More often than not someone would be sleeping propped against the downstairs gray-metal front door in the morning. Since the building was illegal for residence, the gap between them and us was not all *that* wide, or so I guiltily convinced myself when I felt the thump of a body on the other side. CBGB's and the Amato Opera company were across the street. One block over, on East Third, was the Hells Angels clubhouse that I strolled by more often than necessary to ogle the tattoos and motorcycles, and feel the danger. The teenage boy behind the counter of our deli on Bowery had splotches of red on his face from the time a customer threw acid at him. A story I wrote in the front room, "Mister Brown," not surprisingly had a character modeled on Burroughs, but also lots of "shots" of our turf, as its leads, Cabel and Eileen, walked to the Kiev restaurant for a breakfast of kielbasa and eggs and coffee: "They go down Third Street past the Men's House of Detention, veering to the right and left, by instinct avoiding certain characters, and make it to Second Avenue, turn left, and continue on a freer path. . . . Eileen stops once to look in the window of a stationery shop. Cabel stops once to look at a peeled-away poster showing four young men in black and white with cut black hair and instruments who make up a band."

The films that Howard was cutting in the back room were al-ways jumpy. If I had to pick one image that would encapsulate them, it would be of the windows of the apartment, panes divided by white wood, open to let in a breeze, the shot tilted at an angle, a bloody handprint on one pane. The films were a clash of *noir* and thirties Hollywood camp-vamp comedies, passed through the grinder of a seventies aesthetic, with a wink to Howard's being gay. I remember the titles better than the story lines. There was *Killer Come Home* (backing up that image of a bloody handprint). *Apollo Belvedere* was another, its *Maltese Falcon* device the chalk bust on pedestal that Howard toted to our new apartment from Prince Street. And *Leo de Janeiro*, the only image I believe I retain, a guy in wife-beater T-shirt with cigarette burn hole, and sprouts of underarm hair. Around this time Howard wrote and shot a scene for Dr. Benway from *Naked Lunch*, where William played Benway, and, as the nurse, Jackie Curtis, the Warhol "superstar" Howard befriended as he/she hung out at his/her grandmother's corner bar, Slugger Ann's, on Second Avenue. Jackie, in nurse drag, splattered in blood, and whisking back a cheap brunette wig helped Dr. Benway (William) operate on an ailing patient (How-ard) on gurney with a toilet-bowl plunger and Sani-Flush. I'd been in college when I learned of Jackie, in Lou Reed's "Walk on the Wild Side"—taking speed and valium, and thinking "she was James Dean for a day." Now I saw him usually in jeans, a poet, coming by to hang out with Howard.

In the spring of 1980 all of Howard's doggedness and am-bition for his film paid off in a contract between Burroughs and Howard's new corporation, Citifilmworks, created expressly for the purpose. He had advanced, step-by-step, from his original

thirty-minute film school senior "portrait project." He later told me that on the night we met, his crew, at the invitation of James Grauerholz, had actually only been filming the filming of Burroughs by a Swiss documentarian in the Bunker. By the end of that year, December, he was invited to film the Nova Convention, a four-day festival in Burroughs's honor at a theater on Second Avenue. No longer at one remove from the action, he was interviewing Patti Smith, Brion Gysin, Lauren Hutton. In one sliver of a shot, I was an extra, looking like a smudge surrounded by curly hair, in black cashmere sweater, white shirt, squeezed into a smoky crowd next to Camille O'Grady. When he got around to editing the footage, two years later, he wrote me a tender letter, addressed "Dearest Beastest" (by then my nickname was "the Beast," and his "the Hairless Beast"): "While viewing the Nova

Convention party scene, I saw a shot of you—my hairy beast, the Gooch. You look so young and sweet . . . but now you look sexier and handsomer." (I got the nickname because I had a hairy chest and a doglike unkemptness.) Around the time of the contract, Grauerholz set up a "country home" for Burroughs in his own college town, Lawrence, Kansas. Sealing the deal, an impulse not foreign to Howard, he helped James rent an eighteen-foot truck that they stuffed full of boxes and drove together nonstop to Kansas. The two talked ceaselessly in the front seat, Puccini and Verdi blaring from Howard's cassette player, both popping white crosses—speed pills—and smoking Marlboros.

As our lives merged in our ramshackle loft, beginning with a sharing of friends, and parties, we were also being pulled (or pulling ourselves) in centripetally different directions. Actually Howard kept doing exactly what he was doing the night we met. I, however, was having some kind of nervous meltdown that expressed itself as pursuing that card from the booker down the dizzying path of modeling. My pursuit wasn't a midlife crisis, more like an extended-adolescence crisis. When I passed my orals for my doctorate that spring, I remember thinking that maybe now was my last chance to have an adventure before a dull future as a literature professor. Maybe I could write a novel about male modeling. Ironically, though, my first break in the modeling industry came my way at Columbia University, where I was a teaching assistant for Professor Edward Tayler's undergraduate Shakespeare course.

Ted Tayler was a compact cube of a man, tirelessly devoted to maintaining his reputation on campus as an entertaining brainteaser of a professor. He was lecturing one spring afternoon on *King Lear* to a packed classroom of eighty or a hundred. At some moment in

his meditation on the cruel ironies of old age, Tayler looked out at his listeners and said, "You're all nineteen years old. Not one of you understands what I'm saying. None of you believes he is going to die." His voice cracked. I'd heard the same lecture as an undergrad and caught the same crack in the voice, the gazing out into the lecture hall, the poignant breaking of the fourth wall, but the studied repetition did not detract from the melodrama. (The only other lecturer in Columbia's English Department who commanded rapt student awe was Edward Said, who wore dark-blue tailored suits and used the word "power" dozens of times in each lecture. I'd once snarkily counted.) As I packed my book bag to split that day, my fellow TA, a young woman, shared with me, unprovoked, that she was working part-time as an assistant to the fashion photographer Deborah Turbeville.

Turbeville, said she, had booked a job for something called *Vogue Patterns*. But she was an artist and hated dealing with "real" models and was looking for "nonmodels" for the shoot. Turbeville's was a name in the atmosphere at the time. My fellow TA told me their main project that season had been shooting the private rooms of Versailles, and that the editor for the book was Jacqueline Kennedy Onassis. When the French government intruded on a shoot where Turbeville was photographing partially nude female models in the golden light of the receding planes of mirrors, Mrs. Onassis called to ask her, "Can't you just cover their titties?" Eventually the TA got to her point: I was perhaps the right "nonmodel" for the sensitive artist. I told her about the modeling card on the street. She looked disappointed and suggested that I not mention the card. Cut to meeting Turbeville, scattered, intelligent, with unruly brown hair, disheveled, wearing a peasant dress. She led me out by an ele-

vator to make a Polaroid for the client. The camera jammed, so the TA took the picture that came whirring out. Cut to me on a small plane to Gurney's Inn on Montauk, Long Island, the last plane out of La Guardia as a hurricane was threatening. The art director was also an art director for Warhol's *Interview*. The female model was taller than I. We were photographed in high winds, tousled, next to a seaplane at the East Hampton airport. The final result looked goofy, I thought, in a magazine full of sewing patterns.

My next big break came equally effortlessly. "Hi, Brad. It's Marc." Marc Lancaster told me that he had been at dinner at Da Silvano, a one-room Italian restaurant popular with artists and dealers on lower Sixth Avenue. He'd seen Eric Boman, a Swedish friend working as a fashion photographer, and told him of my one-day modeling stint. Eric said he thought I could do it and would I stop by his place to do test shots. Eric was about forty but looked twenty-seven, with blond hair and glossy skin. He took pictures in what he said was "golden, Italian light" on his penthouse terrace. The next day he called and said the contact sheets looked good. He was shooting a *New York Times* ad for Bloomingdale's in Central Park. Did I want the work? I spent most of the day of that job in a trailer, watching women being made up, and flipping through an *After Dark* magazine with Jon Voight on the cover. The other models, both male and female, were, again, taller than I, and seemed to have much more presence. Just days later, a check for $500 arrived. This job is *much* better than teaching, I thought. So I decided that I needed "to get my book together," a phrase that I had impressionistically picked up on the shoot.

The only photographer I really knew was Robert Mapplethorpe, now living just around the corner from us in a loft on

Bond Street. Usually, I only saw Robert at night at the Mineshaft. Once we tried to have a sex date but whatever self-administered hallucinogenic date-rape drug I took made me think Robert was the devil and the chill paralyzed me. I superimposed him in my mind against an onyx Lucifer bust in a corner of his living loft and photographer's studio. To pop the question about my modeling portfolio, I stopped by during the day. When I brought up to Robert the news that we had both just won New York State CAPS grants, me in fiction, he in photography—an award with a $3,000 stipend—he scowled, "That won't even cover my overhead." I'd never heard the word "overhead" and was impressed at how adult Robert was. I discovered that during the day Robert talked a lot about money, and his desire to work for *Vogue* magazine, so I felt comfortable bringing up my career schemes. He was a likely coconspirator. Robert had a black assistant that month who knelt down next to his Mission armchair to go over the day's "to do" list. When I went in the bathroom, a silver-gelatin print propped above the toilet showed the back of the head of the assistant (or a very similar head) bent down into the bowl in front of me. Robert was proud of pictures he'd taken for the cover of Patti Smith's next album, *Wave*. Then he showed me more scurrilous shots, done in the studio in the back, of a milquetoast guy being worked over, voluntarily (at first), after hours by Mineshaft friends wearing swastika armbands. The series was painful, but mesmerizing. "Sure, I'll help you with your portfolio," Robert agreed.

I showed up at noon a few days later with a garment bag. Robert and I were both pretty clueless about fashion photography. I'd brought along all the "formal" clothes I had, changing into cordu-

roys, brown shirt, thin tie, ratty, black cashmere overcoat, and a short Scottish scarf. Robert did what he knew how to do. He produced a box full of cocaine powder, seeming like a snuffbox, which he held in his fine, ivory fingers. Robert was a boy from Queens, but he channeled an aristocratic WASP manner—the side of him that collected silver and antique furniture. This combination of contrary traits was common enough at the time, as in the Mineshaft doorman, part-time fussy fine-furniture curator and part-time faux-uniformed cop. Both those guys were drawn to uniforms and to images of controlled violence. Robert plied me with coke until the moment when I'd finally forgotten all about the modeling pictures. Then he decided, "Okay, let's go in the back." At that instant he either flipped a switch, becoming a mad scientist versed in mind control, or I imagined that he did, and was too zonked to tell the difference. He set his camera, on a tripod, at crotch height. I stood in piercing sunlight. "Move your index finger a quarter inch to the right," he'd say. In the final portrait I look like a glazed-over victim of childhood abuse, dressed for a nice restaurant, with a jagged werewolf shadow cast behind—not a photograph designed to charm a fashion market still trading in all-American innocence.

Then things started to swerve off course a bit, after two years of our being together. Revision: Now that I think back, I can clearly see the "private ghosts" that Howard had prophesied all over the Bleecker Street apartment, like ghost-buster photographs that reveal, when developed, a congealed wisp of smoke next to a tea service, obviously the poltergeist that was slamming doors in the middle of the night. I believe the fault was mine. Well, no, I don't believe, but I *feel* the

fault was mine, though when I mull matters over I *understand* that we both collaborated. At the time, Howard believed the fault was entirely mine. I, contrarily, believed that there was no such thing as my ever being at fault. I had unlearned any guilty responses from Reichian therapy onwards, learning to honor my every impulse as the natural electricity of my sacred body. A favorite film of ours to see at an art house on the Upper West Side whenever it showed was Ingmar Bergman's *Scenes from a Marriage.* Originally a TV series, and supposedly responsible for a spike in divorces in Sweden, the film was a flat sequence of coldly lit monologues or discomfiting dialogues out of couples' therapy, all shot in suffocating tight frames. If the intense soundtrack wasn't Anton Webern—screaking-atonal-violin-frequencies—it should have been. Soon enough the mood at Bleecker Street, with its tilted, splintered floors, was that of a self-conscious and introspective Bergman film.

The plot point that triggered the shift from Vivaldi major to Webern minor chords, from tonal to atonal, from Bruce Springsteen and Donna Summer to David Bowie's "Berlin" albums, done with Brian Eno, like *Low,* playing on the stereo that season, was my pursuit of modeling. It was the snake in the Garden. The threat always hovered that I would soon be abandoning our almost comically cold-water flat, with its traces of carbon monoxide, for a different kind of life, or another lover. If my West Village "clone" life was suspect in year one, modeling put more of a gloss on those early suspicions. "Who *are* you?" was reintroduced. A sharp inflection could get into Howard's voice when the topic, mostly left unsaid, insinuated itself. Or, more often, was tried out on third parties. "I notice that Brad has become vainer since he's been thinking about pursuing a modeling career," he helpfully told a mutual friend. A

nickname that began to stick was "Brooke," for Brooke Shields, the fourteen-year-old appearing on the cover of *Vogue* in early 1980 (and, later that year, in a jeans commercial, saying the lines "You know what comes between me and my Calvins? Nothing"). My eyes "wandered" onto a page that Howard scribbled (we both sent messages this peekaboo way): "I feel threatened by Brad's going off to exotic places, doing exciting things, meeting interesting people, without me."

Another insistent issue was sex. I had put together the pieces of my coming-of-age by mythologizing, or politicizing, sex. All those lurid ruby-red-lit rooms I'd stumbled through were scenes, in my mind, from *Orpheus Descending*, and in the private, last chamber of Hell, there was the Minotaur, and there was my identity. While other teen boys around me in public high school were budding, showing off newly grown penises and weeds of pubic hair, I was zipped-up and buttoned-down. From the time I ate whipped cream and a maraschino cherry off Bobby's thing, making it a sundae when I was thirteen, not much happened until I came to college in Manhattan. I inhabited a physical and romantic flatland. When I finally found my way to the Gay Lounge in the basement of my dorm, Furnald Hall—while the rest of the students were protesting Vietnam, we "sat in" at the dean's office to demand sticks of university-issue lounge furniture—I found other boys with adolescent libidos stunted and mesmerized by the same dark psychodramas, and we finally kissed.

Yet Howard brought me up short with his distress at my continuing casual hookups. He was ostensibly much hipper. He wore black jeans, black T-shirts, smoked lanky cigarettes out of the side of his mouth, and was snide, funny, and sarcastic. I often felt like

an ordinary television laugh track next to his biting Lenny Bruce running commentary. He, likewise, knew well that he was a refugee from ordinary first love. He was not delusional. But he came to different conclusions. "After eating my heart out over Rick, torturing myself for a year, I haven't a great capacity for pain," was the funny-bitter way he put it to me when I'd hurt him. Especially odd to remember was his great argument for monogamy, related somehow to his Russian-Jewish grandparents. "I want monogamy and I want the rewards that come from sacrificing for each other," he'd say in so many words, while I'd slump in the armchair. "I haven't had sex with anyone but you for months and months, and *never* in New York." (I noted the nuance of *"never* in New York" but didn't pursue.) Odd that seductive, Loki-like Howard in the middle of this maelstrom of erotic acting-out should have been voicing traditional wishes, while I put a utopian spin on the behavior, making it some kind of romantic quest or political action. And so we went on debating these two great alternatives periodically in our living room, like characters in a current gay allegory, our issues reflecting those of many other couples trying to work out love in an unruly time.

My nun-therapist Sister Mary Michael was blasé as I discussed my heated escapades over the years in her tower room at the Cathedral. (By now, Tim Dlugos was seeing her as well, and wrote a sestina, "Close," as he sat in the Cathedral close waiting for my session to wind up and his to begin: "We share a therapist up there three stories. / I'm here to recollect, and recollect I shall, / but first let me get over this amazing blue.") She actually emboldened and enabled my behavior, with her questioning of how it made me feel, or whether Howard had dealt with x or y yet, or the question of control, and other heady bits of analysis worthy of *Scenes from a*

Marriage. I clearly remember one comment: "Over the years, part-ners in couples often change roles." A clue to one of those invisible x's or y's at play, not yet known to me, came up about that time. A message on our machine was from William, doing his W. C. Fields drawl, saying, "Howard, could you bring over three lightbulbs when you come?" Lightbulbs? Howard sidestepped, explaining that the "lightbulbs" were actually bags of heroin. Over the next decade we switched roles quite a few times. I was not always the libertine. He definitely was not always Moses the Judge. Rather, we were both addicts, needing our separate escape hatches from life and love, me with sex, he drugs. So we swerved, but also colluded in staying on track.

There, I've said it. And having spoken, the finger moves on, as it did in our life together. Every so often we would simulta-neously freak out from the pressure of rapidly changing atmo-spheres, our present so unlike our pasts. But, mostly, we were pleased, thrilled, to be who we were, with each other, where we were, then. Nostalgia has not sprinkled fake gold confetti on the before- and just-after-1980 period in New York. We knew it then. I remember conversations as you'd be walking down the street, and say, or have said to you, "Isn't New York amazing?" Euro-peans would come for the weekend. Howard and I weren't Studio 54 types (though I used to bartend at early parties there for grad school tuition money), but Bob Colacello, writing for Warhol's *Interview*, said that friends would get off the plane from the Phil-ippines, or Berlin, and take a taxi straight to Studio. That kind of energy filtered down or, more probably, filtered up as Studio was the final bloom of a lot of exotic gay-disco plants with names like Twelve West, the Loft, Truck Stop, Flamingo, Le Jardin. You

could feel inventiveness or freedom just walking down the street, as in the trend of guys' not wearing underwear, and having holes in the ripped crotches and seams of their jeans. A hint of hairy balls was *fashionable*.

A quality Howard and I shared with our zeitgeist (and may have tweaked by zoning out with our addictions) was the ability to step outside our bodies and see hilarity in ordinary life situations. Sometime in the eighties, Jackson Browne released a single, "Lawyers in Love." I remember when I first heard the song having a mental image of Howard and me negotiating the many clauses of our relationship. A journal entry of his that I found from the time gives the flavor of some of the content of our analyzing: "I have something to lose in losing Brad. Is it more than companionship? Social connections? Career connections?" He'd say some such out loud, and then he or I would get a glint in our eye, as if it were a joke that we were in on. The joke was that we were both *sure* we'd be together forever. That punch line was the bottom line of our love. And our apartment helped by morphing into its own at-home version of a club, or did on nights when we had big parties. Perhaps the more gnarly the personal issues, the more we decided to open out the cast of characters. I only remember crowded explosions of unlikely types separated by the ding-dong of the downstairs bell that I'd clomp down to answer, while Howard turned the music way the fuck up ("This ain't no party. / This ain't no disco"), and poured tumblers of scotch firewater. I once heard from a girlfriend of Howard's original boy-crush Kevin of Great Neck who remembered those parties, and Kevin at them: "He was such a complicated person—tender and ridiculous and scary and exhilarating. I don't think I ever got over him." Her one-line reminiscence—jagged, romantic, capsized—captures

those bleary nights that we never "got over" better than any recon-structed nosegay of numb faces and names.

Because of those parties, and because we were in lawyerly love, in a cool fashion that didn't exclude others, our social life expanded. Some who had been friends of one or the other became friends of both. I had known Joe LeSueur since I'd been the boyfriend of J. J. Mitchell—they had both been intimate friends of Frank O'Hara, Joe having lived with the poet for over a decade, through four apart-ments. Then he had been a cute blond button. Now he was one of a species of gay tribal priests, preserving an entire history of under-ground gossip about gay, or simply bohemian, writers and artists, their sex and love lives and the backstories of their work that was still taboo (or concerned figures then of little public interest) for general publication and consumption, and so was only passed on through oral history. Once a month or so, Joe would have dinner parties of all guys crammed around a table in his teeny walk-up apartment on Second Avenue at First Street. On the walls I remember a big, blowzy, blue Joan Mitchell abstract oil painting that she had given to Joe; a Joe Brainard found-object work, *Cigarette Smoked by Wil-lem de Kooning*, with the Dutch master's scrunched cigarette butt, as relic, or homage; another beautiful enamel painting by Joe of a 7-Up logo; and some medium-sized canvases with swathes of abstract dark-brown paint messy enough to have been made by the sweep of a floor broom wielded by Mike Goldberg or Norman Bluhm.

When I brought Howard around, to my relief—I was always a bit nervous when introducing different pieces of my life to one another—Joe was captivated. I felt that it could have gone either way. Joe decided, within minutes of their sitting together on a couch covered with tan canvas material, that "Howard reminds

me of Frank! That's what Frank was like!" I never entirely understood how so, but Howard did work his charm on Joe. And Joe paid him the biggest compliment available for someone with charm, echoing one of the common comments about O'Hara, that fifty people in New York thought of him as their best friend. I remember Howard sitting on one side of the couch, in khakis, moccasins, his dark eyes glittering, telling tales—often teasing, or naughty ones. "He had a very chow-down-able butt," Howard said, describing a gaffer, to Joe's great giddiness as he poured another cognac and lit more joints. For someone whose secret motor was his need for the security of a committed relationship, Howard liked to add a soupçon of sexual titillation when about in public. In one of the stories circulating at Joe's dinner table, when O'Hara first met the painter Larry Rivers—the painter somehow both straight and available—he slid with him behind a curtain at a party and mumbled, "Let's see what a kiss feels like." Howard seemed like someone who might flirtatiously part a curtain at any moment. Joe began taking him around (without me) and talking him up to friends like the poet and dance critic Edwin Denby, who likewise professed to see O'Haraesque qualities in him. Writing for a soap opera, and making good money, Joe also agreed, at a crucial juncture, to invest in the Burroughs movie.

Another friend of mine who took to Howard in a forceful way, and, more surprisingly, to whom Howard cleaved, as well, was Canon Edward Nason West, the subdean of the Cathedral of St. John the Divine. When I had lived in Paris after college, I'd read a collection of Thomas Aquinas's writings titled *Treatise on Happiness*. Often recovering from, or getting, a flu, jaundiced, weak, and living in a studio apartment behind the Montparnasse cemetery, I

became entranced with the French medieval spirit and style, beginning with the cathedrals. So I got into my head that I wanted to be a contemplative monk, and when I returned to Manhattan, having never participated in a mass in my life (I grew up with a "Jeffersonian" agnostic father), I tried to infiltrate the Roman Catholic Church, but everyone kept nudging me toward the Episcopalians. A young, handsome priest, Tom Pike, said Canon West was the man to see. So I showed up at the cathedral, and was ushered into a movie set of an office: two stories of dark wood shelves of books with ladders, dusty air filtered through clerestory windows. In the midst sat this 2-D movie character of a holy man, bearded, arcane, wearing a black cassock, his black cape draped over a nearby chair. In the library next door sat the writer-in-residence, Madeleine L'Engle, author of *A Wrinkle in Time*, who had only begun writing late in life after Canon West questioned her about her ambitions at a party. She was devoted to him. He was also an easy target to caricature, which she did in the character Canon Tallis in several of her novels. "You've come to see me, so you must have decided to grow up," he said to me as his opener, reaching for an oversized teacup emblazoned with his self-designed coat of arms.

The first time I brought Howard along to Canon West's, the opening half hour was pretty much a parenthesis of awkward silences. Howard was leery of ornamental Christianity. Canon West was several times interrupted by phone calls on his black rotary phone as we sat on his leather couch. These were often calls from people in trouble or needing money. He kept an active ministry going amid all the Tiffany glitz of his apartment, upstairs from his office, full of icons, photographs of godchildren, the Czarevich's communion cup. Then he finally talked to Howard, discovered he was

Jewish, and lit up. "The Jews are the exposed nerves of the human race, my son," he said, earning points. There ended the serious part of the evening. Soon vodka, followed by shots of Glenfiddich scotch, kicked in and they discovered a madcap element in each other. Canon West trusted a drinker. Howard trusted someone who basically got high every night. Soon enough Howard was dressed in a Sherlock Holmes deerstalker, and cape, and Canon West's gold-tipped walking stick, to take the dogs downstairs for a pee. I remember thinking that Burroughs in his sealed bunker, and Canon Eddie in his mirrored-lined quarters, while opposites, one representing Lucifer and the other Jesus, were not so entirely dissimilar.

For his part, Howard, rather than ignoring his prying parents, decided to take me along on his next visit to Miami. Elaine, his mother, would always tell the story: "I was very suspicious. Who is this older man stealing my son away from me? But then I saw this face, and who could resist a face like this, like an angel?" she would say, and lean over to pat my cheek. She also told Howard regularly that "Brad is the kind of man women find attractive," an appraisal that had a weird edge I tried to decipher but never could. Her reassessment must have taken place at the luggage claim at the Miami Airport, where I first met her, amid lots of hubbub. I could see her son in her tanned, urbane face. She was picking us up, driving us to the development on the lake, and then rushing off to play tennis in her sporty whites. Howard's father arrived later, from work, the quieter of the two. If there was more drama, I was spared it. Howard and I drove around South Beach—mostly old age homes with grandmothers rocking on the porches. We skulked in sweaty Cuban bars and drank beers and talked, talked, talked, as if we'd just met. The Brookners went off for a few days and we queasily broke a taboo by making love in his par-

ents' bigger bed: smell of suntan lotion, sound of lake crickets, view of planetarium stars in window.

If W. H. Auden was the "more loving one" in his lifelong relationship with Chester Kallman, according to the gossip at Joe LeSueur's, Howard and I did not have any such simple equation. I think we were both in it equally, though our different temperaments registered matters differently. Howard sometimes felt I didn't care because I was going off to Europe, or sleeping with a guy I'd met on the subway. I felt that Howard was mean, or belittling, and, so, uncaring, when he was hypercritical and faultfinding and bitingly humorous, which I called "chipping away." "I know this is a flaw of my grandmother—complaining and criticizing people," he admitted. "I have inherited this curse." But the pluses and minuses always resolved into an equals sign. Whatever ghosts flitted occasionally through the apartment, the relationship was essentially strong. That season, I wrote a poem, typing at my big desk in the front room, that captured forever for me that place, and the feeling tone of us in that place—the tilted stage set of this second or third phase of our first love. It was another letter-poem, with no title, just "Howard," a dash at the top, and memories of intimate times in the parlor:

And fire, fire is what you make dexterously in our dangerous
Fireplace, when it gets cold and we drink and talk, politely,
As though we were just introduced by the lamp to one another

PART II

MILAN/PARIS

———————

S OMETIME IN SPRING, 1980, I TOOK A PLANE TO Milan. Dan Deely at Wilhelmina made a deal with an agency in Milan with the spunky American name "Model Plan" for me to travel there. All the planning was done by telex, the great-uncle of the fax machine, and the price for the Alitalia ticket was advanced against future monies that I would undoubtedly be pulling in—an arrangement that resulted for me in a kind of indentured servitude, though I wasn't yet intelligent enough, in the sense of "street smarts," to foresee this. My head was too full of flashing strobe units and the contours of a smooth and glossy new world. Walking into the Men's Division at Wilhelmina did feel like walking onto the set of a TV show. Modeling was a world controlled by the image-makers, as if we were all trapped inside a TV set or, flattened and two-dimensional, inside a mirror. I felt unstuck, out of place, and never shook that jangly, ominous feeling, a taste of poisonous excitement.

We had mirrors at home of course, too. Mostly I gravitated toward the standing oval mirror, framed in walnut, a Victorian umbrella

stand left by a bygone resident. I tried to figure out my best angle by turning this way and that. I was also going on "go-sees" for work (that never panned out) or test photographs by photographers who were themselves looking for work. Often these photographers wound up wanting to take nude shots and suddenly I turned from a standard-for-the-era promiscuous gay guy into an uptight potted flower who was shocked and could never do such a thing, while all the white-bread college athletes sent by the agency didn't think twice as they slipped out of their Levis (and usually no briefs). I was more comfortable studying my angles in the mirror in the corner of our front room. Or checking out the tight, uncomfortable, tan Tony Lama boots I spent all my money on because they made me an inch taller, or the rough hair gel versus soft hair gel. Whenever Howard caught me in the act, he'd scoff or look worried, depending on his mood, while I'd pretend, as if we were in a "Lucy" episode, to be examining a splinter that might have flown into my eye or some other fake cover-up.

In the fraught week before I left for Milan, I did the unthinkable. I went on a bender after a party and escaped to the Mineshaft, while Howard slept alone, using as his pillow a rolled-up sweatshirt of mine from France, with a rooster emblem and the word "Training" on it. (Not out of tenderness, just a weird mistake; he was drunk, too, but the tangle was my first bleary sight when I walked in, gray light beginning to suffuse the plastic window sheets.) We had a terrific hungover fight that went on all the next day, with lots of quiet yelling (resembling actual yelling, but neither of us raised our voices), and crying jags, unbroken until I blurted out, when he threatened breaking up, "Then I won't be able to be the Beast anymore!" Somehow that cry from the heart broke the spell I'd conjured—that, and showing my understanding of the seriousness

of my act by having an emergency session with Sister Mary Michael in her medieval tower. She shared a few banal zingers, obvious news, backed up by past evidence. "You're afraid of intimacy," she said. "You two seem to need to fight every time you're facing a separation." If I'd been sniffy about doing nudes, that day I felt psychologically naked, and blushed with shame. So we reverted to our comfort zone of lawyerly deals. I recorded all the clauses in my journal: "We have a commitment not to find new lovers for the next 9 months, though we're not committed to abstinence. Also H. may try to come to Milan to edit for a month." At the airport, waiting for my plane, I was still scribbling: "I just feel *very very* relieved that we left on good terms, not break-up terms. Now I'm just exhausted from the tremendous emotional drain."

I recently found a letter Howard wrote that Thursday, just a few days after I left. I don't know why it was never sent but he expressed all the ache and roiling that I felt that long night on the way to Milan in my cramped tourist-class seat and tight Tony Lama boots—the confusion about what in the world I was doing. Was I running away? Would this quest make sense? (Absurdly, I dramatized trying to get jobs selling dress shirts or bridegroom pants as a "quest.") "Monday morning I was on the verge of tears all day," Howard wrote in blue ink on three-ring-notebook paper, in his pebbly penmanship. "Today again. I had love attacks all day, the melancholy kind. Tonight I came home to an empty house, and objects were weighted with all those things which provoke memory. When you are here, I still feel as if you've gone. Everything about you is precious to me. I love you as much when we are always together, as when we take little vacations away from each other. But when we're apart, I dwell on the details. I can see your love flowing towards me. I don't feel abandoned. This is

life. We are both pursuing careers, and this is the result. I know I can wait till you get back. I'll work on the film, videotapes, be reminded of you when I go somewhere, hear a certain song, smell a whiff."

Still crashing when I arrived the next morning, I made my way through the little glass Malpensa Airport, almost like a small-town airport, except for gray-uniformed guards with oversized machine guns. I was weighted down with my own brown L.L. Bean duffel bag. On the way into town in a cab I decided, "Milan is the Pittsburgh of Europe," and then used that formulation endlessly, when I found it made people laugh. I had lived in Venice and Paris, after college, but wasn't finding the intricate charms of those cities—cats' reflections in canals, florid marble statuary, cracked ruins—in brutal, contemporary Milan. Squeezing under underpasses, we passed smokestacks, glossy billboards, and elevated power lines crowded with birds, arriving finally in a city center of stolid gray buildings. Long, red Communist banners hung from a department store as an angry crowd out front shouted slogans, shaking their fists. "*Sciopero*," the driver said. "Strike." (There were many in those days.) When we arrived at the address I'd written out—84 Corso Magenta—I was deposited abruptly on a sidewalk in the late-morning sun.

Model Plan (modeling, in Europe, in that era, was all about marketing American-style brands, using mostly American models, hence the agency name) was housed in a Renaissance-style palazzo, with a courtyard full of fountains and cypress trees, down the street from the church with Leonardo's *Last Supper* mural, which was being restored the entire time I was there. Only able to make out patches of a painted yellow robe or snatch of gray beard behind workers' scaffolding, I would often duck into its cool, dark shadows to escape the excesses of the Italian fashion world. The bookers' room at Model Plan was

at odds with the solid, brown, antique shell of their building. Two men and two women sat around a clear plastic table, on plastic swivel chairs, talking on brightly colored plastic phones, all in sleek contemporary Brionvega design. One of the men's bookers, Simon, was a black Brazilian, the other, Luigi, a native Italian. They feigned surprise at seeing me. "You weren't supposed to come this week, were you? Did Dan say? Do you have your book?" They passed around my clunky book of pictures. "*Stupendo*," exclaimed one of the women, thankfully. "But it's a holiday and there is no work until next week." "*Facciamo il ponte*, we make a bridge," explained someone—Italian for stretching a vacation from Thursday until Tuesday. They made a few calls, set me up in a hotel, and out I went again, feeling blindfolded and spun about three times.

Pensione Carrobbio was a few blocks down from the gray muddrip Duomo Cathedral, which was on a square banked with Times Square–style billboards and the glass arcade of the Galleria, where boys skateboarded on wet pavestone all night long. The hotel was fine for tourists on a budget, less fine as a home for four months. My cell of a room was a fusty conglomeration of a narrow bed, a shuttered window that muffled all light, a plastic bidet stashed under a corner sink, and, the only touch that, weirdly, reminded me of my real life—my already former life—a copy of a Bronzino painting of Neptune. More vivid was the parlor downstairs, like the parlor of one of my aunts or grandparents in Pennsylvania, with the one available phone. Much time was spent trying to call Howard in New York, or trying to be there when he called. More attempts than not were failures. "*Aspetta*," the owner would say, taking the paper on which I'd written down our number in New York for the nth time that he had to call from his little office with the framed cheap illustration

of the Virgin Mary, roses sprouting around her face, pasted on the wall, while his family sat in the kitchen eating pasta and smoking and yelling. Fidgeting on the couch, I flipped through a pile of books left behind, mostly cheesy Harold Robbins novels. In and out were American kids, all would-be models. I realized I'd been typecast, but wrongly. The first of my colleagues I met was a tall basketball player from Michigan whose "girlfriend from college" and "real girlfriend" were both living on our floor, he informed me, stressed. Having spent a decade escaping high school, I felt dragged back.

Milan was an innocence-destruction machine. My own innocence was mostly gone. But other newbie models tended to be juvenile, on the cusp of their twenties, often never having been out of the Midwest before. A lot of the young women ended up on yachts rather than go-sees. Modeling in Italy came awfully close to prostitution, with bookers doubling as pimps. I was the only openly gay male model I knew, and I was circumspect, as if I were back in high school. But there were, I noticed, a number of guys going off for the weekend on a Greek island with an Italian designer and coming back with contracts for a big campaign. Especially because I wished to write a novel, the more dramatically their innocence was challenged, the more interested I became. I did spend lots of time in my room, where it was always dusk, scribbling notes about these kids, romanticizing them as a new "lost generation," partly to put a nice spin on my own plight and keep me from imploding from a combination of nerves and boredom.

I was entranced that spring by one of the earliest of the famous Calvin Klein male models. When I left New York, or on a quick trip back, his image, naked and muscly from the waist up, filled a several-stories-high painted billboard on Times Square. In Milan, he was rumored, in knowing asides, to be a heroin addict who kept

stealing camera equipment on shoots to pay for his habit. True or not, when he'd stumble, or stride, into a casting in some courtyard, in Army fatigues and reflector sunglasses, I'd watch for signs of collapse, wishing he would be my new best friend, imbuing his distress with James Dean tonalities.

Gay cut both ways in that border time in that border culture. To Italians, all male models were assumed to be gay hustlers. So outsourcing male fashion jobs to Americans wasn't entirely a compliment. No self-respecting Italian male peacock would do the dirty work. I was booked to do a shoot for *L'Uomo Vogue* by Oliviero Toscani, who was adding to Italian fashion what Fellini added to film—a circus atmosphere. The spread, dominated by wedding scenes, was titled "Matrimonio." In mine, the edgiest, dressed in a double-breasted business suit, I held hands with another boy model, also in a suit. Ahead of its time, the shot was seen less as the call to liberation Toscani presumably intended than as a punch line, and, like a Hollywood actor doing a gay part (considered career suicide at the time), an aura of queasiness stuck to me. My biggest near break came when Giorgio Armani summoned me for a one-on-one as the "face" of his next campaign. Armani was impressive, a mensch. Short, tan, robust, with wavy silver hair, wearing some approximation of a white lab coat, sitting at a black marble table in an eighteenth-century palazzo, he looked at my pictures with a long-stemmed magnifier. "I like your hair back like this," he said, tapping a photo. "If we use you, we will probably wet the hair." When the booking failed to materialize, Luigi (at Model Plan) told me it was because they'd heard I had sex with an Armani assistant I'd met at Prima Donna club—high school, again. No matter the homoerotic subtext to these ads, rumors of actual gay sex were a hard no.

TIGHT O DOPPIO PETTO?

Back in New York, Howard was living our shared life for both of us, and somehow that life grew at an exponential rate, but so, too, did the minuses of solitude. Left with a half-empty mattress, he felt the same ache, a body-ache version of a toothache, as I did. Howard had a pulp romance in progress that spring and his letters to me about the book—"Who would have thought we would have a literary correspondence?"—were as romantic as the plot he churned out.

I've been kind of lonely lately, and this loneliness creeps into the book. It's hard to write a tear jerking romance and not be affected myself, so the work goes slowly. A few things I've immediately noticed since you left. Most music seems somewhat depressing, and certain songs—disco, show tunes—put me into a funk. I've been afraid to play certain records at all. I'm sure you know which ones. The nights are the hardest. When I'm in bed I can see you there in characteristic positions. Last night I thought of you baring your teeth and making a sound, which I don't think there is a word to describe but it sounds like you have something caught in your throat and a little like a heavy exhale and I started to laugh. Then I made the sound. It was then I realized that the worst thing is that we can't communicate. I think of things to say to you all the time, but there is no release. Love attacks go unsatisfied when I get home.

He went off to Miami the week after I'd left, seeking some familial support. Drinking a neat scotch on the plane on the way down, he fantasized hijacking the plane and forcing the pilot to fly to Italy. "I could tell everyone I was in the Red Brigade," he wrote to me, "then disappear into the crowd at the airport (everything's so disorganized over there.)" Expecting more comfort from his

boyhood whippets, Kizzie and Tuffy, than they could give, he was let down: "They both slept with me last night. I used to think that a person was a weak substitute for Tuffy, but now I feel even his faithful presence is little consolation. I miss you, Brad. The oddest things make me want to cry. Cuban refugees. Parents of hostages. Divorcee friends of my parents." Yet the raising of the topic of his "troubles" by his mother again caused him to book an early return flight: "She speaks about my 'troubles' as if I am some kind of paraplegic. Here I am missing my boyfriend, and she expects me to have a heart to heart about That Subject. Such is the insensitivity of the heterosexual. My father has become exactly like John Glenn Gooch, he doesn't want to know any gory details. I wish my mother could adopt the same laissez-faire attitude."

Back in Manhattan, Howard was more sought-after singly than the two of us had ever been together, and he had enough manic energy and sheer anxiety to pull off successive nights that ended at sunrise and then just started up again. "I came home and listened to the answering machine," he reported. "23 messages." When he was in bed, he'd read, appropriately enough, Elizabeth Hardwick's *Sleepless Nights*. He went to a screening of a documentary about Virgil Thomson at MoMA. He went to the photographer Gerald Incandela's "Third Anniversary in New York" party, where Gerald pitched a Bedouin tent on his terrace, torch lights set all over. He spent the first part of the evening talking to the photographer Marcus Leatherdale, "until Robert Mapplethorpe took him away to dinner." A few days later he casually mentioned Marcus coming by, and their having a late supper: "He has had such a wild life that I'm sure he must be a liar, but probably he's not. I'm just used to more normal things. After sunrise he finally left. I slept for two hours."

At Gerald's he fell into dancing with my boyfriend-before-him, Frank Moore. At another party, Frank brought gifts of basil plants, wrapped in paper still wet with red, purple, and gray paint that got all over Howard's blazer. His personalized wrapping paper from Frank was emblazoned with "FUCK CUNT" in red and "FUCK FUCK" in black.

Either everybody in New York was bleary and out of it or Howard was and just reported everything out of focus. One morning, while he was doing his push-ups to the *Who's Next* album, turned up loud (he'd gone out and bought seventy-six dollars' worth of records the night before), Ruth Kligman, the girlfriend of the late Jackson Pollock, nicknamed "Death Car Girl" by Frank O'Hara for having been a passenger in the car the night of his fatal accident, phoned: "She said she is getting baptized in two weeks. She wants you to go to church and pray for her. She gave me her Christian Rap. We spoke for about a half hour and then she asked, 'Who is this?' She sounded drunk and a little bit like a bag lady." Canon West invited him to dinner and he brought along Richard Elovich. "I hope you won't be embarrassed if I talk about you, my child," Canon West said, then proceeded to tell Richard he had "El Greco skin." He also unhelpfully opined that I was truly a poet, not a model, and had made a great mistake by going to Italy. In the crew that night was a twenty-six-year-old priest from Georgia, Jeff, whom Howard mischievously enjoyed quoting, saying, "I was fortunate enough to realize I had a calling at an early age." "We drank," wrote Howard, "ate spicy food, drank some more, and drank some more." Afterwards Reverend Jeff invited them for a nightcap at his apartment nearby: "He was lewd and suggestive and wouldn't let us leave. After we left, Richard wanted to go back and fuck Jeff's friend. He called from a pay

phone. There was no answer so we went down town." When Howard got home—"I had been gone six hours"—he found ninety-two messages on the machine, many of them, eerily unexplained, hollow hangups.

Between-the-lines, and in-the-lines, of many of the tales told were drugs and alcohol. One Friday night he went to the Bronx apartment of Joe, his old boss at the Met, and Joe's Hungarian nephew, Istvan, and bragged of trying to turn them on to cocaine: "I left at midnight . . . the subway ride was depressing and to die from." Joe LeSueur and a record-producer friend stopped by uninvited one late afternoon—"We all sat around snorting coke (mine) and drinking." The record producer invited them over for supper, said Mick Jagger would be there, but they went to Joe's tenement instead: "I came home. I read for a while. I slept for an hour. I called you, as you requested. I read some more. I felt like shit. I had an anxiety attack, which suddenly and mysteriously subsided." Those letters were full of tossing and turning—"Then at some point the pain just stopped. All at once I felt relaxed and passive, like I had just taken a shot of junk." Burroughs came for lunch, then dinner, with Giorno, and Richard E, "and nine other peoples." For all the detail, Howard left gaps in these dispatches—"I realize I have left out many juicy details." Among those, I later found out, was a friend of ours nearly OD'ing on the floor one of those evenings. Howard's snapping out of his nod to stop a third party from calling the cops, and reviving said friend, prevented several nearly ruined lives.

At last, all the date books went empty and all letter writing stopped. That month of August is obliterated from all my files. I didn't need to write down a single note, because Howard and I were together again. We met in the beginning of August in Rome.

Howard had a rental Citroën Deux Chevaux, the two-cylinder French proletariat car, I believe because Howard's visit had begun in Paris, where we were to return the car mid-month. I believe the hotel was the Hotel Londra (I was on my way from Venice, where I did a job that involved jumping into a swimming pool in a linen suit.) Howard was in Rome because there was a poetry festival involving William Burroughs. He told me within minutes that the night before he had dressed up as a woman, with Jackie Curtis, who had much more practice, and they seduced and blew an Italian policeman. Howard was lively when I'd first met him, but a cork had definitely blown during those three months I was absent from Manhattan that was never again to be replaced. There was a bitter irony here: I had gone off on this great adventure and wound up in the eye of the dopey weather pattern of male modeling, feeling at times like a ghost hunter in search of the ghost of my former self, or Peter Pan trying to get Wendy to sew back his shadow, while Howard, by staying home in downtown Manhattan, 1980, had liveliness bursting from the seams of his suitcase. Either way, we fell into what felt like a bed of silk that night and just held tight.

For our August vacation, we drove the sleek Mussolini-era highways that cut through the midair of Calabria, a rocky region still full—like a Middle Eastern country—of women in black veils, and then took a ferry to Sicily and a boat to Panarea, one of the Aeolian islands, formed of black volcanic ash, where much of the Milanese fashion crowd went for their regular August holidays. "You can take a little boat to Panarea"—Howard liked to repeat the instructions we received from a Tadzio-like boy on the docks in Palermo. Feeling rambunctious, rebellious even, wanting to shake off the restricting coil of modeling, I ducked into a barber shop on

the wharf and had all my wavy brown European-style hair shaved to a more severe, American military boy's crew cut, a gesture that felt liberating enough. We took that little boat and spent a week reaffirming our self-evident love on an island that we decided qualified as "punk," with its black beaches and reliance on generators, making electric service as fitful as in our apartment on the Bowery. We lived in a white stone retreat set back in the hills, a cave really, illumined at night only by our flashlight, candles, and lanterns, overlooking the dark parchment of the Tyrrhenian Sea, making love like Henry Miller and Anaïs Nin, a cheesy shared fantasy we enacted. Here was a bumped-up version of our Skunk Hollow cottage of two summers before.

My memories of the next month are a chopped salad. We did drive back to Paris. I had a translation of Proust's *Remembrance of Things Past* to read aloud to Howard on the road. I recall a scene involving an elevator in a Balbec hotel. In Paris, Howard introduced me to Melinda, his campy friend from his Paris year—in one of his student shorts, she put a sweetheart's film through a meat grinder, then zanily tried to patch it together. She was living in the apartment of an enigmatic French art dealer, Arnaud, and it was arranged for me to rent a small room with them. But at Glamour, my unbelievably named agency in Paris, my new agents, Bernard and Stefan—a bit like the Vegas animal act Siegfried and Roy—expressed horror at my buzz cut and insisted they couldn't use me until my wavy hair grew back and that I might as well go back to New York and have Dan telex when my hair was at the proper length. "This look is not commercial here in Europe, baby," Bernard, the younger, clucked, scolding me. So Howard and I returned to Bleecker Street in tandem.

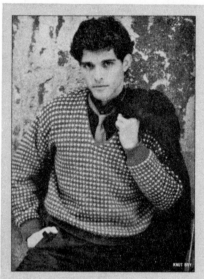

KNUT BRY

FRONT PHOTO: S. HATALEY

PRINTED BY DC&S (212) 736-4121

PETER KNAPP FOR L'UOMO VOGUE

WILHELMINA
MEN

9 East 37 Street
New York City
Print: 532-6806
Television: 778-9406

HEIGHT	5'11½"
SIZE	40R
WAIST	30
INSEAM	32
SHIRT	15/33
HAIR	Brown
EYES	Hazel
SHOES	9½D

KEN HAAK

I spent a few weeks back in our New York life, feeling the entire time as if I were walking a few inches off the ground, never quite relaxed, skulking around as the lame-duck boyfriend. Every week I'd visit Dan Deely for the humiliating exercise of examining my hair length, until the telex was finally sent announcing its acceptable length, and then back on the plane I went. In big brush strokes, my second departure turned out to be a replay of all the distress, sep-aration anxiety, and punchy psychodrama of my first exit, though the cards were played in a slightly different order. Our goodbye this time was formal and awkwardly unruffled. I flew on Air France instead of Alitalia. I traveled to an actual apartment promising an adult life in much more intriguing and dimensional Paris. But I inadvertently left behind a ticking bomb, like Poe's telltale heart, on an orange-crate "table" by our mattress: my black sketchbook journal in which I'd scribbled all my private thoughts as well as de-scriptions of illicit escapades, a slip whose implications I didn't need Sister Mary Michael to explicate. Tick-tock, tick-tock. For several days, Howard, on phone calls, didn't say a word about the diary, and so neither did I.

We did our talking now from the rotary telephone in my new home, Melinda's Paris apartment, in a hall off my bedroom. Located on Rue de Douai, near Place Blanche in the ninth arrondissement, the Proustian vanilla-walled apartment rambled through three bed-rooms, a living room (*salon* would be a better word since all furniture and sepia-tint photographs were nineteenth-century), kitchen, and two bathrooms. The apartment actually belonged to Arnaud, a dealer in neoclassical *objets*. Before I got to Paris, the buzz, mostly from Howard, was that the thirty-two-year-old Arnaud was never seen in

the apartment and led a mysterious private life. But it seems that before my arrival he'd contracted some nineteenth-century-style mild tubercular ailment and was forced to stay home, and, consequently, his patterns had changed. I was surprised on the afternoon I arrived that Arnaud was the only one in the apartment. I was surprised, too, to find that he was so friendly, since Howard had said he pretended not to know English, when really he did, to avoid conversation. But we got on immediately. Arnaud made tea and toast, his hand shaking as he poured the hot tea, apologizing for having taken so long. I of course said no, not at all—"*pas du tout.*" I think we got along because we both enjoyed oriental bowing, thanking, and apologizing to each other.

Sipping my tea in the living room that afternoon, I observed Arnaud—a bit shorter than me, with thin blond hair, translucent skin—as he slipped into his room, returning in a red smoking robe and with a cigarette holder, explaining that the holder reduced nicotine intake, cough, cough. Soon I'd learn Arnaud's routines: whenever he went out he usually put on different kinds of pale corduroy clothes, but always looking very elegant. Rumors were that he spent much time at the Arab baths, but he never mentioned them. When he stayed home nights, he'd buy a bottle of good wine, not so much to drink it all, there was always plenty left over, but to sip, and have nearby. He arranged cut flowers in vases, rotated paintings on the walls, and lit fires in the fireplace. That day, light streaming in the front windows, he invited me into his bedroom, where he kept a large collection of old books from his grandfather's collection, a heater, and a tape recorder with a few classical tapes, such as Fauré's *Requiem*, which he often played. I studied a book next to his bed about German alchemists of the sixteenth

century, in which he'd underlined many phrases. Over his bed was hanging—somehow rightly—a reproduction of David's painting of the stabbed Marat in his tub of blood. Arnaud would fuss, languish, and occasionally erupt, quite the hothouse flower. Mostly kind, he snapped at me only once: "Why do you have no wrinkles? Has nothing happened to you in life?"

Although the apartment belonged to Arnaud, and his moods hung over the place as pervasively as weather, Melinda was the lady of the place, its animating wife, and typhoon. (Note: I identified her as the *apartment's* wife, not Arnaud's.) Then thirty-six, American, but having lived in Paris ten years, she spoke along an ascending scale of high notes and trills. "Oh my deaaaaar," she began when she bustled in later that day with supplies for a dinner party that evening, and then just kept bustling. Soon I came to know Melinda's routine, beginning with when she stirred in late morning (except on days when she went to French class, a joke in itself as she had lived in Paris for a decade without getting as far as the subjunctive). She would make a bowl of café au lait, dial a round of phone calls, then work on her watercolor drawings, mostly illustrations from Proust—looking like Aubrey Beardsley's, but in color—into the afternoon. She did drawings on commission for rich people, or restaurant menus. A friend requested Wagner, so she concocted a drawing of an India-ink concert grand with a bust of Wagner atop and two dashing men playing together four-handed, their coattails swaying behind.

Melinda's prime time was evening, when she either went to a dinner party, or made one herself. She was intensely social. Many of her friends were homosexual men. She was most in love with Colin McMorty, doting on his blond hair and striking intelligence. Colin was Arnaud's business partner and was both knowledgeable and

witty. Most of Melinda's friends were witty. Her social circle was a mélange of American and English expatriates (well, Colin was Irish) and native-born Parisians who got together to create a replica of *ancien régime* society, the foreigners even more convincing than the French. These friends are difficult to describe, though they already acted and sounded as if coming off the pages of antique novels. Playing roles so much, they knew well the difference between public and private, the divide making for most of their nuances and jokes. If I had only met Melinda at parties, I might dismiss her as a "fag hag," or think we had little (except Howard) in common. But the staged dialogue at dinners was nothing like our sweet, cooing daytime talks in the kitchen, waiting for water to boil. In the apartment, water often was boiling on the stove, either for coffee or tea. I usually bought honey for the tea, as well as milk, endives, pâté. Arnaud bought wine, cigarettes, and flowers. Melinda bought everything all at once for her dinner parties and always served, for dessert, a baked apple covered in cream and sugar.

I was working some modeling gigs. In those first few weeks I booked all the shoots I could manage—beginner's luck—for the remainder of my time in Paris. I lay in bed in a tux with a negligee-clad woman wrapped in Christmas tinsel, the photographer on a ladder, looking down from the ceiling. When I asked if I should look at the camera or the woman, her breasts level with my eyes, he answered, "Look at the girl. The viewer doesn't know I'm here." I suppose I was overthinking the situation. Or I stood barefoot in Lee jeans on a cold afternoon at five o'clock in a high wind, eating tomatoes out of a picnic basket with two women and another guy in the Bois de Boulogne. Gossip circulated on that shoot about my first photographer, Deborah Turbeville, having

that summer marched her female models around hot, stinking Venice all day until they collapsed on some café chairs, and at that point said, straight-faced, "That's it, that's what I want," and took the shots. I posed as a goofy groom (with a woman this time) for an image that wound up on the curved walls of Paris Métro stops. I swayed on skis on fake tissue-paper snow, mostly pretending to laugh at all the cutting up by the photographer, who resembled Fearless Fly with his frizzy blond hair and silver jumpsuit, playing air guitar with a broken-off broomstick, or ogling the girls when they appeared in their bras and panties. Surrealism in Paris was by now a chapter in art history, but a kind of surrealism verité thrived each day in its fashion studios.

About a week later the phone rang and reality came crashing back into all this surreality. I knew something was terribly wrong from Howard's voice, suspected the cause, but filmmaker—or sadist—that he was, he drew out and framed the anguish, telling how tired, bedraggled, and dizzy he had been since I left, unable to fall asleep until dawn, thinking about going to the baths, but then not going. He said he remembered telling me he thought we should be faithful to each other while we were apart, and that I, of course, had said "No," but he decided that he would anyway, and then pretended I was doing the same. The night before, he'd gone to see a late screening of Pasolini's *Arabian Nights*, with its implicit moral for our situation left unsaid: Aziz, unfaithful to Aziza, realizes his horrible mistake only after she is gone. Coming home from the film, he crawled into bed and, said he, found my diary. Some excuse papered over the indiscretion, such as his thinking I'd asked him to read it or some such. Either way, deciding to be current, he turned to the last page, where his eyes fell on my confession (to myself) of having just

returned from an afternoon of sex, of my being afraid he would find out, but writing that perhaps his anger would relieve my guilt—a neat insinuation that I really wanted this discovery.

He began rattling off incidents, having read not just a page, but backwards through many pages, starting with my saying I had "jungle fever." (Hence the outings Mapplethorpe and I sometimes made, he more regularly, to Keller's, a bar for black men and their admirers at Christopher and West.) Then there was some Milanese, Sandro, and a model from Nebraska named Scott. Or the Brazilian from the Paris Club Sept I somehow snuck in while we were in Paris at the end of August. After reading my journal entries back to me, Howard revealed that he had actually called at four in the morning his time, earlier in the day. Someone visiting Melinda informed him that I had not come home the night before, had stayed out all night, but I was never told. "With your record, I know what you were doing," Howard, in effect, said. "You knew when you left you were risking our relationship. Now it's done. We'll make some equitable living arrangements if you return to New York. I know now I'll never be able to trust you. I wish I had drugs, anything to numb me. I love you so much. But I want a lover who is faithful. I may never find one, but I'll start looking." Click.

Thus began a horrible emotional log-flume ride that went on night after night, at odd hours to adjust for our work schedules and the time difference. We would talk and give up and hang up and talk again. I felt terminally punched in the gut. I had never entirely bought the argument that I was doing something so horrible. Yet after all those hundreds of sessions with Sister Mary Michael, and the softening of all those nights when Howard and I were trustingly wrapped in each other's arms, even with my history as a classic West

Village seventies guy, I had allowed a more ordinary definition of intimacy into my emotional dictionary. In a brilliant debating-team tactic, Howard argued as someone more Brad than Brad by spinning on the word "faith." He even sent me a sixteen-page neatly handwritten letter, in that familiar blue-ink script of his that somehow got to me more than any of the words expressed, including an appendix of familiar quotations about faith, ending with Paul's Epistle to the Hebrews: "Faith is the substance of things hoped for, the evidence of things not seen." Eeek. Those words, written over several days, were excruciating to read, but, finally, by the end, he, and other friends of ours, had, thankfully, blessedly you might say, talked him back into my ("faithless") corner again.

Howard offered a deal, an experiment in monogamy, as a condition for our reuniting: "Let's do it for six months. If it is impossible for you to do it, after six months, we can talk about changing it. . . . And also, we *must* speak our minds. Discuss all anxieties, insecurities, as they occur. I know this all sounds a little Hesse-esque, but we have a couple of years together. We have proven we can enjoy an adult mature relationship. We have succeeded at what most people seem to want, and miss in their lives. I want to get to know the other you who I have just discovered in your journal, and let you know the other me. The one who risks his life for drugs in order to numb himself. We both have these self-destructive, anxiety-ridden, self-hating, egotistical, insecure people inside of us. We must get to know each other intimately, and help each other." Ambitious for love, eager to escape pain, and melted by the scorching of his letter on faith, I agreed. The plan: in two months he, too, would live at Melinda's, editing his accumulating Burroughs footage.

During those two months I punched my modeling card less and

less, falling into a magical lassitude, unusual for me. I sat on the couch by day, reading Paul Bowles's translation of a Moroccan novel, *A Life Full of Holes*, by Driss ben Hamed Charhadi, and I playfully scribbled and taped one of its sentences on my wall as a description of my model's life, which it hardly was, except in my hardcore fantasies: "For a few days I looked around the city for work. There was no work. No one was working and no one was eating. . . . The stork has to wait a long time for the locust to come. Then he eats." I'd wait for rain, not a long wait in Paris in autumn, and then walk into the fluorescent-lit Chapelle Sainte-Rita on Boulevard de Clichy, filled with sick people who were seeking the protection of Saint Rita; or to the steep hill of food shops lining Rue Lepic, one with a scratchy loudspeaker always playing Edith Piaf; or to intensely popular Bruce Lee movies in the Arabic neighborhood Barbès. I bided my time until the sky turned copper, signaling evening, when Melinda might be ready to go out and take me with her.

Typical nights out from that season were buffet parties at David Rocksavage's, the seventh Marquess of Cholmondeley. Melinda called David a "tax deduction," as he was one of several English lords who needed to live outside England or lose a large sum of money because of British tax laws. He was twenty-one, studying philosophy at the University of Paris, very sweet and very spacey when he came for dinner at Melinda's. She and Colin, and most of the over-thirties crowd, worried that he would be hurt by "sharks"—people seeking to use him for his money or coat of arms. I suppose there were some sharks at the party but I wasn't attuned to picking them out. Equally high profile was David's infamous counterpart, John Jermyn, the seventh Marquess of Bristol, in a position similar to David's—English, young, rich—but using his

powers rather differently. He purposely surrounded himself with sharks, and himself looked like a shark, or a rock star, blond hair cut ragged, given to pranks like spilling drinks in friends' laps. His majordomo was a tall, gray-haired American with a voice like Rock Hudson's, a dummy laugh, and, often, a pretty woman on his lap. Both times I saw him he was wearing a flower behind his ear. "My dear, do you think he's a CIA agent?" Melinda cooed to me one night, eyes wide with mockery. "Do you think he's queer? I think his voice is too *deep* for a heterosexual."

I spent most of one memorable evening there with three young men from John Jermyn's contingent. One was David, a young, blond American from Colorado who had done body shots for *Blueboy* magazine two years earlier. Now he was driving a sleek car and was very aggressive and friendly. He managed to find me an extra plate of food and made lines of cocaine for everyone. He distributed the cocaine in one of the bathrooms. His friend Phillip was twenty-one, a better-looking Jerry Lewis with French parents and a mixed-up story. "I compliment you for being over twenty-five and not having turned into a monster," he said to me. "So many people turn into monsters between the time they are twenty-five and thirty-five." I responded, illogically, "This is the first time everyone I'm starting to meet is younger than me." The third, a Frenchman with a New Wave hairdo, told me he took a plane on Mondays to Brittany for work in petrodollars. Anne, passing by, said that we looked as if we had stepped out of the 1950s. A disenfranchised princess with a husky cigarette voice, she was on her way to be introduced by the majordomo to a fat man in red tie, red Adidas, and thick black glasses—an interrogator for the British army in Cairo during World War II. "Anglo-Saxons are the storytellers," I heard her opining. "While the French excel at memoir."

David was the oddest guest at his own party. When I first went up to him to say hello he just smiled and didn't answer. I felt peeved. A few hours later, I walked into the cocaine bathroom by mistake, bowed out, ran into David dressed in his dark-blue corduroy suit, asked where the "real toilet" was, and he draped an arm around me and said he had been wondering when I was going to show up. Then he went off without answering my question. The other David, the blond Coloradoan gigolo, on the way to showing me where the "real toilet" was, showed me David's bedroom, famous in anecdotes because he had messed up and, having a friend pick patterns for the wallpaper, ceiling, and curtains, ended up with wallpaper from the curtain design and curtains from the bedspread design. I left without saying goodnight near the end of the evening when David, with his fine hands and long thin hair, sat down to play piano. As his guests began to tiptoe up to take their leave, he went on obliviously playing Chopin. Eventually they turned awkwardly away. I especially enjoyed that last sight of David, playing away all the politeness and all the guests, as if he were powerful enough to make them disappear, only because he really didn't notice. It was a Melinda drawing, or a Paris fairy tale.

For some stretch I hung out with the arch marquess, John Jermyn, and his so-called gangsters, until one night they stood me up. Left with nothing to do, I skulked in my room, virtuously typing on my novel, and then I met Andy Warhol, and had my not fifteen minutes but maybe fifteen hours with him over the next three days. Watching Warhol operate, if that is the right verb for his singular way of tinkering with life and reality, I gradually realized that the fifteen

minutes of fame was the time spent with him, as he shined a bright spotlight on one innocent after another (including half-innocent me) and then moved on, not cynically but with the unerring direction of an id, or force of nature, or, in his case, force of artificiality. This provocation of so much special thought began with a phone call around seven that same evening. "Hello. Is Brad Gooch there? This is Fred Hughes." Fred, a Texan, a thinner Belmondo, always in a trim suit, ran the business side of Warhol, though we had never met. "I'm calling for William Burke, who is too lazy to get out of his chair." William, a friend who ran an art gallery, around thirty, receding blond hair, an attractive adolescent bounce, often wore a hooded sweatshirt under his suit jacket for quick, warm exits, was temporarily staying at Fred's Paris apartment. "I was wondering if you wanted to come here to have drinks with Andy Warhol." "Yes," said I, quickened simply by the name.

Though no whistler, I was whistling a Dvořák melody while slicking back my hair with Tenax, the French hair gel of the moment, in front of the mirror. I even took a twenty-franc taxi—my rule was buses to go-sees, taxis to jobs, so I'm not sure how this meeting rated a taxi—to the apartment on Rue du Cherche-Midi. I was relieved not to have to stew about my dinner jilt, making the shock when I arrived not so much meeting Fred and Andy, but finding my original dinner plans—David, the Colorado gigolo, and Jean, the Jerry-Lewis French boy from the Rocksavage party—having *their* drink with Andy. Rather than my appearance stopping the action, I paused near the side while Jean finished telling about his father, elected to the Collège de France for his insect experiments. "I've been eating every night in restaurants since I was a boy," he was regaling everyone. "When my father filled our kitchen with test tubes and glass

containers of living flies, our maid quit and we had to go to restaurants each night." As soon as I realized they had simply forgotten me, they were just as quickly gone past me out the door, and I slid onto the two-seater couch next to Warhol, an art hero of mine ever since I read in an art magazine in high school about his smart prank of sending look-alikes to deliver his college lectures.

Andy couldn't have been more charming. With his white mop-top hair and serious transparent glasses and mien, he reminded me of being with a definitely gay, even fey, even flirtatious and cute adolescent friend, though with an intelligence that transcended gender and sexuality. He was everyone's biggest fan, and seemed to evade ordinary critical responses—reminiscent of T. S. Eliot's judgment of Henry James as having "a mind so fine that no idea could violate it"—and, so, he was a bit of a dandy, closer to Marcel Duchamp than to either the rich people or club kids with whom he was identified (only because he actively identified himself with them, especially as the decade of the eighties that was just beginning was getting rolling). In about ten hot minutes sitting on that love seat (was the heat entirely the heat of fame? No, I don't think so), Andy said to me:

"We want to do a story on you in *Interview*." . . .

"You could take Truman Capote's place. Truman is so busy selling to Hollywood right now. He's not writing his column." . . .

"You should do publicity shots for us, shouldn't he, Fred?" . . .

"A boy named Todd in New York, just your look, looks so beautiful on the new McDonald's commercials saying, 'I'm gonna make it big. Big Mac Big.'" . . .

"Does everyone say you look like the young Terence Stamp in *Billy Budd*?" . . .

Everything I said was "Wonderful" or "greeeeat."

In this single way, Andy reminded me of Melinda. Both were flatterers. Melinda ooh-ed and ahh-ed at everyone at her dinner parties, never snubbing or cutting anyone. At first this power of positive talking is heaven. However, like heaven, if you think about the quality for too long, dark subtleties emerge. You wonder if the barrage of nice is a shield, or a stroking designed to earn strokes in return. Andy did finally receive more attention than the "superstars" he put in front of his flash. I didn't know about Andy's or Melinda's deep motives. But for me, being a fan could be romantic, sexy, a way of putting on lipstick to mask competitive fang teeth. Warhol's almost camp adoration made the other person an object, a star with less being than a human, and therefore was the most competitive trick going. And it was also a way to learn by drawing people out. It was also a form of love, like a blowjob, or a kiss, or feeding hungry tigers with your body, like the Buddha in one tale. Well, more like a blowjob or a kiss than like the Buddha.

Five of us went on to dinner that first night from the Rue du Cherche-Midi. Andy. Me. Fred. Geraldine Harmsworth, a model whose father, Vere Harmsworth, the third Viscount Rothermere, owned a tabloid newspaper in England, the *Daily Mail*. Christopher Makos, a young photographer friend of Andy's. Fred asked Andy if he could order a two-hundred-dollar bottle of wine. Andy agreed, with a wince. They brought the wine already poured into a giant old chemistry-class flask (reminding me of Jean's father's flies) and put the moss-covered original bottle down next to it. I picked it up and looked blankly at the label: 1966. Somehow I'd been expecting a date closer to 1866. "They probably added food coloring to the wine," said Andy, in his singsong. Geraldine then told about going to mass at Notre-Dame, even though she couldn't

speak French. I perked up and we talked about the Catholic Church as white magic, though she ended the discussion by bringing up the topic of her Tarot cards. Still, I was pleased to meet her. David, the Coloradoan, had once put me off Geraldine by saying that she only talked about how her Cardin watch hung on her wrist. She was in that month's issue of *Interview*, looking just right, stark and sophisticated with pillows of white light behind her body.

Andy grilled Christopher about what he had done in Germany after they left him there, teasing, with a tinge, I felt, of jealousy, insecurity, for Andy was weirdly, transparently needy and vulnerable for a dandy, both in the game and out of it. Makos, in black leather jacket with American flag pin on the collar wouldn't say. Then Andy mused, "I wonder what Cecil Beaton's sex life was like." "I threw away a picture Beaton took of me when I was a teenager because it wasn't any good," offered Geraldine. "Andy, you're showing an excessive interest in sex these days," said Fred, drily. Lots of Minox spy camera pictures were taken of the boy cooking our lamb in the fireplace. He wore a white toque and had a German-looking haircut with blond hairs cut evenly all around in a reverse bowl. The wine turned out to be vinegar, so Fred turned sheepishly away when he handed the check to Andy. We went on to Privilege, a more exclusive part of the club of the moment, Le Palace. On the way, the notion of fake coloring came up again as we drove past La Tour Eiffel in the wash of its spotlights. "Look, they've painted the Eiffel Tower white!" exulted Andy, of the structure actually painted a shade of brown. "No, no, no," others objected, "it's the lighting," though I was sure they were all being fooled by sphinx-faced Warhol, who pretended not to be convinced that it had not been repainted white.

The next day, under the influence, I found myself trying to

out-Andy Andy in my world of models, who were mostly of the personality type susceptible to those strokes. At one go-see I ran into dark-skinned, unselfconscious, twenty-year-old, bound-to-go-far Richard, a model the bookers at the Glamour Halloween party, at a club named—with some overreach—Apocalypse, had dressed in a costume of Scotch-taped models' composite cards, then blind-folded with "Glamour" mailing stickers, and sent out to dance on the laser-lit dance floor, until other models ripped the cards off and he was down to briefs.

RICHARD: Gee. It's been raining for days. And just today, when I had my first outside shoot—editorial—it's beautiful out.
ME: Great. How did the shoot go, Richard?
RICHARD (his eyes going deep and bright): Wonderful. They gave me the best clothes. I did all the single shots. When they put me and another guy in a shot they always put me in front.
ME: A star.
RICHARD (reflecting): Well, no. I just need tear sheets for my book.

Or this conversation with a French model the same week—

FRENCH (singing a pop song): I have an audition tomorrow so I have to practice.
ME: Really? An audition for what?
FRENCH: I'm a singer. Just look at this face. Can't you see me as a singer?
ME: You'd look great on a record cover. I can see it.
FRENCH: You'll be asking me for my autograph in a couple years.
ME: A star.

FRENCH (reflecting): Well, you never know what's going to happen.

That next night was a big party in someone's enormous house in honor of somebody's wedding. The fireplace was twice as tall as me. You needed to stand by it if you had a cold, which I did, beginning to drag from the partying, since the room was big and stony, like a wing of the Metropolitan Museum of Art. Lots of oval tables with white tablecloths were set up and we sat at one where one of the English "tax deductions" started doodling with his black pen on the tablecloth. Andy leaned over. "Oh, that's verrry good. Are you an artist? You should think of being an artist!" I was seated next to Rudolf Nureyev and squeezed his thigh, which felt like marble. David Rocksavage was at our table, too. Andy plied him with questions while snapping more flash pictures.

ANDY: Which books do you like these days, David?
DAVID: I like *The Glass Bead Game* by Herman Hesse and *The Magic Mountain* by Thomas Mann.
ANDY: So, then you like thick books?
DAVID: No. I don't like Tolkien's books and they're thick.
ANDY: Who are your favorite poets?
DAVID: Ted Hughes. T. S. Eliot. Sylvia Plath.
ANDY: Oh, I like rock-music lyrics. They're the real poetry. They're better than T. S. Eliot.

On the last of my Warhol nights that week, a group of ten of us went to an expensive restaurant, maybe La Tour d'Argent. Near the end of the meal, a lively queen at the table boasted, "My

boyfriend has very big pecs." "That might be true," said Andy, "but I'm sure that Christopher's are bigger." "My boyfriend's pecs are definitely bigger than Christopher's," said the queen. "I'll bet you the price of the meal on that." Andy, not tsking at a bargain, asked Christopher if he would unbutton. Both did, and Christopher turned out to have the more developed chest. Much uproar. Free meal for Andy and gang. The wager motif. Another Paris fairy tale. On the way out and down the street, going again to Le Palace, Andy was listening to his Sony Walkman, a ubiquitous yellow accessory that models on the streets in Paris were sporting, among the first because they were returning from jobs in Tokyo. Models in those days were like camels on the Silk Road, carrying new technology, and fashion, around the world. "What are you listening to?" I asked. He put the plugs into my ear and I heard, not Roxie Music or Lou Reed, as I expected, but the soprano princess's "Three Questions" from Puccini's *Turandot*.

I can't say that I would have wanted to stay on Planet Warhol forever. It was a giddy, weightless planet, but without much oxygen. Howard was the oxygen in my universe, but he came with some pain, the pain of taking deep breaths, and definitely with gravity, a coming down to earth. We were each other's oxygen pack. We grounded each other, and, therefore, we needed each other, but we also needed an escape hatch. When Howard arrived in Paris we had some heady nights with Andy, and he quickly took over my spot on the love seat. I remember the two of them carrying on in a sustained giggle. "Howard's able to supply voracious Andy nonstop with information," observed Fred Hughes. I don't know what I supplied, and the supply was lim-

ited, though I would keep seeing Andy back in New York, too, at the Factory, or at a couple of parties at Mr. Chow. At one dinner that I thought of as a throwback "Paris dinner," at a restaurant on the Upper East Side, with the usual entourage, when the check came, Andy autographed the menu as payment. Whenever I had more than two nights of Warhol, I felt the tug of Howard, and, once immersed in Howard, wished for a hit of Andy. If I were drawing a cartoon of my life in that brief period, such would be the scenario, with my vacillating soul in the middle.

In preparing himself for Paris, Howard first went to Miami, still his home base. There he sat alone, down by the lake at night, drinking Harveys Bristol Cream on the rocks, smoking cigarettes, and finishing another of Stephen King's—as he described them—"psycho-religious" novels. Howard worried over matters close to him. He'd brought for his younger brother Steve's birthday Bruce Springsteen's new album *The River*, but while they listened together, Steve told him that their mother got depressed whenever he played a Springsteen record, and asked him not to play any when she was around. She said it reminded her of a sad time in Howard's life—the connection being that he played a lot of Springsteen anthems at high volume the weekend that they asked him if he was gay. And he worried over larger matters—the election, just a couple nights before, of Ronald Reagan, truly the beginning of all that would underline the high-contrast decade to come. Howard was prescient about its coming polarizing significance. "I waver between fear and hope," he wrote me. "Anything is possible now, the greatest extremes."

The big revelation to him, and to me, though, was that he had been trying heroin seriously, and was having his first bout of

kicking the addiction. The cause, I always maintained to myself, was his seduction of Burroughs for his film. The circle of young guys around Burroughs, his disciples, always seemed to be players in junk, and shot up with their hero in a ritual, where he shot first, and passed the needle down, perhaps explaining his own longtime survival and the death of many around him. But Howard also implied to me, in the timing, that the need for a fix was a response to the pain of my going off, and my betrayals. I blocked out that explanation, not entirely believing, and certainly not wanting to feel a terminal knot of guilt in my chest. Probably the explanation was both, and I was implicated, and so do still carry a kind of junk sickness when remembering the first-heard notes of that harrowing little melody of addiction that would become a leitmotif from then on in our lives, rising, falling, like the Rhine maidens in Wagner, and never entirely going away. "I am also getting over (just starting to stop) another habit, which I picked up after you left," he wrote me. "I was in such incredible pain, sleeping alone, and then finding your diary. And I have no way of dealing with the pain, and am afraid of it. So I numbed it, and now all these numbed feelings are rushing back, as the drug leaves me." He didn't name the drug, but for the first time, and not the last, he was suffering through its shivers, insomnia, hot flashes, cramps, and diarrhea.

I met Howard's plane a week later at eight in the morning at Charles de Gaulle Airport. I don't know if you'd call it emotional filing away, or whatever the explanation, but when we were together in the same space, much angst dissipated, and the immediate joy of being together returned. The phrase "molecular joy" pops up, as the sensation of seeing Howard again was a physical jolt— leather jacket, laser eyes, and quick succession of movements,

like Eadweard Muybridge's stop-motion photographs of a gallop-
ing horse. First thing down the ramp, he handed me a paperback
copy of essays by the Trappist monk Thomas Merton, *Love and
Living*. He knew that I liked Catholics. And, of course, due to the
upset caused by my cutting out, the title pointedly (and Howard
was always pointed) spelled out the theme of a long talk, or se-
ries of unfinished small talks, we needed to have. I could smell his
musky smell, like tincture of Shiraz, when I pulled him close to
me, and he me. Then the luggage carousel and then the trunk: a
classic black oversized steamer trunk, with metal stripping, filled
with all his unedited clanking reels of footage from the film that we
lifted together and squeezed into the trunk of a Parisian-gray cab.
The stairs up to Melinda's spiraled, with three-minute timed lights
that we outlasted while trying to hoist the trunk upwards. I joked
about the casket toted and heaved throughout Faulkner's *As I Lay
Dying*—not the last time we'd strain that trunk up stairs, through
tight spots, and down some narrow escalators.

No one was around that first weekend of Howard in Paris, so
we had the apartment to ourselves, for getting reacquainted. We
went to a sauna in the Arab quarter. A Frenchman, wrapped in a
towel, sat on a bench, and I remember through the steam hearing
him ask Howard, in English, what sort of film he was making, and
Howard's answer, "Part comedy, part documentary." I thought
his answer smart, and I was moved emotionally, even sexually,
whenever someone young, taut, and fiery said something smart.
We picked up charcuterie food (shredded carrots, a slice of goose
pâté in jelly), and ate supper stretched on the oriental rug of the
main salon. "This room would look better upside down," Howard
cracked. "With the white plaster ceiling as the floor, and having

to climb over the door lintel to get into the room." "Our Bleecker Street place is already like that," said I. Later he imagined that a flaking brown pipe in the toilet was a dinosaur's leg and that if the dinosaur awoke we'd be in trouble. As Howard's daffiness resurfaced, the junk issue subsided, by a kind of unspoken collusion. I let myself feel that I'd just met him at a cocktail party and was impressed, while feeling simultaneously that I knew him better than I knew anyone in the world. Years later, when I read a remark by Betsy Sussler, editor of the downtown literary magazine *Bomb*, remembering Howard as a "magical being," I flashed first on that revelatory weekend of our Paris reunion.

Lots came into focus by looking at the familiar with another set of eyes, his. The giant gilded mirror topped by a Venetian lion's head in my (now our) bedroom that had become completely ordinary to me never failed to spark some irony from Howard; as did the Ceylonese houseboy who kept arriving regularly no matter how often Arnaud complained of the bottoming-out of the market for nineteenth-century French paintings on classical themes, or how much Melinda resorted to borrowing francs to pay for taxis to her dinners. When we strolled in nearby Pigalle, I saw everything more cinematically, imagining Howard's point of view, feeling his framing aesthetic at work on Boulevard de Clichy after midnight, the Arab teenagers with excited looks in their eyes, the transvestites, an old Scottish couple with gray skin, tourist buses mainly for Germans, Japanese, fat people with hanging cheeks, scrawny vendors for the bottomless shows, grifters and pickpockets, the sliding-closed glass door of a shop, an ass disappearing around a corner, everybody burning. Even though I wasn't a filmmaker, I wrote like one, relying on exteriors, and thrilling to the seen and heard, as

did Howard, so we practically burned holes through dark windows, trying to take in all the sensual details, while psychically holding hands.

In the apartment, Howard was a welcome foil for Melinda, who adored him and loved triangulating in dialogues about Brad. "But my deaaaar," she would say, "if anyone heard about this poor model living in Paris taking cabs home from a dinner party to his room with his handsome movie-director boyfriend no one would feel sorry. He should save his blues for twenty years from now when things get really serious and he's going to be fifty and won't have the same looks and hasn't become a successful writer. But even then I'm sure he'll be invited to faaabulous dinners!" Our back-to-back fifteen minutes (I guess half-hour) with Warhol wound down, but Howard, like me, seemed smitten, and found a copy of *The Philosophy of Andy Warhol (From A to B and Back Again)* at Shakespeare and Company to add to our pile. I took Howard to the Glamour Thanksgiving party at yet another nightclub. The saddest day of the winter was December 8, 1980, when we received news that John Lennon had been shot outside his apartment building in New York. Howard took the news as hard as I ever saw him take any news and spent the entire sleety day walking the hard streets and curlicue bridges over the Seine, listening to "Imagine" and other Lennon songs on *his* Sony Walkman. In the complete obverse of that mood of serious cultural engagement and mourning was the season's silliest day: my twenty-ninth birthday, in January, in the apartment, all men, talking in treble clef, in suits, drinking champagne, the only woman its impresario, Melinda.

I shared private excitements I'd squirreled away with Howard, like the dodgems ("*les voitures trompeuses*," in French, or,

more street, "*les accidents*") that had been set up in the Clichy *quartier* as a temporary moneymaker, the shacks where all the riding and banging took place strewn with colored lights. One rainy afternoon—always icy rainy, always to-the-bone cold—on the way to a tailor's, Howard asked me why I had switched from being attracted to older men, by which he meant the Eagle-clone scruffy daddies, to the high school boys with earrings who hung around the dodgems. They had been *his* territory, he implied, almost competitively. "Modeling's cured me of seeing myself as an object of attention," I philosophized. "With older men, the younger is the object of attention, with younger men, vice versa." "Shrewd," he said, as, I think, a compliment. Somehow, discussing our attractions in this aesthetic manner was not at all threatening to either of us, but was instead a zone of shared interest. We were both philosophers of the bedroom at heart. Burroughs also came to spend a few days, while Arnaud and Melinda were away. Howard said that it was like having our grandfather staying with us, and "Gramps" became our nickname for him during that stay, when he indeed reminded me of my Welsh grandfather with his (their) gray flannel trousers, and soft tan Hush Puppies–style shoes, and quavering voice. Displaced from his lair, the Bunker, he seemed more fragile, and warmer, especially around Howard, whom he trusted, and we three would sit at a card table covered with a cloth (Melinda's drawing table) in the front room for breakfasts of eggs and chèvre cheese and big bowls of chicory coffee mixed with milk and little bricks of sugar, as he reminisced, in a truly relaxed manner, about his days in the sixties at the Beat Hotel at 9 Rue Git Le Coeur.

The first week of February was Fashion Week, and, a younger

Rip Van Winkle emerging from a long Paris nap, I booked a few shows. I fuzzily recall one group show, the first, I believe, for the designer Thierry Mugler. On a runway, I wore his broad-shouldered jackets, like football-player couture, the beginnings of the power look of the eighties. Most memorable was the booking, as much as the show, for Pierre Cardin. Monsieur Cardin sat in a Louis Quinze–style drawing room, on a chair that resembled a throne, and we guys walked up and down before him. In a game of musical chairs, we were then picked and dropped, *oui* or *non*. Weirdly, probably as an outlier, I was picked. The show, the week's finale, was the most desirable because Cardin eschewed rehearsals in favor of an aesthetic of spontaneity. We showed up on Sunday night at Espace Cardin, were given haircuts, then were given cocaine, which basically dropped from the sky, unexplained, then were shoved, buzzed and zonked, onto the runway with no clue, having been dressed randomly by backstage dressers in a crossfire of boots, paisley shirts, red velvet bathrobes, and props, such as long cigarette holders—more a publicity stunt than a seriously considered spring line. Cardin recited poetry through a megaphone, again, spontaneously, as it rolled off his mind. As I walked the plank, I realized that the front-row seats on either side were filled with familiar New York faces—Dan Deely, Andy Warhol—and I was so stoned that I stopped to fumblingly talk and smile an elastic smile, making logistics worse. Somehow, afterwards, Howard and I wound up having dinner in a little booth at Maxim's, which Cardin had just bought, with him and his business partner, Pierre Bergé. The enabler was the young, handsome Swiss art dealer, Thomas Ammann, then just beginning his ascent,

and in talks with Howard about possibly backing his Burroughs film. Cardin seemed nonplussed by having to dine with one of his pawn models—me—as if I were a double agent around whom he had to watch himself, but Howard distracted him with sparking non sequiturs, and Thomas was the epitome of a sexy newish nexus of art and money and fashion: crew-cut dark blond, just thirty, Swiss accent, he dealt Picassos along with Warhols, and already, or soon, young Clemente and Bleckner and Fischl.

A week later, for Valentine's Day—another American holiday made much of by American models fancying themselves in exile—I left a "card" propped for Howard on our bed that was a full page of the brunet American model Jeff Aquilon, posed with a golden Labrador, in an advertisement for a store on Saint-Germain, shot by Bruce Weber, ripped from *Vogue Hommes*. In our ricocheting erotic life we both agreed on the masculine beauty of Aquilon, who began the male modeling wave and convergent amateur athletics boom of the early eighties, with the male-as-sex-object cultural advancement promoted by Weber and Klein, and in whose undertow I was being pulled along. On the page, I drew a heart in black Magic Marker and wrote: "For Howard, Happy Valentine's Day, 1981, Love Brad." In return, waiting for me was a far more exquisite and vulnerable and beautiful card that I've kept over the years: a baroque heart painted in pink and silver and red watercolors, with the message: "A Heart for a Beast in Love From His Howard," the border of the heart the word "Forever," obsessively repeated and linked, in blood-colored letters, with the entire cutout mounted on black-bordered parchment, and cut from a newspaper the phrase "left ventricle" pasted in the upper-left corner, a brilliantly composed collage that, in frilly punk, seemed beating still.

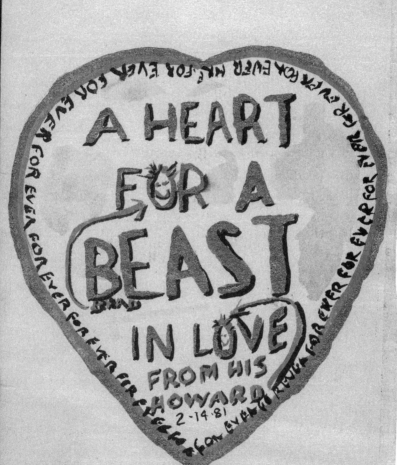

We had only a month left in Paris. We'd been having talks. I don't remember the words. It was like a jazz piece. Howard spoke in tenor sax, and I answered in tinkling piano. But the music underneath was moving us closer to going back to Manhattan. Behind the dynamics of our conversation was one theme: we wanted to be living together in a more intentional way. I was already into my thirtieth year, and my plan for my life had always been to give up the willful odyssey of modeling and cut my losses by eventually writing down the collage of material I'd collected in a novel. "Every time you leave I follow you," Howard wrote in a vulnerable note, and said as much to me in our conversations. "I don't know how long this can go on, perhaps, at least I hope, until you are ready to settle down. But I'm spending all my money on these little trips to be with you, with no opportunity to earn money in Europe. But this is still a cheaper price than loneliness and emotional pain killers." Those "emotional pain killers" got to me. And this time, we were making the decision together.

Those last few weeks in Paris I let go of modeling altogether, although I would continue dips and slides when I returned to New York. I was wrapping my head more around our commitment to living together (though hadn't we already done so before?) and around concocting a narrative out of all the imagery and bits of conversation I'd been hearing. Influenced by Howard's irresistible pull, and maybe playing up to Thomas Ammann, who had been talking of movie producing at the dinner, I briefly and unsuccessfully tried hedging my bets by simultaneously turning my notes into a screenplay titled *Glamour*, in honor of my agency, or more exactly their agenda book, with *Glamour* in big gold letters on the front. Instead of fighting about which of our mediums—film or

literature—was superior, we were now collaborating. I went to the screening room and helped Howard make editing decisions about cutting Allen Ginsberg here or there. He helped me think about writing a film script, or a novel, or both. (Turned out that I was better at writing novels that I imagined were movies than actual movies; but that realization came later, helped by Thomas's disinterest in my script that could never decide whether to be East Village minimal or Hollywood maximal, and also his contrasting great interest, and investment, in Howard's documentary.) My last memory of Paris, in keeping with the film motif, a reel that sputtered out rather than coming to a controlled *"Fin,"* was the two of us walking down yet another wet street to a charcuterie. Unlike Thomas, he was encouraging my ambitions.

HOWARD: I think that first scene you wrote should be filmed very straight on, low-key . . . that even though it's funny she should say her lines in a kind of jet-lag mood.

BRAD: I agree. In fact, most of the lines I write sound best in monotone. That's why there shouldn't be a shot of a plane taking off at the beginning. Too exciting.

HOWARD: I agree. . . . And I thought a great thing for the credits would be to have a head sheet open out and just zoom across and stop at the picture and the name of the actor, but blur over the others, then, click, stop again.

BRAD: That's a wonderful idea.

HOWARD: I have ideas, too, one or two.

I felt for a sputtering instant that we were happily married: married by art.

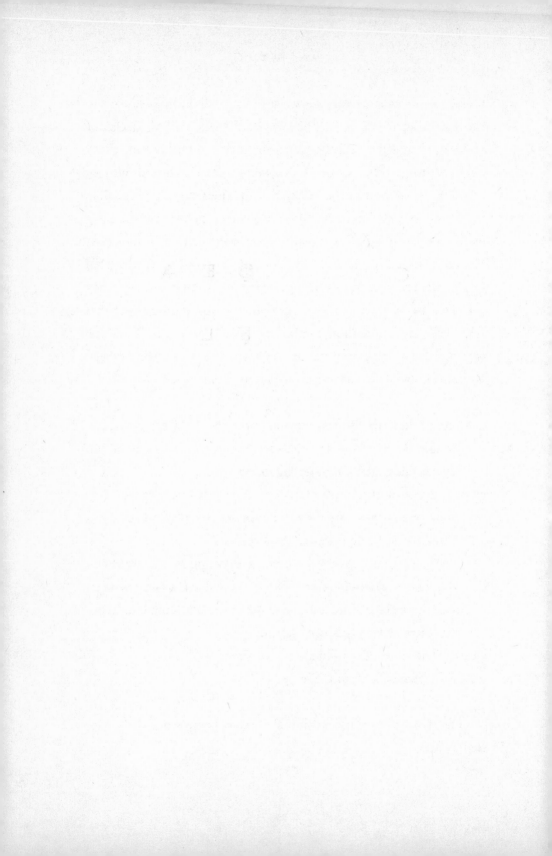

PART III

CHELSEA HOTEL

————————

H OWARD AND I SHOWED UP IN LATE JUNE AT THE
Chelsea Hotel, answering an ad for a sublet. The only hard-bitten sacrifice we made to be together, and to stoke our adventure in Paris, was the loss of our Bleecker Street place. Neither of us had the cash to hold onto the apartment while we were away. We knew the Chelsea Hotel well, and it beckoned to us. I had never actually been inside, but I had frequently walked by the tall, red-brick Victorian gothic apartment building. Most often I had been on my way to or from leather bars on the western tip of Chelsea—a largely Hispanic, or "Puerto Rican" as we used to say, neighborhood at the time, much like my old college neighborhood of Morningside Heights. Its bronze entrance plaque gave credit to some old-time celebrity boarders: Dylan Thomas, Thomas Wolfe. Howard and I could easily update that list in our minds: the Warhol films made there (Viva was still living on the premises); Patti Smith and Robert; the ghost of Sid Vicious's knifed girlfriend, Nancy Spungen, still blamed for elevators stalling on the first floor.

We looked around the lobby, its walls crowded with art, mobiles hanging from the ceiling, everything rusty silver or faded pastels. Like much of the hotel during our time, perhaps always, the legendary was mostly gold bits grifted from a mucky stream of ordinary life. I did recognize one piece: a group-grope tableau Larry Rivers traded to stay in the hotel. Most of the residents passing by us in the lobby were mangy middle-age parental bohemians, looking like aging porn actors with bellies and retouched hair, who were often serious, maybe too serious, composers, sculptors, filmmakers, and writers. Stepping out from his office, owner and manager Stanley Bard invited us back for our interview. My impression was that we three experienced love at first sight. Stanley was wiry, with receding hair, a bad suit with wide seventies lapels, and a loud paisley tie. But he could have been an uncle of Howard's. He twigged to something in Howard's businesslike rap. Everything that had been a liability in procuring an apartment was suddenly a plus—I was a poet, Howard was shooting a film on Burroughs. Instead of a sublet, he offered us, in his high, winding whine, a leased apartment, not cheap, for $1,000 a month, which we took.

Our first room was on the fifth floor, front, number 511. We still kept a few sticks of belongings—the TV, Howard's grandmother's chair and couch. A "housewarming" gift from Howard was a red Schwinn bike that I left to rust on the balcony through the winter, a sore point between us. In the bedroom, I tried to write some. I had been flirting with a straight boy poet from Los Angeles, and I dedicated to him a poem titled "Ed's Boots," which was published in an L.A. poetry magazine, *Barney*, and included a line about "the hands that pick up your boots," very fetishistic stuff. "I went to the signing party for the issue and people were asking me if 'Ed's Boots' had

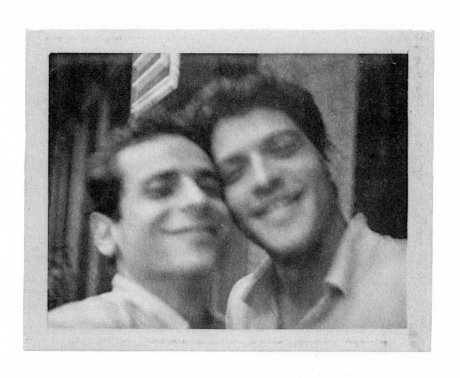

anything to do with me," he wrote me, in a noncommittal mono-tone. "I said, 'Yeah, well I was there.'" Howard and I debriefed each other about the kinks of the hotel. I told stories of my foiled attempts to flirt with an androgynous punk living at the end of our hall. "He won't even play his music loud enough for me to bang on his door to complain," I moaned. Howard won the contest. "Oh God," he said as he walked in one day, slapping his forehead at the macabre scene he had witnessed in the lobby. A fifty-year-old alco-holic, living on the seventh floor, was wheeled out, in a black body bag, by ambulance attendants. As the gurney passed the front desk, Jerry, the loud, hilarious attendant, shouted, "Checking out?"

A more charged memory of that summer involved reading an article in the *New York Times*. I sat on the couch, gray muted light through tall balcony windows, a misty day, no sunlight, pretty quiet. It was the July Fourth weekend, 1981, exactly three years after How-ard and I first slept together. The article was titled "Rare Cancer Seen in 41 Homosexuals." As I read, I felt a palpitation of fear in my heart, a palpitation that became synonymous with my heartbeat soon enough, but not yet. I talked about the science-fiction-sounding piece to How-ard, but don't remember my words. Howard said that Burroughs once had Kaposi's sarcoma in a toe. "More proof that he was avant-garde," he joked. During that same stretch, I saw my friend Matt at the YMCA across the street. He was a literature grad student, a friend of Sontag's, a reader of Beckett, Irish background, pale skin, freckles, thin black hair, I'd had a crush on him, written a couple passionate poems for him, we'd had sex at Columbia. He told me he believed he had the "gay cancer." A chasm opened up in front of me on the gym floor. I looked out the window toward my bike on our balcony, felt an animal panic, a sweat, and mumbled a few words of disbelief.

Our response to this news item was that we entered into a year or so of three-ways. We agreed that rather than having clandestine sex on the side, or being loyal and monogamous—an experiment that was now collapsing for both of us—we would express our solidarity with shared glue. The strongest of those glues was Nick, an Italian boy Howard found who liked to come over and drink bittersweet aromatic liqueurs that we supplied, in front of our fireplace, stocked with Duraflame fake burning logs. I loved the general *atmosphere* of these three-ways, but I was a tease. I began a pattern of dropping out when matters heated up and Howard (politely? I don't think so) wound up closing the deal. For all my claims to promiscuity, I'd always been more of a fantasist, a voyeur, and in these three-dimensional grinding situations, I turned out to be the wallflower, the cold fish. Our most memorable three-way occurred on my thirtieth birthday. We would now be into January 1982. We had a party in the apartment. Nick, in a wife-beater T-shirt, was the popular bartender. Howard and I devolved, staggering, later, to the Mineshaft, and together, on our knees, blew a facsimile of a cop, in his NYPD uniform, down in the damp basement of the fading club. I remember locking eyes with Howard during that forced fun, realizing that neither of us was happy, and feeling sad at our loss.

That winter, too, my job life as a fabulous male model finally hit the wall. I was hired to do an editorial shoot for *New York* magazine at the Gramercy Park Hotel, then even more decrepit than the Chelsea. The clothes were meant to evoke a snooty English drawing room. I fit well into buttoned-up black-tie-style costume, and so I was featured, my hair sleeked back. I remember gazing at myself in a gilded mirror and thinking maybe this job isn't so bad after all.

Then the fashion editor from the magazine arrived. Her name was Anna Wintour. Eventually she would turn into *the* Anna Wintour of *Vogue*. But then she was a young editor with an English accent, seemingly just right for the mannered mood being cultivated by the photographer. Her first move was to sit in the corner, wearing her (later) signature dark glasses, watching wordlessly, like a scolding sphinx, until everyone was uncomfortable. Then the lights began blowing, apparently from faulty wiring in the old hotel. I remember thinking that she was a sorceress and had cast a dark spell on the poor photographer. Eventually she rose and started ripping up his concept. Fast-forward a few loooong hours, now well after dusk, and she had a guy and girl half naked in a sketchy bathtub, drinking champagne, looking wrecked, and me sidelined. The photograph was undoubtedly improved, edgier. I wondered who this talented, chilly editor was, but resolved that I'd had enough black fashion magic. I had never quite managed pulling off modeling anywhere but in foreign cities that were removed from my life as a writer and a boyfriend. I also noted I was getting very little work.

So I was more available than I might have been to Howard's next bright idea: we would open a business. Chelsea was slimly prospected as a residential neighborhood. We calculated that there was no movie theater, no bookstore, and no copy shop. With Howard the engine, and me the caboose, we opened Chelsea Copy, in a narrow little storefront next to the hotel entrance. Howard dealt with Stanley Bard, because the hotel owned the space. He raised money from Joe LeSueur, an investment Joe would come to regret. And he found Hector, a "humpy"—we called him—Latino guy, our one employee. My contribution was asking Frank Moore to paint our sign, which he did in beautiful burnt orange, red, and black paint on wood. I also looped back to Columbia,

where I started writing a much-too-serious-for-my-own-good dissertation on the influence of the sermons of Lancelot Andrewes—chaplain to King James I—on T. S. Eliot. Howard, highly convincing, promised that I could sit upstairs, typing away, while he and Hector cleverly made the nascent business soar.

The business never did soar. One of its odder patterns was that whenever Howard went away for stints of filming and I was left, with my patent incompetence, to handle the shop, the receipts from the register at the end of the workday spiked. No one ever figured out my magic touch, and only later did I put the pieces together to realize that Howard probably had been skimming cash from the register for drugs. Nearly two years had passed since he opened up to me about the habit he'd picked up in my absence—but it was characterized more as a vanquished demon, a lesson learned, a dirty secret never to be told to grandchildren. The pivot in that muffled time was the High Holy Day of Yom Kippur, in September 1982. Howard, depressed, spending hours on the couch, listlessly watching TV, was intent on our going to the service of atonement together. He chose a synagogue on Gramercy Park. We both donned white yarmulkes, picked from a cardboard box in the entrance foyer, and I confessed my dark sins, too. Howard went further, fasting, not using any machinery, and not answering the telephone for twenty-four hours. When he did check his messages, he found one that he'd been anticipating for months—from a BBC producer in London, offering him an editing room and funding to finish his film.

Howard was magically, or spiritually, convinced the phone call was providential. He took it as a sign from the great executive producer in the sky that he was meant to (a) finish the film, and (b)

clean up his act. Just a few days later, he opened up to me about the true cause of his recent, endless lying-about on the couch. He had always casually claimed that he was stoned—if I asked, which I rarely did. I went along with these explanations. Now he was telling me that he had been nodding, as a result of his now fairly regular use of heroin, the rasp in his voice being just one of many clues, while I had simply thought to myself: "Too many cigarettes." Galvanized by the prospect of going to London and becoming a big success, he had just enrolled himself into "primal scream therapy," a form of therapy that John Lennon had supposedly undergone, hence its attraction. Sessions were not simply to be taken up with screaming, he told me, but also with reliving childhood traumas, expressing roiling suppressed anger, and painful truth telling. As a first step in the healing, his therapist had insisted that he inform me of his ongoing addiction and of the months of cover-up.

For a second time in three months a chasm opened in front of me. This time I was looking in the opposite direction, through the rusty bike spokes and leafy balcony to the McBurney Y across the street. The loss of space and place, when he told me, the vertigo, the fear that the whole jigsaw puzzle of my life, our lives, included pieces of doom, returned with force. I was so angry that I screamed, too, without the need of primal scream therapy. I felt duped and betrayed by his expertise at covering his tracks, and said words that were close to fire. I was also experiencing one of those role reversals Sister Mary Michael had prophesied. Living with me in domestic commitment was supposed to have been the cure-all, in Howard's mind, but instead had brought on renewed addiction. Did this also mean that our commitment was coming unstrung, too? Now I was the one feeling panic. Soon his therapist wanted me to meet with her. She was young—our age—not

like my nun-therapist. I was happy to vent my righteous fury. But she surprised me by opening a line of inquiry on how I could possibly not have known. How could I have been so checked out?

For two months, I joined Howard at many of these sessions—him center stage, me off to the side, getting some "Earth to Brad" treatment, listening to these gritty confessions. The cure meant having to hear him yell at me, even without raising his voice. "Why are you angry at Brad?" the therapist would ask. "He demands I respect his need to work," he would growl, "but he won't respect mine because he's an egocentric, spoiled only child who can't give the respect he demands." Okay. I did discover some of those aspects of Howard's hidden self that he had suggested we share with each other—his anger at my selfish work habits, for instance—though of course we never would have without this intervention. Much had to do with money. Howard had the misconception that his parents were wealthy and that his Dad would bail him out whenever necessary. I flashed back on their many intense phone conversations, often revolving around the credit card his family backed. Every so often his Dad would take the card back because of an infringement. This topic led into the tangled wires of Howard's not taking responsibility, the copy shop as play money, or play career, with no consequences, and the doctor asking a lot about fears of success.

Touchingly, at this time, Howard went out and bought a small Sam Flax black hardback sketchbook in the style that I had used for years for self-examining—the very notebook that he had cracked to discover my promiscuous betrayals—and began writing down his thoughts and dreams. I found it sweet to see him somehow being me, as if I were an older brother, a role I never imagined. "I still don't feel I'm much closer to the mystery of why I take heroin,"

he wrote in that notebook that fall. "I know I still feel the impulse. Partially it's connected to habit. If it rains, I think of doing dope and sitting in all day. Or Sundays, when I get that scared/depressed feeling inside. I have noticed a good release valve for the scared/depressed feeling I get almost every day at some point. It is a way of almost thinking about it. Trying to figure out why I'm depressed or scared, and then it instantly vanishes, and is replaced by a good feeling, which might be the absence of pain, or might be a tricky way of preventing myself from finding out what is the real cause." Room 515 became our claustrophobic laboratory of mutual introspection.

Not cured, but certainly not willing to jeopardize his big break for the intangible benefits of more weeks of self-examining, in late fall Howard flew to London, where he remained, with one Christmas return to Miami and New York City to see his family and me, and then finally back at the end of January 1983, timed to be there for my birthday. As a gift for one of those holidays he brought me from a London shop a nineteenth-century Russian icon painted on curved wood of "Christ Pantocrator," a woeful Christ with steadfast gaze, holding a globe of the cosmos in his hand. Canon West was snobbish about its provincial "late style," but I fell in love with its concentric calm. My own Sam Flax diary turned into dialogues, with "C.P." (Christ Pantocrator) taking the part of my higher self. Like me, Howard that New Year's Eve wrote resolutions in his journal, number one being, "no more schmekle, none" (his code for heroin), plus: "Understanding of Brad and consider his feelings and our life together when making any career decisions." And he resolved to listen to Bruckner's Eighth Symphony on his Walkman.

But his life in London was pretty much a repeat, in its spiraling and whirling, fueled by anxiety, of his time in New York without me,

and most of his times on his own. Howard didn't like to be alone. Left to his own devices, he was much more galvanized, much more socially fun, but also much more given to playing Russian roulette with his shadow side. By day he worked at the BBC studios in postproduction on his film. He had a circle of friends, the writer Peter Ackroyd, who cast himself as Howard's "guardian," like a male Melinda, art critic Richard Shone, and the filmmaker Derek Jarman. He discovered that he had a fantasy of being a "sugar daddy"—unfortunately never acted out with me for reasons of age and finances—but realized in London. One of his new friends was a pale boy named Miles, whom he liked to take out to dinner, and to a piano bar where Brazilian transvestites entertained. Then they would arrive home, and he would fuck Howard, and they would stay up drinking scotches until five in the morning, the beginning of the workday. He went to the same club with other "rent boy" types. Howard was telling me some of these tidbits by phone, our monogamy now mutually shot.

A lot of his nightlife revolved around the big gay dance club Heaven, near Trafalgar Square, and a second club called Bang. The Apollo and Dionysus in his life, or maybe the two Dionysii, were Miles and Adrian. A dancer from Bang, Adrian was the more demanding, asking for ten pounds before going off to work, then knocking at the door at three a.m., asking for a place to stay. Miles at least had what Howard described as "the dick of death" and would leave him spent, while remaining untouchably passive in temperament most of the rest of the time. At dinners with one of them, or one of his friends, or with Derek Jarman, discussing Caravaggio, Howard might swill four gins before the meal, followed by three glasses of white wine at dinner, then three huge scotches back at his leased apartment with Peter and Richard and their friend Brian.

He called me one night as I was going out to a gay disco in New York, the Saint, pretty much the Heaven of New York, asking me to help him to decide whether he should take speed or Quaaludes. "Being clean," to Howard, meant taking Xanax instead of codeine, or drinking sherry or port instead of vodka, the transitions between poisons smoothed by packs of cigarettes.

After one of his hangings-out with Derek Jarman, Howard, then twenty-eight, revealed that the live-hard-die-young template of the romantic artist was on his mind, or both their minds. "Glad I'm clean, with the New Year, and the film opening," he recorded in his notebook. "I must make concerted effort to stay this way. Must not slip. I hope I stay clean till my thirtieth birthday. 'Many great gay artists die young,' Derek aged 40 said today. Caravaggio, Orton, Marlowe, Fassbinder. I will need time to do anything. I feel my powers coming, and hope this film, which I think is actually very, very good, is not a fluke. I think I've learned enough so I could do in 6 months what this took 4 years to do. Of resolutions—am still not writing letters, am still biting nails, not exercising." Derek was plotting his next film, *Caravaggio*. Howard found all his talk about the painter's sexuality "boring to listen to," but loved when he shared a print of *The Calling of Saint Matthew*, which reminded Howard of the poses of street hustlers "out of the Haymarket."

Having set my birthday as his return deadline, Howard eventually focused on editing like a diamond cutter, giving up cigarettes, running mornings in Hyde Park, fighting a tendency, exacerbated by drugs and alcohol, to linger in bed until two, feeling lonely and depressed. "I must finish the film to be back in NY by Brad's birthday," he wrote in his notebook. "I miss him, of course. By the time I get back, we will have been apart for two and a half months, with

2 weeks together in between. I've had no thoughts of leaving him, and find my 'freedom' a kind of burden. I think he also feels our relationship is strong. If we can survive this absence, I'm sure we will be together for a long time. I hope forever." Indeed my version of Miles, in New York, was the opposite, a young banker, Ron—a new breed of gay guy who began to appear in the early eighties, the gay yuppie, or "guppie." I was acting out a fantasy to balance Howard's "sugar daddy" fantasy by dreaming of being kept by a young gay banker in a suit. But, like Howard, the satisfaction of my hyperventilated wish was undercut by the ache of missing our life together.

When Howard returned, we moved to a different apartment, number 410, in the rear of the hotel, looking out toward all of downtown. That was the last apartment we would actually live in together. I suppose the apartment could well be a bad, or mixed, memory, as the unraveling of our domestic arrangement occurred there—but that moment was still far off. I actually have some of the strongest, warmest feelings about that place, and time, and, even, mysteriously, of our love as having bloomed into another order of being there. Howard and I really came to some authentic caring for each other. I don't think, from our residence in 410 on, we would ever say or do anything consciously to hurt each other, though accidents did happen. It was as if the further apart we stood, the closer we became. I've never seen such a dignified phase spelled out in any psychology textbook, though some subtle poets have said as much. I'm thinking of Rilke on the barely touching lovers' hands on an Attic stele, in *Duino Elegies*, or Rumi's reed-flute singing of separation.

Number 410 was a bigger and more user-friendly one-bedroom. I scored the use of the extra room as my office, mostly out of Howard's guilt because he was away more and more in pursuit of new film opportunities, and making final touches on *Burroughs*, and I was left more and more to oversee the dubious golden goose, the copy shop. I holed up with my Christ Pantocrator and was productive, writing my dissertation, and stories, and porn reviews, and pulp books on rock stars Hall and Oates and Billy Idol, each taking a month to write—these instant bios were meant by the publisher to cash in on the successful acts of the new MTV channel. For the first time I was a workaday writer. Our main room was the vast living room with our bed and all the furniture now covered with white sheets. If I got my office, Howard got his Sony color television. We spent much time lying in bed, watching MTV, or *Andy Warhol's TV* cable talk show, or Pope John Paul II arriving in Poland, or the *Winds of War* miniseries. The public-access channel was frontier territory. I loved one show where a freaky guy, whom I found vaguely sexy, fancied himself a cult leader (shades of Jim Jones) and kept his rapt camera on, filming his rolling diatribes. I called him once at the crawl number on the bottom of the screen. Often when Howard was lost in TV, I was dialing something called "Apology Line," where you could listen to anonymous callers' confessions of their extreme crimes, from stealing to ritual murder, left on an answering machine. Apology Line was conceived as a conceptual art piece. Besides TV watching, jerking off in the back windows, too, was common practice on more than one floor in those rear apartments of the Chelsea Hotel.

Close by, on another floor, was our friend Chris Cox. I'd first met Chris while Howard was in London. Chris ran a hustler ad in the pink pages of the *Advocate*. I assumed that being a hustler was just

another sex fantasy, and showed up without intending to pay anything. In Chris's case, or perhaps generally at the time, he had the same assumption. He was having fun, taking breaks from editing manuscripts for Ballantine Books, where he was an editor. Chris was southern, wore round wire-rimmed spectacles, and had been a member of an original circle of gay writers, The Violet Quill. He was also Edmund White's boyfriend at the time, or had been. He complained that Ed, with his infidelities, had no concerns for the niceties of being lovers. I thought the remark strange, shared with me, sitting on his mattress in a room over a thrift shop on Twenty-third Street, having answered his hustler ad. But Chris was a winning combination of macho and loopy, and full of cyclonic energy that could never find a satisfying container. He smoked endlessly. He was a coke fiend, and his other reward to himself for editing a few pages was snorting coke, so that his vibrating only intensified. He was a cook—southern food—and when he moved into the hotel he often prepared collard greens, spiced with Tabasco, and invited us.

Especially when Howard was away, I hung with Chris, the Ethel Mertz to my Lucille Ball. Chris was friendly with the composer Virgil Thomson, who lived on the top floor. I'd first met imposing Virgil in the elevator, where he told me that my name would hold me back from becoming a famous writer. I preferred John Ashbery's comment that my name was very American, like a character out of the thirties comic strip "Joe Palooka." Neither assessment was exactly inspiring, though. I grew to like Virgil more when he started inviting Chris and me, Sunday nights, to dinner, and we ate in his kitchen, barely big enough for him to lower the stove door. He prepared mac and cheese, or recipes from *The Alice B. Toklas Cook Book*, which he had contributed to in the "Recipes

from Friends" section: Shad-Roe Mousse, Gnocchi Alla Piemon-
tese, and Pork "Alla Pizzaiola" of Calabria. Virgil had famously
been a friend of Gertrude Stein's. Since his hearing wasn't great,
he would deliver monologues on their friendship in Paris in the
1920s. And as he was nearly ninety, he told us, of his healthy sex
life, "I get down on my knees every morning and thank God for
gerontophiles." He also gave me advice that the only item I would
need to go anywhere was a pair of good shoes. "People always
look at the shoes first," he said. "I didn't have good suits in Paris
but I had fine shoes." And, of his solution to hearing an unsatis-
fying concert by a friend: on the way out he would say, "Full of
pretty things!" We often had fire scares in the hotel. Virgil would
fully dress, put on his good shoes, and lie on top of his made bed
until the firemen arrived to escort him downstairs.

Chris was the third energy source, too, for the Ladies Parties,
special events that define most vividly number 410 in my memory.
I don't recall how the frilly notion began, but Howard, Chris, and I
concocted a plan to throw parties with a small group of our friends,
involving lots of martinis and dressing up like women. Part of the
joke was that none of us was much interested in drag, and had never
been to the dress-and-wig stores on Fourteenth Street that were
a honeycomb for drag queens. We thought of ourselves as poets,
writers, filmmakers, or, when we were horny, leather guys or hus-
tlers. We went to the Gaiety, above a Howard Johnson's at Forty-
sixth and Broadway, where boys appeared onstage and runway
twice, once clothed, once nude, making dances out of push-ups
and squats. You could meet them between shows in a seedy lounge
equipped with a giant bowl of Hawaiian punch mixed with astrin-
gent Alexis vodka. But the Gaiety was hardly a drag bar. There

was a club we did start going to, though, La Esquilita, packed with Spanish drag queens. I remember Howard and me tumbling down its narrow staircase one Saturday night to watch a lip-sync contest of Spanish Barbra Streisands and Judy Garlands singing their bilingual hearts out, as admirers stuck dollar bills down their nearly convincing cleavage. We were transfixed by watching one gang member—a red bandana wrapped around his calf—dancing with a stunning, quite-a-bit-taller, post-op transsexual. Perhaps those Spanish drag queens in their sequined gowns did inspire our three Ladies Parties.

The first, and best, took place in the spring of 1983. The most convincing drag queen was Howard. Not because his feminine principle was particularly strong, but his demand for production values was, and he was the most professional at hair, makeup, and dress. For the occasion we decorated the apartment with pink candles, pink carnations, girlie hors d'oeuvres, and, most importantly, jumbo-size martini glasses with a requisite James Bond–style silvery martini shaker. We opened our cracked-mirror, tan-tiled bathroom to our little group of friends who arrived giddily, warily, with their store-bought wigs, makeup kits, and dresses. The group for the first evening, besides the three of us, included: Dennis Cooper, Los Angeles darkly punk writer who had just moved to the East Coast, to our great excitement, after guiding the poetry and art scene of our generation from his *Little Caesar* magazine out west. He had recently burned himself into my brain with his *Tenderness of the Wolves* book of poems, especially the prose piece, "A Herd," about a John Wayne Gacy–style killer of teenage boys. Along with Dennis were his boyfriend, Rob Dickerson, and the poet Donald Britton. Feeling peeved at being left out, Joe LeSueur and Tim Dlugos were included in the

next party. The plan was that we would all stay in character, and let the alcohol help loosen our tongues and thicken the plot.

Howard was Lili La Leen, a German actress who claimed to have been in all of Fassbinder's films yet didn't speak a word of German. He/she protested in a bad Russian accent that the reason none of us had ever seen her in any of those films was that she was such a brilliant chameleon, a true actress. Lili had the best dress, a Mary McFadden—as she often repeated—which Howard found not in the well-worn drag shops where the rest of us shopped, but in an actual secondhand boutique in the actual women's section. Most extraordinary was Howard/Lili's precise makeup, eyeliner, sharply combed black wig, gleaming and unmoving double circlet necklace of white pearls, and ever-present thin clove cigarette. I remember that while I had been casually smearing on bright-red lipstick and pancake makeup behind him at the bathroom mirror earlier, he was focused, sober, and almost martial in his tight concentration. But then my messiness fit my floozy character, June Buntt ("The second T is silent"), the wife of the astronaut "Brad Buntt," who had "been in space for years now." In my crinkled red-velvet dress, a pink carnation stuck crumpled into my low cleavage, I grew even more wacked with every martini.

Chris Cox was Kay Sera Sera, a redheaded southern broad with big tits pushing up under her Christmas-red top, which she matched with a short green skirt, a red fox boa draped casually over her broad shoulders. She reminded me of some of the football players in my junior high school who would boldly choose to dress up as women at Halloween school events, working their shoulder pads into their outfits. Kay was outgoing, a well-worn belle now on her eighth husband who talked up her former plantation life and Auntie-Mame

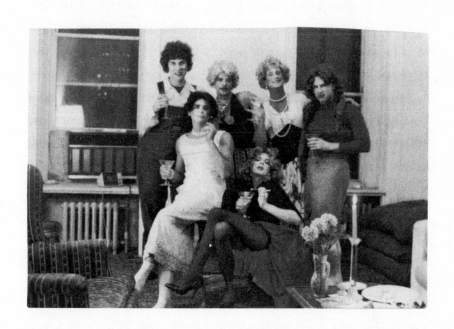

world travels, but was currently living, she confessed, in a tiny studio apartment in Queens. Dennis Cooper was the most resistant to drag archetypes, in blue-jean coveralls, as the butcher-than-any-of-us-were-in-our-regular-lives-and-gender Mavis Purvis, a lesbian farmer living on a rural commune with her lover, a famous African-American poet. Mavis was never without her African-American baby doll, I believe named Charmin, which (who?) was covered with cigarette burns, cuts, and other scars, assumed to be their badly abused child, though Mavis insisted Charmin was not abused but simply accident prone.

Dennis's very young, androgynous boyfriend Rob, described by him proudly as an "it boy" of the downtown gay scene, was Candy Swanson, the most convincing girl in a black cutaway Ann Sothern dress, like a fifties secretary. Candy was living beyond her means, and searching high and higher for a sugar daddy to cover her expensive tastes. Donald Britton was Doris Brittania, the most proper of us, in blond wig, pearls, and clubwoman dress. She was the unflappably well-behaved wife of Mayor Ed Koch of New York City, then in his second term. To the next party, or perhaps the last, occurring on New Year's Eve, arrived Joe LeSueur aka Lucille LeSueur (Joan Crawford's birth name), and Tim Dlugos, as Bernadette of Lourdes, a very high-maintenance French feminist. Actually, Bernadette's portrayal of a needy drama queen (at odds with her saint's name, as Tim was still trying to screw loose from, or further into, his past as a seminarian) became slightly too real and an acute alcoholic psychodrama ensued, its causes I forget. By the final Ladies Party the tenor had modulated from John Waters hilarity to Douglas Sirk melodrama. We just skirted becoming maudlin Girls in the Band.

Howard's postcards to me over the next few months attested to the impact of those Ladies Parties. Suddenly he was "Lili," in his correspondence, and I was "June." The postcards told a story of an increasingly peripatetic life. I was now the stay-at-home New York boyfriend and he the traveler, off to see the world, shuttling between England, France, Italy, and Germany, on various missions involving dubbing, or fundraising. On the back of a Folies Bergère postcard of can-can dancers waving red feather fans, he wrote, "Lili is too old to travel." He informed me that the BBC had green-lighted a documentary he wanted to do on Canon West (who agreed, not letting on that he was flattered), but only, he added, ". . . if I will make a film on Spielberg & Alice Walker (*The Color Purple*) in Africa in 2 months. What should I do?" The message was heady stuff for the back of a postcard. From Paris, too, a photo card of the young Marcel Proust, signed "XXX Lili," with the pitch, "How's this for the cover of Christopher Street? He's Parisian. He's Gay. And he's only 23!!" "Ciao bella June," he scribbled on a postcard of the "Judgment of Paris," with lots of pink buttocks, from the Uffizi. On the back of a shot of a plane on the runway of the Frankfurt Airport: "Lili misses you already. But her flight was filled with American soldiers. So many uniforms, such a short flight!! On to Rome."

I have to wonder what the Ladies' season was truly about. Not the parties, they were about hysterics, reinventing "camp" for our new generation. But calling ourselves by our girlie names also meant that we were changing gears into something resembling the old gay slang term "sisters," meaning gay men who didn't have sex with one another, a change that didn't make much difference among friends, but did between lovers. Howard and I stopped go-

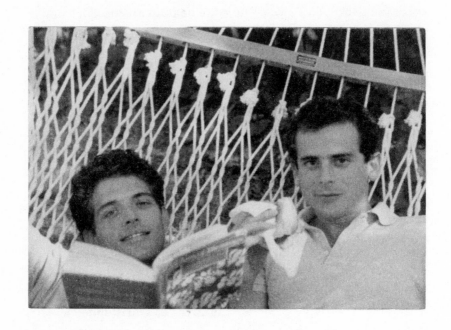

ing at it with each other in room 410. That was the year that he urgently recommended to me an interview he ripped from the *Advocate* with two old geezers who were lifelong lovers—not a typical article for that time, since gay couples of a certain age tended to exist in the media shadows, comfortably reticent. One of the lovers said that the most important element was the sleeping together every night, not the sex. That was news to us, but news that seemed relevant to our stage of life. Howard began repeating again his grandmother's article of faith that she and his grandfather never slept apart one night for their entire fifty (or however many) years of marriage. Somehow in this shift, too, was our growing awareness of the condition by now being called "AIDS." I looked at Howard and wondered what he was doing with all those rent boys in Europe, and I shrank back a chilly millimeter sexually, from him, from myself, trying to find a cautious balance. That tensing, combined with a feminine softening, was our new way of being in the world, but still so subtle that neither of us changed much in our unsafe sex mode with anybody else. We were not having sex with each other, but could still get caught in moments of heat.

Probably a sign of exactly the same shifting uncomfortably and often inconsistently for a new position in response to AIDS was my amping up of my new writing venture—porn reviews for the gay newspaper, the *New York Native*. I didn't think then of that beat as having anything to do with the still faint thrumming of the epidemic, but now I can appreciate its psychic cleverness as yet another slight adaptation, allowing me to have my *frisson* and eat it, too. By 1983 we understood that AIDS was a virus, but were far from a treatment, or even knowing its source: Semen? Air ventilation systems in the Mineshaft? Saliva? So a freeze set in, a holding of that pose, a game of

Statues. My quirky pieces attracted underground notice; enough that they led one gay reader, who was a *GQ* editor, to invite me to write "real" pieces, which I did, first about the artist Andrew Lord, then about L.A. poets Dennis Cooper and Ed Smith. I think the tailwind of interest was stirred partly by others in the same fix turning to porn for sublimated, safe arousal, something that happened conveniently at a moment when gay porn was having a golden minute. Celluloid, not videotape, was still its medium, and, as there were no real gay films, some gay directors had an overly sanguine notion that these films could cross over as European-style art movies.

As stimulating, or liberating, in a slummy way, as the films, were the venues you needed to frequent to view them—especially the Adonis, at Fiftieth Street and Eighth Avenue. A baroque movie theatre from the Gilded Age, when such places were palatial in size and ornamentation, the Adonis was now gone to seed. Christened, in 1921, the Tivoli Theatre, instead of Rudolf Valentino's *The Sheik* or *Gone With the Wind*, the Adonis was now screening *The Bigger the Better*, or *Boots and Saddles*. With high vaulted ceilings, double tiers of balconies, and loge seating, the place was crowded with dark figures lurking, creaking, standing and sitting, rising or falling, in silhouette against the screen, blending in with tacky disco music soundtracks. One of my favorite bits was a WARNING FROM THE MANAGEMENT, a public-service short, alerting us about pick-pockets afoot in the theater. You'd hear a voiceover, "Forewarned is forearmed," then see on-screen a cute pickpocket wearing only cut-off denim shorts servicing an unsuspecting stud . . . while reaching into his back pocket to pass along his fat wallet to the quick hands of a waiting confederate. Its style was pornographic, a savvy case of "Know your audience."

The Adonis was a state of mind, as was porn, and before or after screenings I usually wound up walking the Times Square *quartier*, reliving the seediness of years past, but with more looking than touching. I went there to smoke joints, chain-smoke cigarettes, and feel like a pervert—in short, to have irresponsible fun. The gay-straight divide was broken down in this still shady section of town, as its video booths and movie theaters attracted a jumble of buzzed clients. I liked the upstairs at Black Jack. Downstairs was gay, while upstairs, female prostitutes sat behind Plexiglas sheets with tiny voice holes punched in, and for a dollar their interlocutors could get off with them. Across Forty-second Street was a straight porn theater, and I used to compare the films, and ambience, with the gay versions. I found the straight porn films to be much more realistic tales of swinging couples, or boss-and-secretary workplace situations, rather than the more far-out cowboy and motorcyclist scenarios that were a staple at the Adonis. Upstairs was a "couples balcony," to solve the problems of what to do about women customers. The mood there was even more violent than at the Adonis. Real cops kept banging around in the back, traipsing up and down stairs with their equipment belts jangling and guns and handcuffs getting in the way. A cloud of smoked weed hovered.

I loved all that darkness made half-visible. And I suppose I loved the same quality in the movies I was, quote-unquote, reviewing. I fancied myself an intellectual of porn, as these little pieces were quite heady, almost programmatic. I was keen on plot, and even cried once in the dank, dinky grandeur of the Adonis while watching a film titled *The Idol*, its plot revolving around memories of a young athlete killed in a car accident, replaying in the heads of mourners gathered around his grave, while the most implicated mourner of all, his boy-

friend, watches from a hill above, where he leans on his bicycle. We see a sex scene first—with his high school girlfriend, then with his coach, following a massage in the boys' locker room, building to an authentic heartbeat romance with the boyfriend, introduced in a pool scene while "Love Is in the Air" fills the soundtrack. I marvel even now that such a structure could have existed in such a film, and of its perspicacity in sounding themes of love and death that were still just lightning flashes on the horizon. Another film, *Cruisin' 57*, was a gay porn version of *American Graffiti*, with "the works," as far as fifties costumes, cars, and sets were concerned. I argued for plotted movies, and against daisy chains and cum shots, like some kind of demented Puritan with a dash of Parker Tyler.

While I skulked in seedy movie theaters, Howard was suddenly popping into legitimate film respectability. Well, not suddenly. He had been working his way by inches along an arduous road ever since we met, unlike me with my helter-skelter flirtations and odd-ball gigs, such as modeling and porn reviewing. That fall Howard's film was accepted into the New York Film Festival. Nothing seemed fully real about the anticipation and excitement in the lead-up until the Friday night when Howard and I were walking in our old neighborhood of the East Village, past Gem Spa on Second Avenue. The *Times* of the next morning, Saturday, was out, as it used to be, around eleven p.m. We stopped at the newsstand, as Howard knew that Janet Maslin's review of his film was due, and there were the opening words: "Rarely is a documentary as well attuned to its subject as Howard Brookner's 'Burroughs,' which captures as much about the life, work, and sensibility of its subject as its 86 minute format allows." And then more magic words: "The quality of discovery is very much the director's doing, and Mr. Brookner demon-

strates an unusual degree of liveliness and curiosity in exploring his subject." A light rain was falling, or a rain of light.

The next day was the screening at Lincoln Center, October 8, late in the afternoon, the day before the festival closing. The theater was packed. We were seated in a loge balcony. I remember James Grauerholz sitting in front of us, and watching the back of his neck for blushing, as there were moments when he made some uncomfortably damning remarks about how he was the son William had wanted instead of his actual son, Billy, an awkward comment. I remember such anxieties as there often are around biographical treatments. (Howard shot a scene of Billy Jr. with William, but the younger Burroughs had died in 1981, of cirrhosis of the liver.) The audience was palpably following the momentum of the film. When it ended, in raucous applause, a spotlight swerved from the projection booth to the loge, where Howard stood in a shaft of vanilla moonlight that made my heart burst. At moments around the acclaim of that film, as the caliber and the number of phone calls to room 410 accelerated, I did feel some pricks of jealousy, or some unease at a new dynamic that mainly didn't interfere with our long-established intimacy, but sometimes did. Yet that afternoon I did not feel anything but an emotional release of happiness for Howard. I remember Kenneth Koch telling us in class that when Frank O'Hara's unexpectedly voluminous, posthumous *Collected Poems* appeared, he had the feeling of seeing someone, a shaggy friend, for the first time in a tuxedo. And so I felt that day, proudly sitting next to Howard, in his relatively new gray Brooks Brothers suit.

The press of excitement did not stop but spilled down the stairs and out into the lobby, where Jasper Johns was standing over there, Jackie Curtis and Brion Gysin here. Paula Court was flashing pho-

tographs, and everyone talking about the film. Howard and I had a test for deciding whether a film was great: when you left the theater, you felt as if you were still in the movie. Howard's was the first documentary I remember giving off that afterglow: its lounge-lizard blues and ragtime music, the blacks and violets, salmon pinks and pale greens of its palette. Its candid content was jarring: intimacy with Burroughs, the least intimate of men. So there was lots of hot moral debate, too. "Watching Burroughs in Howard's movie was like reading one of his books," I think Sara Driver was saying. "I really like him, start to hate him, and in the end he wins me back." But I also saw Burroughs as part of Howard's "creep collection," the distance between him and Melinda or Jimmy the Bum in the student films not so great. Jumping out of frame from the stream of our life together for just a few seconds that afternoon, I saw Howard the way others in the lobby were seeing him—as a cresting young genius with an ambitious vision.

This success led to Howard's involvement in his next project, a documentary about Robert Wilson's epically challenging quest to make a global-scale production for the Olympic Games in Los Angeles the following summer, titled *The Civil Wars: A Tree Is Best Measured When It Is Down*. I don't remember exactly how or when that film project was put together. We both knew Bob some. When I was in college, he had been a major culture hero among us boys. I had a friend, Richie Horn, who wanted to be a playwright, and Wilson was one of his obsessions, so we went to *A Letter to Queen Victoria*, playing in an actual Broadway theater for a few nights in 1974, as we would go to a sanctuary, taking in all the abstract music and discontinuous dialogue and a black actress wrapped in white, like a statue, or like one of the Furies enclosed in an Ascot gown.

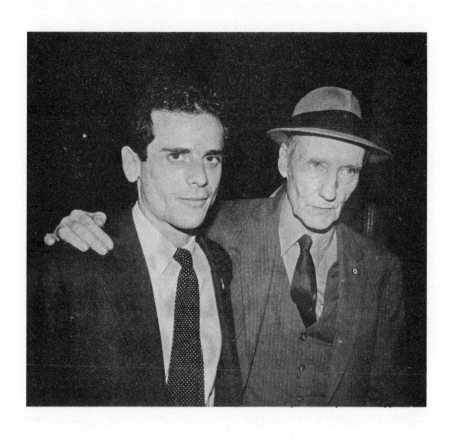

The play was as revelatory as we knew it would be, a theater of dream imagery that shifted our hearts into our heads or our heads in our hearts, as its prime sensation. (Richie's other obsessions were Stephen Sondheim—he'd written, the year before, a fan letter about *A Little Night Music* that was used as a full-page ad in the *Times*—and artist Joseph Cornell, whom he'd visited at his house on Utopia Parkway in Queens. Cornell mailed him a beautiful parakeet collage, which he enshrined somewhere in his dorm room.)

One New Year's Day a couple years after college, I went to a fun-house walkabout in Wilson's loft space downtown. I left feeling that the world was about to open up. On the way home, I did meet Ruth Kligman, who brought me to her loft and sort of seduced me, and we wound up writing a bad script based on a romantic memoir she wrote about her love affair with Jackson Pollock. In that way the installation did jumpstart something new for me. (When her terrace door would blow open while we were writing, she would be convinced it was Jackson's ghost, approvingly visiting us two.) When Wilson, with Philip Glass, created an opera just as hypnagogic and far out as *A Letter to Queen Victoria*—*Einstein on the Beach*—in the fall of 1976, over a year before I met Howard, I went to two of the performances at the Metropolitan Opera. The very venue cast an empowering, Zeusian lightning bolt into our downtown sensibilities. I remember that Wilson, characteristically, delayed the first curtain, as he wasn't ready—a dramatic gesture in itself—and my standing out front at sundown talking to Jerome Robbins until the doors finally opened. I remember, too, a few minutes into the minimal music and knee plays onstage, the painter Joan Mitchell exiting her seat down front in the orchestra and walking out in a huff of a statement. I remember getting stoned, as was standard practice

at Wilson productions, and ambling about during the long show, catching bits on video screens in the men's room. I remember a whirling dervish, stage right.

In the fall of 1983, Howard was summoning his energies for the new project, and the involvement with Bob put a nearly metaphysical spin onto his own creativity and ambition. Not only was he beginning to film the various parts of the visionary work that was supposed eventually to bring together different pieces of the epic drama being created in separate countries by different actors and composers and writers, but, like Wilson, he was on a hunt for his own funding. So he and Bob were padding on parallel paths. Bob rehearsed sections, and Howard filmed—in Cologne, in December of 1983; then in Tokyo, in January of 1984; Marseille in February; Rome in March; and Minneapolis in April—all in uneasy anticipation of the arbitrary finish line to be imposed by the Olympics in Los Angeles in July. Howard put together a much more complicated production package this time, involving separate yet linked deals with German, French, British, and American television. And the postcards kept coming. Some still on the lady theme. On a postcard of bare feet from Paris, he wrote, "Love and kisses from Lili. Miss you. Trying to find the bacon. See you soon." The bacon, of course, was more money for filming. In Rome he was taken to dinner by producers from RAI television— "one of whom was a 'lady' who took me out to a place a lady would like." But the Alitalia plane, with "Isola di Panarea" painted on its snout, made him nostalgic for our boat ride to, and vacation on, that Italian volcanic island, just three summers earlier.

The collaboration with Bob was more existentially significant for Howard than his relationship with Burroughs, except of course for the

pivotal introduction of heroin, as Howard had first procured and shot heroin in Burroughs's circle in the early days of filming. Burroughs was an indelibly great and self-enclosed writer whose inscrutability and dark aura were magnetic, but as far as Howard's life-path, his importance was the film itself. Howard "found his voice" as a film-maker, to mix metaphors. Bob was closer in age to Howard—still in his early forties—with a genius for mounting extravagant, original productions, as well as a genius for convincing rich people to contribute money, or, as was the case with Isabel Eberstadt, to crawl across stage in *Edison* in her Madame Gres gown. These were compatible interests of Howard's, and so he studied and learned from Bob, whose superhuman energy matched at least Howard's ambitions. I cowrote the text of a play of Wilson's about a decade later, in Sicily, and I was the chosen one, who stayed up nights with him, drinking vodka and talking. Collapsing at three or four in the morning, I'd slide off to bed in the room next door, and hear him beginning to make his calls to America, because of the time difference. He did not sleep. Then he would be down at the car at nine, ready to dictate faxes on the drive to the theater. When I asked Philip Glass, the composer on our play (titled *T.S.E.*, after T. S. Eliot), how Bob did it, Phil answered, "He's like Picasso. He doesn't have to go next door for his ideas." I felt Howard's batteries recharged by Bob. His response was to try gambling on his own work with bigger chips.

Meantime I was going through the motions for both of us in the Chelsea Hotel, everything held together by inertia, as I came to understand some of what Howard felt during my absences. Lots of my social memories of that season involve Chris Cox, as a friendly stand-in. One night I saw the only ghost I've ever seen in my life. I'd been asleep, then bolted up, switched on a floor lamp, and yelled out,

"Who's there?" to a gentleman with black-rimmed eyeglasses. When Chris and I went to Virgil's the next evening and I told my ghost story, Virgil retrieved a book with a photograph of a man with prominent eyeglasses whom I identified as my ghost. Virgil informed me that he was Charles Jackson, author of the novel *The Lost Weekend*—a closeted gay man who killed himself using Seconal tablets, in the hotel, and had lived just a few doors down the hall from us on the fourth floor. In Chris's room, on another evening, I met the younger writer David Leavitt, who had just graduated from Yale but represented to me a new generation of gay writers, as he was completely knowledgeable about editors at the *The New Yorker* and publishers at major publishing houses, like Knopf, and not just small presses. New Year's Eve of that year or the next, Chris and I went to Susan Sarandon's apartment on Tenth Street off University Place (Chris had been a stage actor for two minutes and they'd met; he became godfather of her daughter). At midnight, filling a silent pause after all the hooting commotion, a mess of a Leonard Bernstein boomed out, "It's midnight? I'm supposed to be at another party!"

Kept going by inertia, that fall and winter, was my sketchy sex life. I was making the moves that I had learned in the seventies and had been keeping up pretty much ever since. With a whole apartment to myself in the Chelsea Hotel, I was, in theory, left to follow my bliss—not a happy situation as it turned out. One night I brought some guy home from an after-hours club who flashed a concealed knife at me as he left the next morning, explaining that I should be more careful in the future. That put some sand in my engine, slowing down my zesty spirit. A new permutation, gay gyms, began, too, with Chelsea Gym, all gray and chrome, and a new kind of clean-cut muscle guy. We hadn't been too interested in our bodies

in the seventies, but now we were. A veritable lifeguard type named Tom McBride was the class president of buff young men, and highly promiscuous. He was a photographer and an actor who'd been in *Friday the 13th*. I flirted with him some, and he came over to the room one afternoon and nailed me on the rug. I don't remember the event because the sex was so singular but because that was the last of its kind for me. (McBride, who died of AIDS in 1995, was the subject of the documentary *Life and Death on the A-List* by Jay Corcoran.) Soon after my afternoon with Tom, I began having night sweats, as I heard of more cases of friends and sex partners developing AIDS. When I told my still-therapist Sister Mary Michael, she suggested I remove the blankets, which I did. The sweating subsided, but not the panic of thoughts and fears. I discovered that I was a very fearful man, not at all the steady sailor I'd figured I was, as I was faced with a historical-class horror. So I began a regimen of what would later be called "safe sex" that bordered on muscle-deep emotional frigidity. I put my enthusiasms away, after a decade of cultivating them.

Like Howard's, my career was proceeding more briskly now, a response to the prevailing winds of the times. The 1980s was a turn of the page: careerism became important, along with muscles and money and celebrity. The more we encountered the serious depths lurking in the epidemic that we had been trying to deny, the more superficial and driven by stress we became. Not that a career always fit into that Manichean splitting of creativity and cash. My own career development included the publication of my stories, from those first written on the floor of my Perry Street apartment before I met Howard, to the final few written in my office in 410. For the cover I loved one photograph of Mapplethorpe's I'd seen on a postcard, of a punk with a classic rainbow Mohawk, and suspenders, and skinny arms.

Turned out the image on the postcard was a working rock musician, and his agent nixed the usage as too much gay exposure for a punk-rocker. So I asked Robert to photograph his cute younger brother, Eddie, instead, which he did, though not entirely happily, not sure why. His brother then was the cover of my book *Jailbait and Other Stories*, published by the all-gay Sea Horse Press. (Because the stories included straight people, the Oscar Wilde Bookshop on Christopher Street refused to officially carry it, though you could request it and they would sell a copy under the counter.) Dennis Cooper (aka Mavis Purvis) had a book published then, too, by the same publisher. His was titled *Safe*, the cover model his "it boy" boyfriend Rob (Candy Swanson). We held a joint publication party at the former church flipped into the discotheque Limelight, on a Sunday afternoon.

Howard couldn't come to that party, as he was traveling. I didn't blame him or feel paralyzed by his absence. Limelight, an Episcopal church sold and flipped into a Satan-lite disco, was, weirdly, the club of the moment, which shows how oddly the zeitgeist was skewing in the eighties. We had our book party in a barroom in the back, sunlight filtering in, and we even had celebrities—John Ashbery and James Merrill—in attendance. The only vague uneasiness was Howard's absence, fitting into a larger pattern on both our parts. The previous summer marked the first time that we had not taken our annual August vacation, to Fire Island, or Vinelhaven, or Panarea. We noted the oversight, superstitiously. When Howard wrote me a postcard from Checkpoint Charlie, he observed, curtly, "I got your letter. Thanks. It's the first time you've written in years." His travels were becoming more distant. Once he called from one of the phone booths on the Champs-Élysées where you could speak internationally for a single franc coin, and shouted into the phone, "I'm getting

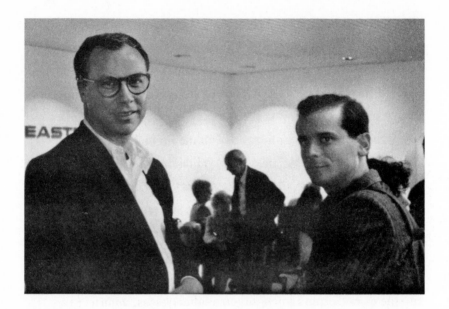

on a plane to Tokyo with Bob Wilson and Bianca Jagger!" He traveled to Israel, which he claimed was full of "the most incredible types, though this is the straightest country in the universe. I miss you Eilat." He failed to mention his clearly non-straight affair with an Israeli soldier on a scuba-diving trip to the Red Sea.

We had stopped sharing our affairs. The three-way phase slid into separate beds, though sometimes that bed was still our queen size in the Chelsea Hotel. I didn't feel any pious obligation to keep Howard's indentation in the mattress vacant during his travels. By the time he returned, sort of, the next year, the practice was mutual. We'd begun having separate affairs again, as distinct from the occasional casual liaison. Probably the most significant of Howard's American romances was with a young actor, let's call him Sean. He met Sean one night at the St. Mark's Baths, while I was away somewhere. The Baths were all about men walking around in white

towels, with keys on ankle bracelets for rooms (more expensive) or lockers (cheap). Howard's attention was caught by this dashing twenty-one-year-old guy who was striding around, coloring outside the lines by being fully dressed in jeans, a flannel shirt, and shoes. Just as striking, and pretty, were his face and eyes and bone structure, very much a young actor of the ilk being pushed forward in the eighties in films full of young male actors, like *The Outsiders*, released the spring before with Matt Dillon, Tom Cruise, Rob Lowe, and other such new talent. Sean, who spoke with a barking Boston street accent, aspired to do film work, which added electricity to Howard's fantasies. Sean fit, as well, into his professional plans. Becoming a feature director was his current desire, and so he had become interested in actors and actresses, a perfect fulcrum for his love of beauty and for his ambitions, which had lately turned more Hollywood (Howard's version of responding to the times). Sean would make just such a Hollywood film within two years.

Howard brought Sean back to the Chelsea Hotel. He confided in him, at least as the story filtered down to me later, that we were having problems, and might not continue living together. We had indeed entered into conversations about possibly moving into separate apartments. Howard was often away, and planning to still be away; the expenses were high; and I didn't want to manage Chelsea Copy any longer. By then we had the same agent at ICM, Luis Sanjurjo, and, like a good agent, he told whoever was interested, "They need space to do their separate work." He was probably correct in his spin. I didn't have the kind of stormy emotions around that move that I might have expected. Somehow it seemed natural. We kept looking at each other levelly with that same light in our eyes that had been there the first night at the Ninth Circle. Our mutual trust remained intact.

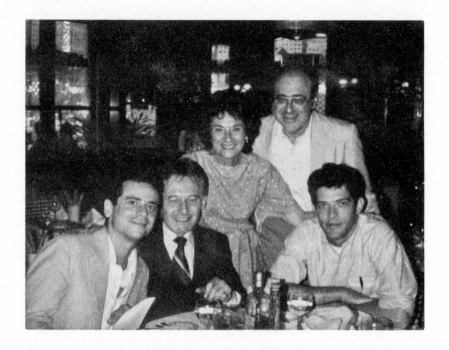

Comic was the reversal that resulted in Howard's parents summoning us to a lunch, at a restaurant across from Lincoln Center, and questioning these plans. They both were fraught, especially Howard's mother. Doing a one-eighty turn, she argued against any such move, while Howard was left explaining that we weren't breaking up, just separating our living spaces. But Elaine was having none of it.

I associate that season, too, with the Wilson film, an archive of a collapsed venture, as the Olympics withdrew their funding from the production. Howard's film, which aired on public television the next year, 1986, was full of images of towers of scenery falling, or *Sciopero* strikes by Italian stagehands interrupting billows of operatic music, culminating with a scene of Bob curled on his mattress in his loft on Vestry Street, going to sleep, as if it were all a dream, coiling to dream up his next phantasm, like an urbane, downtown

Prospero. I also associate the film with my sensing much acting-out on Howard's part, much wild nightlife, in the bars of those cities on his endless itinerary, of which I was now free to be judgmental because I was frozen in my tracks. Touchingly, the last frame of the film was a dedication to me, seeming entirely right and natural, too. And so we moved on, talking all the time about the house that we would share in old age in Los Angeles.

By June of 1985, a little over seven years since we'd met, we were re-settled. (Were we having an itch?) Again, Howard was the real estate mastermind, devising a screwy solution that didn't reflect a fresh start so much as a gnarly compromise. He had a friend from Exeter, Sarah Lindemann. Sarah was perky, and sharp, with brown hair brushed back, and very on edge in those years, as she had just divorced her husband. Howard and Sarah reconnected at an Exeter fundraiser around the time of the film festival, and Howard recognized in her a brainy talent for clarity, and a slight emotional desperation that could be channeled. He asked whether she wanted to help distribute the Burroughs film. She did. Sarah had an inexpensive walk-up apartment on East Eighty-fourth Street, near Second Avenue, above a gay piano bar, Brandy's. Her parents owned a swanker apartment on Gracie Square. After the death of her father, a former head of CBS Sports, her mother couldn't face living in the apartment, and the elegant space, with doorman, was going to waste. Howard suggested, as we were trying to find another arrangement, my moving into Sarah's humble, affordable apartment, while he and Sarah would move into grander Gracie Square. Then we would be living a short walk away from each other, but still have our own spaces, and be paying much

less in rent, especially him. I accepted, not because I felt happy about the new shoebox-sized flat, but to shake off some dust.

If Howard had been wooing Sarah for just this moment, he couldn't have done better. Yet in some flirtatious way they clicked, as brother and sister, boss and secretary, and just plain him and her. When Sarah was in Miami with her father one weekend, during the *Burroughs* distribution phase, Howard had come by their hotel, all aglow about a red convertible he'd rented, and took Sarah and her sister on a slow crawl through the Spring Break crowd, top down, blaring Jessye Norman singing "Amazing Grace," to check out the kids' responses. He also convinced Sarah's dad, in that brief interlude, to get him good seats at a Bruce Springsteen concert in Madison Square Garden, which we took advantage of together. While cutting the Wilson film in England, he arranged a first-class standby on Pan Am for Sarah, to assist for a couple weeks. They took a road trip to Bath, and the highlight was Howard knocking on Sarah's hotel room door in the middle of the night to convince her to drive with him to a gay bar in a neighboring industrial city. His pitch went something like, "Won't it be fun? We'll pretend we're a honeymooning couple who have just stumbled into this bar, and see what the reaction is." Off they went, he in Brooks Brothers, she in Ralph Lauren, and indeed the charade was fun.

Not included in Howard's rosy sales pitch to me for our new arrangement was Sean's camping out in Gracie Square. I'm not sure that he was written into the contract at the beginning. He was more the kid who came to dinner and never left. I felt a burn when I found out—a little zing, like a staple to the heart. By then I was seeing someone, Andrew, whom I'd begun dating while still in the Chelsea Hotel, come to think of it, who was sleeping in the shoebox some nights,

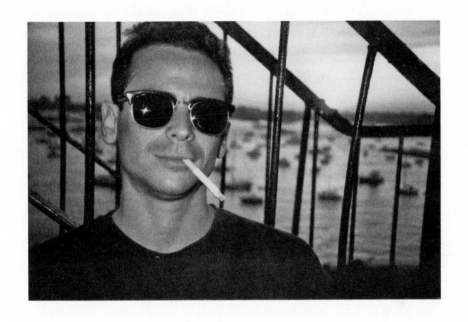

too. So I chose to glaze over rather than erupt at this double-dealing, Howard's crafty shadow side at work. After years of amending our contract of love, we were in such a free zone that the only clause left was no clause. And Howard's complex arrangement at Gracie Square soon backfired, anyway. Often away in London, he revealed to Sean, on one return—unable to stop himself, bragging really—that he had had wild sex with an authentic Brit skinhead kicker. This bragging got him in trouble with Sean, who, well, made a scene, not glazing over, as I was wont to do. Adding to such lovers' quarrels (I'm thinking now of Howard and Sean, not Howard and Brad) at that time, were the big guns of AIDS. Jealousy was not a life-and-death matter, but sleeping around could be, and was certainly a trump card in romantic strife. Sean, as I understood, now refused to sleep with Howard and removed himself to the couch. Howard had come to feel that Sean outstayed his welcome, but didn't bank on the closeness that had grown up between Sean and Sarah during his absences. Nature abhorring a vacuum, the two of them had bonded, and Sarah refused to throw Sean out. Howard started dialing for a real-estate solution, and he and Sarah took a break from each other.

Robert Wilson was away even more than Howard, and, since they were still working on the film, offered him a place to stay, as long as he would vacate whenever Bob was in town. So Howard, the only one not exhausted by all these decampments—such a hopscotch board, I grow exhausted just describing it—moved into Bob's fantastically minimal loft on the top floor of an industrial building on Vestry and West streets, furnished solely with spare examples of rare chairs Bob either collected or made—African birthing chairs, electrocution-style chairs made of metal tubing, a stage throne. Mostly the wide loft was dominated by a series of high windows

that modulated perceptibly with the variations of outside light, reflecting from below the metallic hues of the Hudson River and, from above, the sky, registering time and season. Its main room was a weather clock, like living inside a sundial, rather than observing one from the outside. Here Howard took up residence, filling in his study of Wilson more entirely, and still rent-free.

I landed in an apartment that only I really liked. And I truly adored it. Andrew, whom I'd reverse-romanticized as being "normal," having grown up in New Jersey, a nine-to-five manager at a corporate kitchen, had a hustler friend named, perfectly, Mike Raven, who was leaving his apartment above an Italian *salumeria* on Eighth Avenue and West Twenty-ninth Street, in outer Chelsea. The ceilings were low, the appliances cheap, the wall-to-wall beige carpet worn, but I was happy to be settled back in my own mess, an experience I'd missed since Perry Street. I liked the seedy ambience, including doorbells ringing at funny hours my first few weeks there, by disappointed fellows looking for Mike Raven. (Raven died of AIDS soon after, a checkmark that we started putting after the names of more and more friends.) Picking up on this history, Howard, on his first visit, condescendingly cracked, "I feel like I should leave money on the table when I walk out." I, contrarily, was infatuated by all of it, including the flashing sign with a map of Italy just outside my window.

Our agent, Luis, was partly right about our separation being partly work-related. For both of us, this elbow period in our lives— an elbow in the decade of the eighties as well, a little crook before the dark truth was revealed—was filled with manic work that seemed exciting and preoccupying, though now the details compress together in memory like accordion folds into a much smaller space. I segued from porn reviews to book reviews for *The Nation*,

through an editor, Duncan Stalker, who died of AIDS—another check—but not before he went to a new magazine, *Manhattan, inc.*, reporting on the pulse of conspicuous moneymaking, frantic moneymaking, in Manhattan, featuring Donald Trump and other such recently minted types. He hired me to write a review of Martin Amis's novel *Money*—on theme—that led to my first magazine profile, of club personality Dianne Brill, who also designed a line of clothes. Those 750 words led, with some fast maneuvering, to the editor in chief, Jane Amsterdam, observing that I wrote profiles as if I'd been writing them all my life. Perhaps, because what I'd been trying to achieve with more pretense in my arty stories was a minimal setting-down of whatever you could tell or see of people from the outside, without recourse to their thoughts—the point of view of movies and TV. Perhaps, too, my time in the threshing fields of fashion had acclimated me to the shiny world of money and power and extremely drawn character types. The vision Andy Warhol had of the American fame machine was now coinciding with mainstream media, *Interview* equaling *People*, adding a heady rationalization for me to pursue journalism.

What felt like two minutes later I entered the offices of Tina Brown, the new editor in chief of *Vanity Fair*, a magazine title and concept that *got* the serious joke that was being told right then with such great interest. Here was my version, the magazine version, of the Hollywood Sirens that Howard was hearing. Thirty-three years old when we met—a year younger than I—Tina was tingle-inducing, with her Princess Di short bob and her British lilt, and her embodiment, in her magazine, of an unabashed fascination with power and buzz in all its Reagan-era manifestations. All of which was made even more irresistible, and weird, by her big budget for

writers, and by the power on display in her office, where I recall a clockwork of bouquets sent over by happy subjects of profiles, or would-be subjects of profiles, that were carried in by an assistant for a quick glance and then out they went, until the next appeared, minutes later. I had written my second little profile, about Patti LaBelle, and Tina had the outrageous idea that I write a cover story about actor Anthony Delon, the son of French movie star Alain Delon. Having zero idea how to do such a thing, off I went to Los Angeles, and hung out with him, while staying in a hotel with sheets with a very high thread count. When I returned, Tina took me into a little room to show me my article, with Anthony's picture as the cover of *Vanity Fair*. Not knowing that she had two or three alternative covers ready to go, perhaps goosing other writers as well, I went off thinking my mess was the cover story. It never did run.

I assumed that this failure of the Delon piece, which I took to be *my* failure, the other option being *his* utter failure in her sluicelike eyes, meant shambling back to writing porn reviews. But this failure only seemed to bump me up. Next Tina decided that I, and no one else in the world, should be sent to write a cover profile of the actress Kathleen Turner, whom I'd never heard of, as I'd been spending much of that year finishing and defending my dissertation. I was an adjunct professor in American literature at Columbia and was teaching a survey course that ran right into the hour of our interview, so I talked fast about Hawthorne, left early, and arrived to find the actress tucked into a booth at the Algonquin Hotel, as seductive as the character she'd played in *Body Heat*, which I'd watched in preparation for the interview. She seemed as rarefied as an expensive racehorse. In the limo on the way back to her townhouse in the Village, she stretched out one leg like a living movie poster. When we went into a TV repair

store on Sixth Avenue—why I can't remember—people recognized her not from her look but from her smoky voice. As I left that afternoon she invited me to return sometime for one of her dinner parties. "I have some women I'd like you to meet," she promised. I was more impressed that she had Mapplethorpe silver-gelatin prints lining her hallway. That cover story did run, but I heard that she was displeased, and I never did get to meet her friends.

Howard was on his own trajectory, arcing toward his own version of adrenaline made visible. He sketched out a few film scripts, hoping to interest PBS *American Playhouse* in producing a feature film. Burroughs's *Junky* was one possibility; a Stephen King story another; and a film version of James Purdy's Southern Gothic novel, *Eustace Chisholm and the Works*. I was scrunched in my apartment, finally turning all my modeling memories into a novel. I had such a hard time with my short-story attention-span that I tied myself to my desk chair to keep at it, else I'd find myself wandering the apartment, or the neighborhood, before I'd start up short and remember that I had been in the middle of a paragraph. Howard settled on combining four Damon Runyon stories with daffy characters with names like "Feet" and "The Brain," made-to-order Howard-ish darkly funny types, shook them together, and poured them into New Year's Eve 1928, just before the party went dark in the stock market crash of October 1929—pretty much a "bingo" match for where we were at ourselves, unknowingly, a half-year short of Black Friday 1987. He teamed up for this *Bloodhounds of Broadway* project with an old friend from Exeter, Colman deKay, a TV and screenplay writer. Howard had his own attention deficit issues when it came to writing. Colman was his version of tying himself to a chair—a professional and disciplined guy, who kept the bright laser focused.

Our lives had been simpler and more straightforward when we were starting out, living together a few steps from the Bowery. Our emotional and social life now was far more convoluted. Howard threw a thirty-fifth birthday party for me in the loft, to which he insisted that I bring Andrew. An old Ninth Circle friend, now scene photographer, Patrick McMullan took a picture of me lighting my cigarette from one of the candles on the cake. But Andrew left early because the unsaid bond between Howard and me spoke for itself, challenging anything else in its path. I slept with Howard that night, and I believe that he felt some sort of pyrrhic victory. Andrew soon broke off with me on the grounds that I didn't own a couch, and he couldn't be serious about someone who didn't own a couch. He belonged to that new ilk of "guppie." Howard's complication was that he was now passing for straight, playing Hollywood as it lay, or so he insisted. Sean was still around, slouching, with allure, but he was an actor, and so he was dedicated to being straight, too. I could never be sure. Howard also had an affair going on with an extremely beautiful French actress. I would find Polaroids of her covered only in a white sheet, lying in bed, scattered about the loft, as if blown in from some French *nouvelle vague* film. I knew from modeling the weird sensation of one step forward two steps back on the gay issue—adapting to a closeted or bisexual life after having been openly gay. Now the culprit was supposedly Hollywood, but of course the unlabeled shadow of AIDS had to be factored in. We were being "straight" or "normal," Hollywood or Madison Avenue, madly trying to pedal ourselves away from the stigma of a disease, and its accompanying gay world and bumpy life.

But that unwitting charade—not entirely a charade but a sort of coincidence concocted from subtle hints, and shifts, and whistles

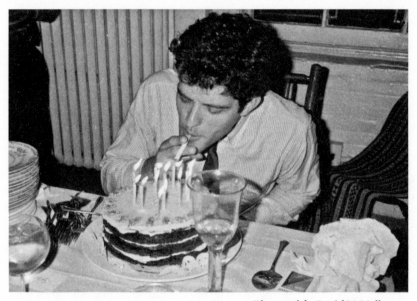

Photograph by PatrickMcMullen.com

in the dark—did not work. The disease began to catch up with us. And then I saw it. Well, I didn't see it. I heard it first. I was walking on a drizzly fall day, crossing Sixth Avenue and then Greenwich, passing by the Jefferson Library, with its gingerbread tower. I was thinking about the Women's House of Detention, which was before my time but I believe had been situated in that triangular lot—now becoming a garden for the library. Women's catcalls had supposedly been screeched down from the windows on hot summer days. Right then I heard a howl. I looked across the street, or by now I was narrowing in on Christopher Street, and across *that* street was a tall, thin guy in his thirties or so, with wiry spectacles, his skin as gray as the day. He had howled, and now he was bawling, and the tears were running down his cheeks like rain, more rain, and in his left hand he held tightly a pharmacy prescription, and I knew that he had just received his diagnosis and that now he was on his way.

PART IV

ST. VINCENT'S

———————

I WAS STANDING BY THE WINDOW IN THE ROOM IN my apartment that I used as my office. The room was cramped, the desk a plank of wood balanced on a couple of filing cabinets. I was talking to Howard on the phone. The news was not entirely unexpected. We had been going together for check-ups to my doctor, Barbara Starrett, regularly, like most everyone we knew. My T cells were holding steady, but cracks had appeared in Howard's tests. His T-cell numbers were falling, and that could mean anything: maybe he was run-down, and some people just naturally had fewer. But there was more, too, about his white blood cells, their increase. (Blood tests in those early days were often only given for confirmation after significant drops in T-cell numbers.) He was calling now to say that he had been diagnosed as *officially* HIV-positive. That could still mean anything, we said. Lots of people were HIV-positive who never developed symptoms. They were asymptomatic. He seemed pretty much fine. And then we started crying. Now we were the ones crying, and he was the one with a prescription in his

hand. *Howard.* I said whatever I said to him in very slow words, with lots of deliberate, spaced pauses.

While we were talking, and after I'd put the phone back in its cradle, I was looking out the window, through plastic slats of venetian blinds. It was as if the world went from color to gray, and stayed there. It was raining. No "as if" there. It was raining, hard. It was a dark afternoon in the spring of 1987. So many memories of those last few years of the eighties are like that: rainy, bleak. It's not possible that the weather was dismal for years on end, the same throughout all four seasons. But those years, taken together, were like one of those mornings when you wake up, the clouds are dense, the barometric pressure low, and no one calls. You feel as if your legs are a little heavy because the weather is creating a low-level system of depression throughout the city. That years-long day just went on and on and on. A traffic light changed, and Howard and I crossed to the other side of the street, and everything was different—ever so slightly different at first, and then wildly, shockingly different.

Howard was healthy—but was he really? Wasn't he thinner than usual? Were those dark circles under his eyes so pronounced before, we wondered. We examined his face, together, in the mirror. When I slept over, or he slept over—we had adopted adolescent language now for going to bed together—his ribs felt as if they were sticking out. "Like Kafka's hunger artist," I lamely joked. We went to Chinatown and bought ugly smelly roots that we steeped in a large, beige Crock-Pot that needed to be lugged—if Howard were coming uptown for the night. Then there were the immune-boosting Chinese teas to be prepared. We bought a blender to combine just the right fruit juices with AL-721, an experimental drug made from egg yolks that was being prescribed to patients with swollen lymph

glands. In bed, we played oceanic-sounding tapes with subliminal healthy messages floating throughout, and warnings on the box not to start them in the middle, or stop them. Howard told no one but me, and we mostly kept our weighty secret for a year.

We were not the only ones keeping secrets. During one of those same weeks, Sharon Delano, my editor at *Vanity Fair*, called to say that my agent, Luis, needed help, needed someone to take him to Columbia Presbyterian Hospital. I knew he had been sick, but all was very hushed, no one was asking, and no one was telling. He lived nearby in London Terrace, though I had never seen his apartment. Luis was a grand number—flamboyant, insouciant, as smart as anyone I'd ever met, exuding some kind of Puerto Rican aristocratic lineage, I forget the pedigree. But when I walked in on him he was shattered. I helped him gather his things. His house-keeper, a guy in jeans, more like a "trick," as we called them, than an employee, arrived, using his key to enter. Luis, unconvincingly, told him that he was going on vacation. I hailed a cab, as he collapsed into my side, my first such act of transport to a hospital. Sharon said that he claimed I had been a very good nurse, a natural, after I left him following his admittance. Soon I heard he was dead. At the packed memorial service, at a theater in midtown, Howard and I wound up sitting on the steps leading down to the stage. Luis never said the word "AIDS," and the obituary in the paper listed his cause of death as cancer, as most did. So who knows? But it was a classic AIDS service. I don't remember whether his father was there. His mother and half siblings may have flown in from Puerto Rico. He led a compartmentalized life, so there were surprises, like Mike Nichols, whose office he had run, though he never mentioned him. Howard and I exchanged alarmed darts of

looks that said, "This could be you." We were feeling that the bell was tolling for us.

Otherwise much life was stirring. The prospect of developing a full-blown case of AIDS, the possibility of facing down his own death, rather than facing down a rent hike, or a spat with a disgruntled lover, brought Howard to life in a startling way. Maybe it brought both of us more fully to life—but, no, Howard was especially galvanized, as if struck by a lightning bolt. Every moment that he wasn't being pulled down into the yawning dark wormhole of encroaching horror, he was setting himself free, at least during that first secretive year. He countervailed, not prevailed, but countervailed. I often thought of him as a daffy type, which is why it made so much sense for him to be channeling Damon Runyon's humor. I remember thinking that he was now like one of those Looney Tunes creations—Daffy Duck or Speedy Gonzales—dodging bombs that were making ink-black crater splashes in the ground, as they scampered over a cliff into midair escapist ballets of revving legs. He never told me that he was tapping into hidden reservoirs since his diagnosis. But he would never have said anything so solemn.

He did start keeping a video diary, recording himself talking on the phone, even jerking off. He used the diary to test angles, lighting, and to test feelings and ideas that were too personal to survive outside the opaque waters of solitude—the traditional use of diaries in written form, too. The day after Luis's death, he made one of those recordings, at sunset, at Bob's loft. Dressed in jeans and a dark, hooded sweatshirt, he announced into the camera, "Luis died yesterday, my agent. I've been sad all day. I never got to thank him for getting me this film. I miss talking to him. I feel sad for his parents." In the violet light, he added, "Luis, this is for you."

He pulled back his hood like a Capuchin monk, and played at high volume "Hymn to Her," sung by Chrissie Hynde of the Pretenders (he'd been thinking of her for *Bloodhounds*): "Something is lost, something is found, / They will keep on speaking her name." He zoomed in on windowpanes: the Empire State glowed gold, rush-hour traffic on the West Side Highway glittered like rhinestones, and the sky turned punk pink. He stepped forward, back, adjusted angles, light, performed semicircles of dervish whirling, in a casual manner, confident even in his hesitations, more confident than ever, lost in his art.

That summer Howard went to Los Angeles for a few months. He was following up on a clutch of successful forays. From an earlier visit, I remember Luis's voice on the other end of the phone telling me, "He's met everyone in a week who people spend their careers trying to meet, David Geffen, Barry Diller. He's going to take a meeting with David Puttnam, the chairman of Columbia Pictures!" Before leaving, he wrote a goodbye note on the back of a car registration card from Vassar College, where he'd worked a deal to use student editing equipment for free, or some such rigging of the system. He addressed it using one of the series of pet names we had been using for a decade: "Dear Bug, Thank you for being so sweet and still loving me after all this time. I love you too. I'm going to stay strong and then we can live together as old dinosaurs should. Have a lovely summer. I hope you can come visit for a while. My ph # is (213) 661-3588. Love, Howard." He rented a bungalow in Hancock Park. I never did visit, but one time—I was floating in a pool in the Hamptons—he shared on the phone that he had befriended a porn actor who talked about the early "honeymoon phase" of the disease, a phrase that he gladly took to.

I was experiencing emotional whiplash. In my little office, where I'd heard the worst news I've received in my life, I was receiving, on the same phone, looking out the same window, lots of promising career news. I had written a proposal for a biography of Frank O'Hara, perhaps hoping to summon the fading New York that he represented to my generation, to me, and to Howard, when we first came to the city to be artists and poets, when we first met at the Ninth Circle, a venue full of youth and fantasy and alcohol. O'Hara's friend J. J., my first boyfriend, whom I'd met there, too, had died the year before of AIDS, April 1986—check. The last time I visited him, at Beth Israel Medical Center, his blond hair had turned white from horror, he was unable to converse as vivaciously as usual and just said, pointing at a nature program on a TV mounted in a far corner, "You'll have to get it from the TV"—his last words to me. So there was lots of recouping involved in my hatching that project. But I'd never written a biography, and the proposal was highly

unconventional. I had a new agent, Joy Harris. She kept calling the day of the deal to report on what, counterintuitively, turned into a spirited auction among ten publishers. Not many months later, I finally untied myself from my chair, and finished my novel about modeling, *Scary Kisses* (a title that unintentionally revealed some of my fraught feelings around AIDS as much as about fashion). Then, too, the news from Joy was good. The eighties was a strong time for young writers, and—thanks to great hopes for national bookstore chains like Barnes and Noble—the money was pretty good. I took it all in, while feeling the steady tugging of our truly scary secret.

My whiplash was a mere crick in the neck compared to the jagged contrast between Howard's highs and his ultimate low. Howard received seed money for *Bloodhounds of Broadway* from the American Playhouse series on PBS, and then in one memorable meeting at Columbia Pictures he managed to convince David Puttnam to back this auteur production of a first-time director with a $4 million budget. His script turned out to be magic, a group hallucination among many young Hollywood actors, all wanting in. Some took a bit more work, but Howard's charms were working full tilt. A meeting took place at Madonna's apartment on Central Park West. She lay on her bed, while he convinced her not only to play a Broadway showgirl, but to dance and swing and sing a swanning period duet with Jennifer Grey, getting her to commit to perform the indie-style role in the fall when she would be back from her 1987 "Who's That Girl" world tour. I don't know if she was briefed on Howard's gay not-so-past. Sarah—reeled back to work in the production office—told me of Madonna's coming into the office one day and asking, in a *haute-contre* voice, "Who's Brad Gooch?" as if she felt she should have known, or had been kept out of a loop. To convince Matt Dillon, Howard took him to

Umberto's Clam House. At the climax of the lunch and drinks, he had his now-line-producer Kevin Dowd (who toted the potato chips for the cookout our first morning on the Bowery) drop off a manila envelope that Howard presented to Matt. Inside were vintage photographs of Joe Gallo lying murdered on the floor of that very restaurant, a Mafia-Damon-Runyon-style rubout. The show business worked: Matt agreed, and later Howard pilfered a pair of his white socks from his dressing room and brought them home to me as a memento, a fetishistic wink. Randy Quaid signed on, and Esai Morales, Julie Hagerty, Rutger Hauer, Steve Buscemi, and Fisher Stevens, and soon they were all reading in a circle in Howard's (borrowed) loft.

Production began on the movie in late September or early October. Most of the filming was done in December and January, in Union City, New Jersey, and the West Village, and most of the time the temperatures were below zero. I never visited the set, was supposed to have been an extra in one scene but couldn't get there, I forget why. I did hear bits of the action from others. Howard was bravely standing up to the bond companies. They kept fighting him over costs, about how much money another inch of snow would add, until finally he banned them from the set, an almost unthinkably bold gesture for a first-time director, but his boldness was part of the bravado of seizing what he felt might be his only chance. He sometimes called me from a heated production van, when they were filming on lower Fifth Avenue late into the night, while angry neighbors pelted them with eggs. Once he called to tell me that he was hiding from going back on set for the shooting of the scene of the death of The Brain, who spent the entire film with a stab wound trying to get to a hospital. Howard hinted at seeing his own death in the scenario and pulling back from that vision. His voice that night

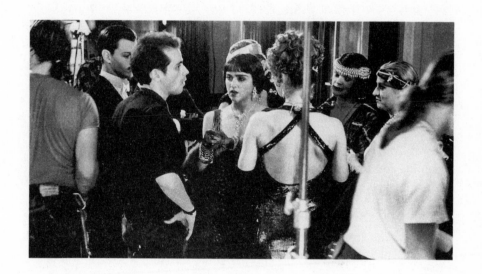



BRAD GOOCH

sounded stripped, like his old heroin voice. I asked if he was doing drugs. He said he wasn't. Maybe he was simply exhausted, getting by on mere slivers of sleep, with all this weighty responsibility, in freezing temperatures, delirious to deliver the goods.

The film was a pivot point. Howard's illness until then had been more of a scare than a palpable intrusion, something to be shockingly remembered and then forgotten. But the Howard I knew never fully returned from shooting *Bloodhounds of Broadway*. I'd say he'd made a devil's bargain, but that implies that he had many (any?) cards remaining in his hand. He had driven himself mercilessly at a screeching pitch, getting by on naps. He also made a choice not to take AZT, a kind of poison that was at least producing results, if only Saint Vitus' dance results, in AIDS patients—sudden manic appearances of coming back to life, followed by another collapse. He tried AZT, found it clouded his thinking, knew the film needed exposed nerves, not dulled nerves, from him, and said, "No," a decision of unknowable consequences. In an attempt to help him recover, to try to retrieve the elusive flush of health, and perhaps to summon the salutary benefits of our summer vacations of years past, we flew to Acapulco in February, taking a vacation home on a cliff next to one rented by friends of mine. The vacation was a failure. A robbery here, "Montezuma's revenge" there. A sky glider with Howard as a passenger crashed and, during the rescue at sea, he lost his grandfather's gold ring, given to him at the funeral by his grandmother the previous March. We rented a jeep to cruise the menacing streets of downtown Acapulco. Howard, as usual, did the driving, but several times nearly got us killed, always with sideswipes from the left of the vehicle. Anxiously, correctly as it turned out, I had questioned his eyesight: "How did you not see that???"

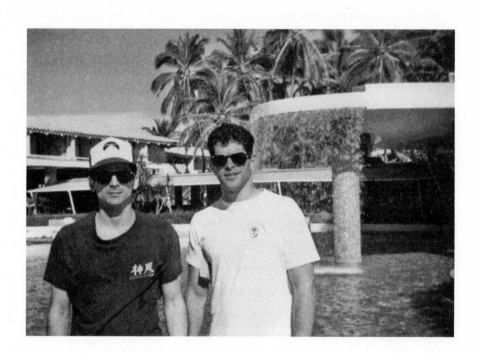

When we returned to New York, Howard went to visit his brother Andy, an ophthalmologist, for an eye examination. While he never discussed the details with me, he must have known that AIDS was, in many cases, detected first during eye exams. Consciously or not, the revelation of the secret to his family occurred in this cinematic fashion. Andy discovered retinal damage in the eye, caused by CMV, an opportunistic virus that can lead to the snapping of connections in the brain, or the death of brain cells. By the time Andy came to visit us to discuss the situation more fully, Howard had been staying with me for a week. There were more tears between us, in the dilapidated apartment that had forever lost for me its bohemian charm—because of the increasingly sad associations of the period—and then between us with his brother, and then on the phone with his parents. *His parents.* I hoped that the damaged cells in his brain had been those that were processing just how excruciating this news would be for them. I did not fathom the science, but I was picturing his brain as a screen door that flies had eaten away so that the wire in spots unraveled. Eye damage was indeed the cause of our near-accidents in Acapulco. Now, just three weeks on, he was definitely listing to the right when walking, and was unable to raise his right arm high enough to extinguish the living room lamp.

I went with Howard that same week to Barbara Starrett's office, at Broadway and West Fourth Street, one of the central headquarters of the AIDS crisis. The waiting room was crammed, always standing-room-only during those years. One patient was smoking on a hookah pipe of Pentamidine for the prevention of pneumonia, while keeping up a hacking cough, and complaining, "I have this chest cold I just can't get rid of." Across the way, in another chair, a blond guy coughed little coughs while reading a brightly colored

paperback on self-healing. The main desk was operating in perpetual crisis mode, staffed by two assistants, both named Michael. The one in a red-and-white flannel shirt that looked like a night robe on him was busy phoning to tell patients their test results. "Congratulations," he would say to those with favorable news. On another call, to remind a patient of an appointment, I heard him say, "Oh, he's gone?" He quickly suggested that the friend bring back leftover drugs to put into the doctor's pool of AIDS drugs, too expensive to waste, to be passed on to living patients. Starrett's office had the mood of a tense pharmaceutical underground railroad stop.

Dr. Starrett was a big woman. She moved around her office in bulging jeans—moseying, really. Her face was sweet, dimpled, pretty. Her eyes sang a tuneful melody, though she was capable of keeping up the distant, inscrutable shield of a medical doctor, deluged by a metastasizing plague that might otherwise easily have overcome her emotionally. I heard one of the Michaels telling a caller that the doctor wasn't taking any new patients at this time. Howard's usual complaint was that she would not take enough time to explain to him what was going on, or the repercussions of all these different drugs. Usually true. But on that day she spent time with him. He went alone into conference with her. Before closing the door, she talked with me openly. She was worried that something was wrong with his brain. The virus had crossed the brain-blood barrier, perhaps because of the lag time in his not taking AZT, which he finally agreed to take, but not until after he had finished shooting the film. A few of her patients in this state were surviving. A few were in wheelchairs. A few were blind.

I walked back into the waiting room, numbed down to a nub. Seated against a far wall was Robert Mapplethorpe, his hair silver and flowing, his face bony, with glistering gray eyes, looking like

Noah Webster. He seemed very much in his element, as if this wait-
ing room were just the next rung down from the Mineshaft, which
he had articulated and repackaged with elegance. I sat next to him,
and he told me that he had been taking pictures of "Jewish prin-
cesses," as he put it, for money. I said, "Every photo an appliance,"
trying to be clever. Most of the time I was distracted by catching
glimpses of Howard as he passed from examining room to blood
room and back to consultation room. My respect for him rose like
mercury in some interior thermometer. He was moving like an old
man, slowly, jerkily. But he beamed in on people with a firm smile
and with firm eye contact. I think that he was happy, even proud,
to have me with him. It eased the pain, since loneliness was just
another degree of pain, and lots of these guys in the doctor's office
weren't just HIV-positive, they were lonely. Howard and I joked
about AIDS patients hiring escorts as status symbols to accompany
them to the doctor's office.

From there we went to a neurologist with a consonant-rich East-
ern European last name. He didn't behave like a doctor. He was a
comedian, jolly, in his thirties. He shared his office with a liposuction
specialist. Josh was his name, and he became important in Howard's
medical trajectory. Josh played teaser mind games with Howard that
day, saying, for instance, "Pull up a chair," when he invited him into
one room; then, "Just kidding," as Howard looked around to see that
there were no chairs. He sent him sauntering down the hall to check
his listing to the right. (The right side of his body was becoming
weaker as the left side of his brain disintegrated.) He decided not to
charge Howard on our way out. Downstairs, at Bigelow Pharmacy
on Sixth Avenue, we waited for five prescriptions to be filled. Those
twenty minutes turned out to be the worst. My eyes blurred when I

tried to read magazines on a rack. I felt I was losing my stamina. I wanted to bolt out of the corridors of sickness to wherever healthy people were. The more I felt this powerful surge, the more clinging Howard became. And then the panic passed over both of us like a wave, and then we were restored to our usual selves. Repeatedly during that day, I caught Howard's face in the distance searching for me with a look marked by horror, a lost puppy. And then that look, too, was erased back into sweetness and light.

Three weeks later we put Howard in the hospital for an experimental course of medicine to try to quell the CMV virus that was destroying his brain cells. When I went to pick him up at the loft, he started to cry as we walked down the narrow white corridor—his initiating the crying, rather than me, a first. We pushed on, Howard bumping every few beats into the side wall, our arms around each other. By then I was crying, too. In those days, if anyone started crying, on TV, even if I saw someone crying in a passing bus window, I'd start, too. The portentous music of Bob Dylan's *Slow Train Coming* resounded from the open doorway as the two of us swept, or wept, our way through the dark square.

Then the mood oscillated. Soon we were laughing again, for a time, with much silly energy funneled into packing, as if we were going on vacation. Howard insisted on taking along all sorts of technology—video camera, portable CD player, a spectrum of CDs, a minuscule radio clock, and books-on-tape with a Sony Sports Walkman for listening. I packed his porno collection into a carton so that his parents, who would be staying there for the next two weeks, would not find the magazines with shiny cov-

ers of tanned boys baring their asses, or bulging dicks. Climbing onto a stool to hoist the box onto a top shelf, I noticed a copy of my book of poems *The Daily News*, which I'd given him when we met, and which I'd inscribed with a drawing of a gun resembling a cocked cock.

The sunset that night was positively Venetian, an orange dispersion turning the waters of the Hudson turquoise, yellow, blue, and white, as the sun bottomed out. I pointed at the extravaganza, yapping about how it was like the view from Accademia toward the Giudecca, filled in for by New Jersey. Howard sat down in a metal chair, and motioned for me to draw up a neighboring chair. We looked out. I sensed some primal fear, and wrapped my arms around him, putting my head against his chest somewhere.

BRAD: Don't worry.
HOWARD: I'm not worried. I don't know what I'm feeling now. It's so scary. A strange bed.

The buzzer sounded. His brother Andy was downstairs to take us to the hospital in his big old car, a '78 burgundy Oldsmobile sedan, with the speedometer frozen at 30.

Once we were inside St. Vincent's ER waiting room, I started to reel again. I was seized by the same sensation of standing outside and looking in that I'd experienced at Bigelow Pharmacy, a trauma victim distancing himself from the source of trauma. The crowded area rumbled like a bowling alley from all the gurneys being wheeled on the floor above. I pointed out the occasional beeps emanating from Howard's chic black canvas suitcase. He tried to say that it was his

"alarm clock radio," but he kept getting the words screwed up, like "sound alarm time radio," until Andy guessed his meaning.

ANDY: It's all right. I have a two-year-old. I'm used to word-association games.

Soon enough Howard was booked into his room, a double on Cronin—the AIDS wing on the seventh floor. His neighbor was in much worse condition than he. And the neighbor's significant other was chewing out the nurse for not giving the patient his sleeping pills the night before. I bowed out to go for a haircut with Gil, a bodybuilder and haircutter, with an expensive loft nearby. Gil, a star of the Chelsea Gym, photographed by Bruce Weber, would soon be dead, as well, after a brief disappearance. Andy and I hugged in the hall. Exiting, I checked out other patients in other rooms chattering on bedside telephones, the views half-blocked by white screens.

When I called Howard later he was in a chipper mood. He'd already developed a new shtick of taking a poll to find out who was Catholic, as the hospital was "St. Vincent's": one of his doctors was, but not the Jamaican wheeling him to his X-ray.

HOWARD: They keep you very busy here.

I told him that I was sure he'd be popular with the nurses. He always got along well with any crew. And his zany humor was made for that hospital, with its Catch-22's and gallows suspense. He was in a hurry to get off the phone to cruise the TV lounge.

BRAD: I'll come by tomorrow after the dentist.

HOWARD: What time?

BRAD: About five.

HOWARD: Okay. I'll pencil you in from five to seven. But it's tentative.

Old issues of control wittily surfaced between us in this sober new setting. And then night truly fell, with no way for me to get from where I was to where he was.

Time speeded up, or rather Howard's decline was so declivitous that I felt as if I were watching decades go by in weeks. He was in a time machine hurtling him fast into decrepitude and old age. I would lie for hours on my bed in my tomb-sized bedroom with the icon Howard gave me of Christ Pantocrator, the wall's only embellishment, like a monastery cell. Each evening I felt sick, my stomach cramping around five o'clock, just before I left to visit him in the hospital. I felt my life force draining into a thin puddle. Hard to believe: when we entered together, the admitting nurse had looked at me and Howard and Andy and said, "Which one is the patient?" And then the nightmares started to occur for him in a rattling sequence, rat-a-tat-tat, in that shooting gallery of an AIDS ward.

Now there was no mistaking the patient. Two weeks in, Howard needed to take a shower, and I realized for the first time that we were definitely into some next phase. We waited a half hour for a wooden stool with side arms to help him to sit upright in the shower. When the stool never came—nor a nurse—we went ourselves down the hall to a shower. I was unwilling to have actual physical responsibility thrust on me. Nothing in my life had prepared me for this task, I thought. I was an only child. My parents never even had me do chores, like

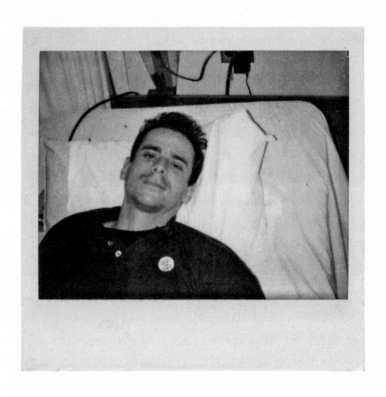

mowing the lawn. I never took a first-aid class. I didn't know how to administer artificial resuscitation. I was frightened to the point of throwing up. I didn't know how Howard wasn't hurtling himself, body and mind, through a windshield, at least emotionally—the dynamics of a Francis Bacon painting—or maybe he was. We maneuvered to the shower room, Howard in the white robe he'd brought from Japan with the name of a Tokyo hotel stitched on the outside, me in a flimsy chartreuse hospital gown. The more confined the space, the more difficulties Howard had navigating. I soaped him down, rinsing off his pale, tender skin, while he held onto the tubular handle on the side, like a bone, bones holding onto a bone.

Some other night, the next, or the night after the next, he was scheduled for an enema, and after the procedure needed to hurry into the bathroom in his room, another confined space that created panic. I rolled his legs off the mattress and pulled him up. He looked about worriedly to make sure that there were no chairs or tables in his way. He liked to have them pushed way back so that he didn't fall into them. He tried to rush into the bathroom, one leg practically useless, pointing askew, as he slid along in his tan moccasins. To get seated on the toilet took five minutes. I grabbed him so he'd be facing the right direction. The actual sitting was the difficult maneuver, with one leg refusing to bend. "Go away!" he ordered. He was standing, lifting his bad arm in a weird akimbo pose, like a shaman delivering a difficult spell, trying to sway down into the sitting position, with me moving in at the last second to grab him so that he did not fall against the wall and split open his head. As usual, the maneuver failed, and he got stuck midway, and started with the aslant arm again, psyching himself down toward the toilet seat.

When I returned to my apartment that night, just as stressed as I had been in the hospital ward, I resolved that Howard must do something constructive. He'd already been in the hospital for two weeks with no departure date in sight, and no friends yet, just me, and his family. Maybe he could talk into a tape recorder, for a script. I wondered if that were possible. Maybe we could do it together. Work on a script, with me writing it down. I was so convinced about my brainstorm that I called him right then. Howard said, "What about *The Golden Age of Promiscuity*?" a gay historical novel I'd been discussing possibly writing. We eventually decided on something called *Roller Coaster*, a movie to be based on Howard's life, on our life together, of a young man coming to the city, as in so many novels, like *The Red and the Black*, trying to find his fortune, having a kind of marriage with another guy, traveling through a labyrinth of gay bathhouses and sex clubs, contracting AIDS, and then traveling through a labyrinth of doctors' offices and hospital wards. I called Joy, full of excitement, the next day. "Wonderful," she agreed, placating.

When I walked into Howard's hospital room the next evening, though, I knew in a second that our planned script was never going to happen. What had I been thinking? Josh was there when I arrived. He informed me that Howard had lost the brain function to give himself commands. He ordered, "Stand up!" but Howard couldn't stand up. Then he said, "Go to Brad!" and Howard sprang up and came toward me. "The springing up is a reflex," Josh explained. "When the brain short-circuits in the command function, Howard often relapses into a primitive reflex." Springing up was one reflex, cowering another. The shamanic arm gesture of the

previous night was Howard lapsing into a cowering reflex when his command to himself to "sit down" on the toilet was short-circuited.

After Josh departed, Howard needed to pee. The nurse was there, and she and I helped him, but the forceful pounding of his heart scared me. When he got back into bed, he told me, in broken signals, that he had this fear when he had to walk to the bathroom. I suggested maybe he didn't have good balance, so he was afraid of falling. No, he said, not a fear like that, a "big fear," and he motioned with his two hands expanding outwards, as if defining the size of a log in front of his face. It was the most scared he had ever been, he said. I remembered Josh's tutorial and suggested that when his brain short-circuited perhaps a primitive reflex of fear set in. He was thrilled when I said this. I had "hit the nail on the head," he said. His thrill was at finally communicating, since he spent most of his days frustrated at not being able to have the conversation he meant to have.

The pleasure of solving a neurological puzzle, of course, was minor, a kind of game played on a board of sickness and fear of death. Underneath, still the crying, and the shock of the new real. I didn't know how we were all passing through this valley of the shadow of death and not simply shedding our skins to try to escape. I sat that night, after I tucked Howard in and turned off all the lights, waiting the five or ten minutes for him to fall asleep, attempting to sink into his experience of trying to sleep in that hospital room—the eerie ghosts of screens and curtains and other whiteness, the beeping of the machines, like in *E.T.*, a movie we had seen together, and the horror, Howard's facing of pain and loneliness, as well as that "strange bed" that he had feared. I walked out past other half-lit dim rooms, like Stations of the Cross, some more like agonizing crucifixion scenes.

After a month of this weirdness, multiplied by isolation, I finally

talked him into letting others in on the secret, in on his life. So far the rhythm was: family during the afternoon, me at night. His concern was the film. He worried that if word got out, the producers would take the film away from him, have someone else edit. That fear was realistic, not simply a primitive reflex. But the convincing finally took hold, and friends began to trickle in. Madonna came one afternoon, creating a stir in Cronin, as she visited some other patients, too. She climbed on his bed and kissed Howard full on the lips, batting away all fears. Out of the initial flurry, a few regulars settled in. Sarah, her hair more disheveled since the last time I had seen her, about a year before, was like a stand-up comedian with a big heart. She had obviously reached deep inside herself and made a commitment to this final project with Howard. Phyllis, his assistant from the film, was the most devoted and hardest-working, like a nurse. But I found her fantasies about him overblown, young. She'd make remarks like, "Oh, you can have your Fassbinder scene on the beach," referring to his notion of finding a summer place. Sean appeared, too, a welcome charmer, with his own raw responses. He didn't own a clock, so his appearances and disappearances were serendipitous, but mostly he fell into my time slot.

I was happy to have Sean there, as was Howard. He evened out our intensity, as third parties often had in the past. We needed him. One night Howard was going on at length—well, in short lurches that added up to length—about losing what he called his "fantasy function," a corollary of the "command function." He said that he could start a sex fantasy in his head, picture a scene, but then he would freeze. He would be unable to push through to the climax. Sean in his rough, gravelly, Irish-construction-worker-meets-Edmund-in-Eugene-O'Neill's-*Long-Day's-Journey-into-Night* voice suggested

porn magazines, but Howard said that he couldn't jerk off with his one good left arm and also turn the pages. I suggested a page-turner. Sean filled in by telling the plot of a soft porn paperback he had bought at the airport that wound up with a boy fucking his mother.

Sean was a true actor. He liked to tease. He liked to invent. He liked attention. When the time came to put Howard to bed, we hobbled him to the bathroom, then closed the drapes, drew the white entry curtain, lowered the bed, tucked him in, and turned off the light. A dim white glare from the full moon lighting up the skies outside registered on the drawn curtains. Howard kept complaining about his short-circuited fantasy function. "It's frustrating as hell," he said. "It's maddening. . . . Tell me a story," he implored both of us. I got up to leave, but Sean groaned and we sat down again in the dark. He began to comply by telling a true-ish tale, as Howard pulled down his sweats and started breathing heavily.

Sean told a story of working in high school at some restaurant in the summer, like a beachside clam house. One night he was down in a basement kitchen area, with another waiter and waitress. The waiter pulled out his cock. He told the girl to go down on it. She did. Then he told Sean to take out his. He did. The guy told him to take off his shirt. He did. Then he started to play with Sean's nipples. The sensation spun his head. "I had never done anything with a guy at that time," Sean added, in a low moan. Then the guy started jerking Sean's dick, and—Sean was now shouting at full voice—"I STARTED TO CUM," just as Howard was shooting. The mood in the room was exultant. "Thanks God," said Howard from the darkness, in his brain-damaged way of misspeaking, as I handed him a food services napkin to clean up.

On our walk back up Seventh Avenue, I told Sean about Molly

Bloom's soliloquy at the moment of orgasm in *Ulysses*, as it related to Howard's climax moments before in the hospital room. "I want to get that book," he mumbled. "Howard talked about that a long time ago." That evening in the hospital room laid bare the nature of our three-way dynamic. Sean's relationship with Howard was palpably sexual, while mine was now something else, with more tenderness. Howard and I were both voyeuristic, and Sean was an actor, so that worked. Howard's fireworks of an ejaculation, and all that preceded, took place at a perfect pitch of collaborative sexuality and compassion, rare and amoral, like the hustlers Howard and I heard about at a dinner party years before, who came to hospitals to let ill patients suck them off. "Terminal hustlers," we'd called them. I gave Sean a long, lingering hug at the corner and off he walked into the moonrise.

March rolled into April, which turned into June and then steamy July (for July Fourth we wheeled Howard onto a terrace to watch the fireworks). He, incomprehensibly, unbelievably, inexplicably, was still in the hospital, still in that room on the seventh floor of Cronin, still deteriorating. Sean and I visited almost every night, although the time we spent entertaining Howard had shrunk, and the time we spent hanging out together in the post-hospital-visit respite was expanding. On one of the more energized of those nights, after we had sprung free from St. Vincent's, we walked up Seventh Avenue in a wild wind, sharing a firefly of a joint. The more stoned I became, the more I eased into being around Sean, hearing his odd observations, dipping deeper into the ocean, gingerly at first, then plunging. We decided to check out Obsessions, a funky, dimly lit, alluring in a shadowy way transvestite club that was located just down the block from my apartment.

When we left the tranny bar, its interior like an Elks Club, with

wood paneling, but sadly empty that night, we walked back to my apartment. I sat on my flimsy futon couch in the dark, and he leaned against a pillow on the floor. We drank vodka and beer and smoked yet another joint, while suitably watching a Paul Mazursky movie about a three-way (with Margot Kidder) made around 1980. Sean confided some secrets about his life that supposedly even Howard didn't know, bonding our separate friendship. Then he started saying, doing sexy things. He took off a sock so that one bare foot was showing, with one dirty sock left on, and said, "It's too bad you're not a girl, Brad. You'd make a great girlfriend." We discussed how we couldn't do anything because of the delicate situation with Howard. Then he was lying on top of me, kissing me. Then I was telling him that he couldn't stay. Then he was throwing up, bent over the toilet. Then I was missing him later, after he'd left, realizing that I now had a messy crush on Sean.

The next night we both showed up at the hospital again. Howard was registering less clearly on me, perhaps because I was avoiding his still intense eyes, while Sean was outlined quite clearly every moment in my mind. I was wondering if Howard's brain damage extended as far as not picking up anymore on subtle interpersonal emotional signals, but that did not seem to be the case. I imagined that he was suspicious. I imagined many things, and felt pulled many ways at once, and then ten or eleven o'clock came around and Sean and I left. We might even have done something corny like him leaving a few minutes before and then waiting for me outside on Seventh Avenue. On this walk he told me about feeling that he had messed up our friendship last night by his insistence, and he told me how he threw up again on Lexington Avenue in the forties walking home. I apologized for making him go home, but said I didn't trust myself. I

told him that he hadn't fucked up the friendship at all. He had made it. Of course I invited him to stop by for an hour. He spent three hours, calling a heterosexual phone sex line, then left.

Subsequently, on some night, we did confess to Howard our evening of phone sex, Sean's calling and talking to a woman, a phone prostitute. Phone sex was on a curve upwards with the dissemination of the HIV virus, or news of the HIV virus, and Howard (to my relief) loved the story. So much so that his eyes began to glitter. Gripped by a special excitement, he suggested that he should call one of the gay dating phone lines from his hospital bed, a favorite pastime during his first, more or less asymptomatic, year. The wish took some rigging to fulfill, but we did. I think I just used my account, entering my credit card number, and Howard settled in. The flat-line tone indicating hang-ups occurred quickly, one after another, as he tried to simulate being a jock, talking about his (true) years on the high school varsity wrestling team, but in his brain-damaged wailing siren of a voice. Then he bravely took a new tack. A line or two into the clichéd sex talk, he'd say to his interlocutor, "My name is Howard. I'm in the hospital. I have AIDS." Weirdly those talks went on much longer, a testament to shocking truth. That night on our walk up Seventh, Sean kept walking, didn't stop by, nor did I ask him. It was as if a fever broke. We'd got to the edge of something and peered over and decided not to. From my side, I was finding our romance interfering with the sweet consolation that I felt only when concentrating entirely on the profound aura around Howard and his dying.

By fall, Howard was finally out of the hospital. He was far from the creature who had entered months before, and certainly was not

capable of going back to the loft, or taking care of himself. His parents had sublet a one-bedroom apartment for him on the eleventh floor of a corner building of London Terrace, at Twenty-fourth and Tenth Avenue, and furnished the place, with no expense spared. The style was modernist, minimal, and everything was black and white: dishes, clocks, chairs, dining room table, lamps, and leather couch. "It's just perfect for him," Elaine sang, proudly. "You know Howard and his black and white!" She set about making the place a home away from home, not only for Howard, but for all his friends, as we were transported back into a kind of teenage den house complete with a mother who kept the refrigerator reliably stocked with Corona beer and Absolut vodka, pistachio nuts for Dr. Josh, and lots of food, lox, knishes, matzo ball soup. The apartment was thoughtfully situated just six or seven blocks from mine. Finally, ironically, we had found a sensible living situation for us, with Elaine's help.

Getting the care situation calibrated took a while. Howard qualified for assistance from one of the AIDS care organizations, either GMHC, or God's Love We Deliver. They sent someone over, a well-meaning helper, selflessly giving of his time. Howard put him to work doing light accounting, straightening out the books, which was not really in the spirit of the enterprise, so he didn't last, and moved on to a more conventional charity case. Eventually the planets lined up with Tony, whom I took to calling "Nurse Thing." Tony was a black guy, loved the word "fierce," and was very snap-snap in the style of the street guys who had begun hanging out on the western fringes of Christopher Street, toward the piers. He wasn't an official drag queen but had some of that sharp sensibility so that even a whiff of the presence of Madonna kept him on board, with occasional sightings of a Sean Penn or a Matt Dillon, whom he

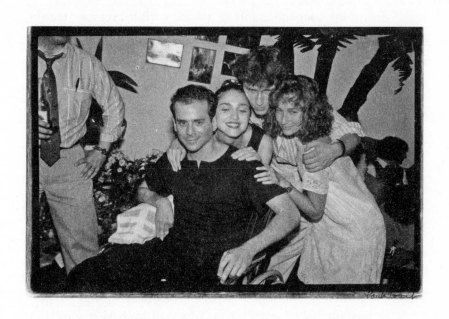

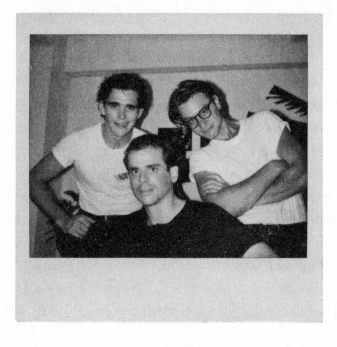

could dish and scream about on the phone with his friends. He and Howard were a good team, a comedy team, occasionally veering uncomfortably close to shades of *Driving Miss Daisy*, but always regaining some dignified equilibrium. Elaine always included his favorite white-powdered-sugar doughnuts on her long shopping list.

Tony taped to the refrigerator a comment of Howard's that reliably got lots of knowing laughs. Actually Howard directed him to write down the comment, succinct as a fortune in a fortune cookie, and tape it there: "There's so much beauty in the world. That's what got me in trouble in the first place." Each time Howard repeated the words, they were more elongated and slurred than the last, and his laugh more disproportionate. He'd first made the crack to me on the phone from L.A., around the time he made an entry in his notebook, while he was still in the "honeymoon phase," and still had the faculties to be melancholy and elegiac about his own destiny: "When I die, my education dies with me. All those years of Latin, French, Italian. We all share the same education, including television, film, music, events. But each person's mix is slightly different. My particular mix will be removed soon from this planet." When I later found the notebook, I realized how early he understood the score.

At the moment Howard was writing those lines, he had stepped outside himself, and saw himself as clearly as a character in a film. I'm not sure that I ever stepped outside of us, of him, so clearly while the action of those days was still being improvised. At first I was too charmed by his good looks and seductive projects to notice. Later I was too drawn into desperate attempts at medical intervention to think. Yet he was clearly an intellectual beneficiary of his educational training, of years of reading and writing and looking at everything, from prep school to Columbia to film school to the Sony TV always on in our

Chelsea apartment, all the raw footage that he was busily splicing on a control board toward more ambitious creation. He rightly recognized his own talent, with that same preternatural clarity, his ability to do well in six months what had taken four years, and the promise to continue to do so. His connivance to be both Hollywood and indie East Village as a life project was working, and would have worked.

In September *Scary Kisses* came out. The book party was a classic shiny eighties launch, with a dinner before, at the club-restaurant MK, started that year by André Balazs, in a converted bank building with arched double-storey stone window frames on Fifth Avenue and Twenty-fifth Street—one of those clubs where, around midnight, a forest of silhouettes would gather in front of the door and Howie, the doorman, would arbitrarily let you in, or not. "If you don't get in within two minutes, you have to move on," a friend of mine, Tommy Page, a pop singer right then, taught me. My party was filler for the earlier part of the evening. The surprise guest at the elegant dinner given by my publisher at around seven o'clock was Howard, in his wheelchair, who decided, last minute, to show up. The effect was a bit like his announcement on the phone sex line that he was in the hospital with AIDS. Or like the afternoon that Randy Quaid walked into the apartment after not having visited in a while and Howard said, "You look like you just saw a ghost." The publicists weren't prepared for such a presence "in the mix." Gay with its shadow of AIDS lacked splash that season. I was surprised, thrown for a second, but Howard added a depth of field that I would never have wanted denied. I met Bret Easton Ellis for the first time at that party. He was an icon

that year in literary social life. I loved his book *Less Than Zero*, and having him was like having Warhol, an imprimatur from the era. Howard stayed a long time, even when the party opened into hundreds, being wheeled around on cold marble floors by Tony, having his picture taken, smiling authentically.

Since I'd never published a book with a big publishing house before, I didn't know what to expect or any of the standard paddle-lines or score-keeping tallies along the way. "The *PW* is in," Joy called to say. "What's a *PW*?" "They're just a bunch of kids who don't know anything, get paid fifteen dollars a review, no one takes it seriously," she said. I knew enough to know the review must have been bad. In my mind, I was an experimental poet of a novelist. In my publishers' wishful minds I had written a glossy commercial novel about modeling, so they tried to sucker in inevitably disappointed readers looking for a young-guy version of Danielle Steel, while snubbing my own little cadre of five hundred downtown readers. The book tour was a step into a distorting funhouse mirror. One day I was on a TV show with my old modeling agent, Dan Deely, and model Michael Ives, taking live calls from moms wanting tips for their own sons or daughters who wanted to break into the business. The next day I was reading in a punk club in L.A., and then I was cross-legged in a chair in an apartment in San Francisco, being taped for a literary radio program by a cerebral host who detected whispers of Foucault in my novel. So many talk shows, so many guests. I learned to talk TV-talk, which takes place at double-speed, with no pauses, or spaces between words, completely artificial in its reality. When it was all done, I came home to Howard, content to be there, even if home now meant illness, and the "big fear," and issues about which items of his might have been stolen by this or that delivery person or repair guy.

We had a new film project. Howard decided that he wanted to film *Scary Kisses*. He asked about buying the rights, so I called Joy again, and again she placated. The notion was that he was going to videotape everyone visiting the apartment reading a short chapter. We sold him an option for a dollar. He had his video camera set on a tripod and—in his original way—transformed sickbed visits into something more unique than dropping off flowers, or having a strained conversation. Not everyone was comfortable with sickness and death, as I had not been either until this immersion course. Now they were either made more comfortable, or less, but everyone had to agree to signing this "guestbook" in the form of a taping. The enterprise seemed a bit like the O'Henry story about the ivy leaf that an artist paints on a wall outside the sickroom of a young woman who says she will die when the last leaf falls. I'm sure Howard fitfully believed that art would keep him alive, and I chose to believe, too. We were both playing the odds, even miraculous ones, for a limited recovery, when a cure was found. And so one after another, an unlikely mix did their screen tests: Sean Penn, Barry Diller, poets from Columbia, Sarah, Chris Cox, Jennifer Grey, director Tom DiCillo, a kid from London.

One of them was Derrick, twenty-one, his baseball hat swerved studiedly "street" to the side. He was my new best friend. For a few months Sean had been my best friend, but he had drifted away, depressed, floating between New York and L.A., more lost with the hospital regimen taken away. Derrick was very immediate, here and now. He was tall, animated, black, and, as a hustler at Rounds and a go-go boy in a Keith Haring–painted T-shirt at the World, on East Second Street, had lots of stories to loudly tell. Andy had snapped him at dinner in that T-shirt when he was eighteen. From a *Cosby*-style family (his father was dean of John Jay College of

Criminal Justice) he'd perfected a ghetto style with "Yo!" big basketball sneakers, a jacket of many colors and logos, and rap-musician gestures with fingers and arms and legs that he could turn on and off like a pantomime. Derrick had the kind of past that got my dark imagination all agitated: graffiti artist; brushes with the law; expelled from high schools like the Cathedral School, where he flunked catechism for not knowing the makeup of the Trinity. But I didn't feel any alarming energy coming from him. Mostly I felt his quick, smart intelligence: reading Henry Miller, Genet, Sartre, and talking about it all, when he wasn't impersonating a thug.

And then in December it happened again: Howard was back in the hospital. Just the night before, Derrick and I had been walking up Seventh Avenue after seeing *Matador*, an Almodóvar film about melodramatic, campy, romantic loving and dying, very different from the clinical version going on behind the shaded windows of St. Vincent's. As we passed by, I thought, "I hope I never have to go back in that place with Howard ever again." I didn't say the thought out loud because I didn't want to give it any real place in the world. When I got home from church the next day, I called Howard. His voice was just a whisper, far away. I asked him how he was. He said, "I don't know." I asked him what was going on. He said, "I don't know." Where are you? I asked. "In the bathroom. Come over. I'm hallucinating. When are you coming? Good." So I hurried right over.

Howard was in bed. Duane, a nurse assigned for house monitoring, was there. Duane told me later that Howard had visibly calmed down the minute he heard my voice at the door, and had smiled. When I walked into the bedroom, he asked me if I saw the faces up there. He asked me if I heard the sounds, "Click, click, click, click, click." He was sometimes holding his head. He went into a shiver-

ing spasm, with teeth chattering. Andy had been there, Duane was telling me. There was a chance that he was dehydrated and so must drink lots of Gatorade. Andy was coming back soon, maybe to take him to St. Vincent's Emergency Room. Andy had spoken with Dr. Josh. Howard kept talking to me in fragments: "You know"; "So what"; "What's going on." But it was a kind of delirium, a faraway soliloquy. I kept getting tears in my eyes, those tears again, and wiping them away. But he looked on blankly, not touching or caring or even registering the tears, though observing them, sort of. He did not respond to any of my reliably entertaining air kisses, or even to squeezes and expressive hugs.

I didn't say, "I love you." I wanted to. I thought, "What if he were to die without my saying 'I love you'?" But I worried the saying would be a tip-off for him of my fears.

Turned out that Howard was not dehydrated, which might have been better news, easily remedied. Andy, Duane, and I escorted him to the St. Vincent's Emergency Room again. I kept flashing on the afternoon, nine months earlier, when Andy and I had taken him to the hospital the first time, with me sitting in the back of that same car, sunk into the burgundy plush seats. That time there was a baseball game on the radio. This time there was a football game. This time they wheeled him immediately into the back of the emergency room where a little miniward of beds and screens was now set up. I was sorriest to notice that when there was talk of a "spinal tap" Howard didn't even balk. A strange new passivity had suffused him on this reentry. He'd said many times, over the past weeks, "I've lost the will to live," and I did see an airy listlessness moving in.

"But maybe his willpower will come back," I thought, lying on my narrow bed in my blank room with the icon. I couldn't believe

I was back *there* again, either. I hoped his force would come back, for my sake as much as his. I'd miss him. So much of my life was wrapped up with his. I felt I would be horrified by the loneliness. I knocked around my eerie apartment. I couldn't concentrate on working or doing anything but walking toward walls and back away from windows. Maybe I should have waited at the hospital. Anyway, I came home. I figured he had hours of waiting, testing. Andy was there. He'd call if he wanted to leave and needed a replacement. One pedestrian thought plodded after another. My head was blown apart again, like a photograph of a nebula explosion in black and white, an explosion that by its presence only spotlighted the void that was there all along. I wanted to be with Howard somehow. But how? I was frazzled and splintered.

When I arrived at the hospital the next night, Sean was there, and Dr. Starrett was talking to Howard. I asked her if she could explain what was going on. She said that Howard had a progressive brain disease that they would treat with experimental drugs.

Howard said, in his faltering way, "How many people does it work on? Ten percent?"

"No," she said.

Howard, brightening: "Twenty percent?"

"No," she said, holding his hand, the plainness of her tired face like candle wax.

She explained that no one had yet survived the brain disease. In the old days, she said, pneumocystis was incurable and everyone died soon after diagnosis. Now they had pentamidine. Rarely did deaths follow now from pneumocystis, though other types of opportunistic infections eventually moved in. If Howard were to weather this brain disease, he would be the first.

"Maybe we'll luck out," she said, with a complex smile.

After she left, Sean started to fidget nervously, rambling in manic half-sentences about how Dr. Josh had knocked Howard's apple juice off the tray earlier.

"Would you leave?" Howard said to Sean, simply, with no malice. "I want to be alone with Brad for a while."

We sat there in the gloaming of the eerie light of the efficient hospital lamps, with a white curtain pulled halfway around on its overhead track. I felt it was important to say whatever was on my mind. Every so often I had to stop. But mostly I finally said it all.

BRAD: Do you believe in life after death?
HOWARD: I hope not.
BRAD: Why not?
HOWARD: Because I'll go down.

He pointed with his thumb in the direction of Hell.

BRAD: Because if there is, be sure to come and visit me.
HOWARD: I'm so sad. I've never been sadder in my life. It just hit
 me. I never thought I was really going to die.

It was true. I'd known it. He'd known it. But even to imagine death spreading out its presence of absence right there where Howard was, "And therein campeth, spreading his banner," as Sir Thomas Wyatt wrote in a sonnet about "the long love," was breathtaking and nauseating and still finally impossible to comprehend.

HOWARD: I'm in shock.

Then he instructed me to go to his storage room, and destroy everything there, as the papers or whatever they were would be embarrassing to him. He said to either keep or destroy his paintings (ugly surrealist things from Exeter that I always made fun of when they were hanging in his Prince Street apartment, but which I could never destroy), but to definitely keep the copies of all of his films. He had one print of each of his movies, including different versions of the movies, all of the versions of the *Burroughs* movie, for instance, and all of the little reels of his early film school movies. He suggested that maybe we could have a retrospective someday, or show clips at a memorial service.

BRAD: It's so sad that we'll have to leave each other. I love you
 more than ever.
HOWARD: I can't believe I won't be in your life.

When I walked out of the overly lit hospital, the night was dark, gray, and cold. I was now officially alone. Endless cars were turning the finite street corner just up ahead.

It was the angriest of times. I remember an editor at one of the shelter magazines I was writing for calling one evening and saying, "The black limos are out tonight." Those black limos were one of the symbols of that anger, as they whizzed past all the homeless people. In this Dickensian world of cartoonish injustice, these limos might as well have been running over these people, their windshield-wiping squeegees seen as weapons, as angry-villager-pitchforks. Everyone was angry. Tom Wolfe's *The Bonfire of the Vanities* came out around

then. I was reading it during Howard's deadening and repetitive hard-to-tell-apart visits and revisits to St. Vincent's. Bonfire was a good image for the emotion that was burning and was everywhere reflected, and deflected. Clubs were citadels. If you were turned away from Nell's, on Fourteenth Street, you clomped or clicked off into the night, pissed.

There were economic strata, but also medical strata, not based on cash in the bank but on viral count and numbers of T cells. The response to the AIDS crisis progressed from animal fear and terror, the phase of the night sweats, to animal outrage and lashing out. ACT UP had begun. Larry Kramer, who had been one of us, a gay novelist reading books published by little gay presses, at podiums in little gay bookstores, was suddenly turned into a living megaphone by the forces of history, and wound up having been right in his early warnings to stop having unsafe sex, and in much else. (He had published his first wake-up article, "1,112 and Counting" in the *New York Native* in 1983.) I heard news of Richard Elovich, who introduced me to Howard, and had been all art all the time, a kind of rarefied intellectual, almost an art snob, chaining himself to a barricade or a balcony on Wall Street and elsewhere in those years, screaming truths. Keith Haring was not stenciling "Clones Go Home" on East Village streets now. He was making "Safe Sex" banners, and then its next iteration, the ACT UP motto, "Ignorance = Fear, Silence = Death." Small teams within ACT UP were consulting with doctors, like Barbara Starrett, to do drug running as well as guerrilla actions aimed at pharmaceutical companies. I felt as if many of my friends had been transmogrified, like Bolsheviks in the Russian Revolution.

I never attended an ACT UP meeting during the Howard

years. I avoided that important stress point, and in retrospect felt diminished. But, without thinking, I stayed my course, like someone in a lifeboat trying to rescue myself and my family while the luxury liner was going down. I'm afraid that when some tried to climb into my lifeboat, I pushed them off. I felt as if I had only enough emotional space to care for Howard. I felt, with some guilt, my inability to visit other hospitals, or to take on the bigger cause. I was made brave only by my love for Howard, and otherwise was rather cowardly. My friend Shipen, of the monastic community at the cathedral, was in the hospital, but I didn't visit him, saved by not having seen him in years. I did crowd into his funeral at St. Luke's in the Village. Chris Cox's lover was sick and dying, but I didn't visit him. Eventually Chris Cox died, too. I called him once in the hospital but he let the phone slide from his hands. I did speak at his memorial service, not mentioning my lapse. Lots of guys who hadn't been to church in years were buried after unruly, Scotch-taped-together memorial services.

What did I do with my jagged, raw anger in those last days? I stashed it away, like bills from Con Ed or the phone company, in crumpled envelopes on a top closet shelf, for later. Eventually the bills came due, and I paid—but in the upcoming years, not then. I paid out my full expense of anger on the cusp of the decade ahead: drinking way too much; being late, being careless, knocking glasses and steaks off the table at expensive restaurants; putting potential suitors through forced marches around and around the same memories and catalog of medical and political horrors; making cutting remarks. While Howard was alive, I kept it together, and stayed insulated within the cocoon of grief and despair, shared with his family and our friends, and appreciating the great clarity of having

just one thing to do, one swinging gold watch of depleting time to become hypnotized by, almost intellectually curious about this new event: death and dying on a battlefield scale. Yet behind my premature widow's veil, I was crackling with fury.

The holiday season that month was a bizarre rendition of the usual rituals. Howard was out of the hospital, so we went for our eleventh year in a row to visit my parents in Pennsylvania. This time we hired a car and driver. Tony came along, and Howard's wheelchair. Howard wanted to say goodbye, without saying goodbye. My mother had a pained expression on her face the entire time. She took me aside, in a rare show of acknowledgment. "I always thought I would have Howard to depend on to kind of watch out for you," she said. "He would know how to contact us if you got sick, or in an accident. These are the things mothers worry about." My father looked paranoid. He wasn't convinced that AIDS wasn't contagious by daily sorts of contacts, and he wasn't sure what the black drag-queen nurse sleeping on the couch meant. Both were worried, of course, about how my health status fit into the equation. But, blessedly, as Howard had long ago noticed, they never talked much about these glaring realities. We all sat in the living room and watched *E.T.*, a holiday TV broadcast, Howard and I next to each other on the couch. My father questioned why we were watching a movie for children. Howard's left arm and hand were in a splint to control spasms, but whenever the "E.T., phone home" motif recurred, he would move his encased hand over, so that we could do a banging version of holding hands. With those knowing eyes, he resembled E.T.

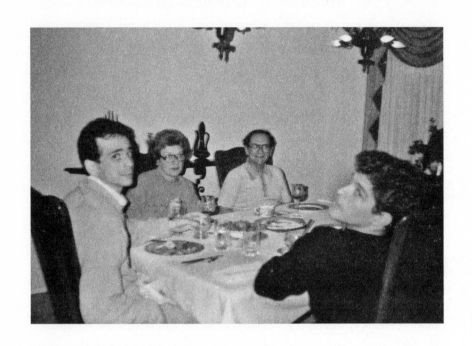

New Year's Eve, a few days later, was a party for twenty friends, in Howard's apartment, mostly *Bloodhounds* cast and crew, and family. Howard's filter for what to say and what not to say was now entirely obliterated. For a long, spiraling part of the evening he loudly shared with an innocent angel face of a film grip the more intimate subtleties of our life together. "That's Brad," he was saying, or wailing, his default tone of delivery by that time. "He's my boyfriend. I mean he's my official boyfriend. But we haven't had sex for four years. David Rephun and Donnie and Keith have sex with me. But Keith lives in London." Another Keith, Keith Haring sent over a big HAPPY NEW YEAR 1989 card/drawing of a lineup of his jive red silhouettes, simultaneously joyful and like crime-scene outlines of bodies on a sidewalk. Sarah constructed a huge surrealist Dalí clock out of colored paper with a moving hand on the wall that she kept adjusting to inch toward midnight. I had a hard time carrying my end of any conversation I found myself in, and walked around with my jaw leading the way, gritting my teeth, feeling strained, and readying, steeling myself, for the year I sensed ahead.

Within the month, Howard received bad news—well, it was all bad news, but here was the kicker. The movie studio had made the inevitable decision to take his film away and give it to one of their editors. He was on some conference calls with Dawn Steel, the new studio head, whom he liked, but she was not in a position to be as placating as Joy. He had seen a rough version of the final cut that was to be distributed by Vestron and was unhappy with the results. They added voice-over. Missing was the film beneath the film, the continuity that only Howard's eye and humor could contribute: of course that eye was unavailable, even to him. When I finally saw the film I was pleasantly surprised,

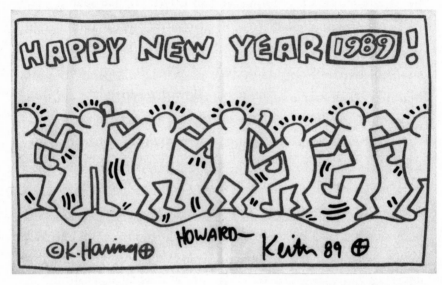

and there were lots of cool touches and beautiful shots. But he had decided that this was, for him, the moment when the last leaf was going to fall off the vine, and so it fell. He had seen it falling from a long way off. At an early contract negotiation, when his condition was still a secret, Howard asked Lindsay Law, the producer from American Playhouse, "What do we do when Columbia wants final cut? You never allow that, do you?" Lindsay answered him, "Howard, this is the first feature film of a long career. You can't expect a studio to give you final cut." To which Howard abruptly replied, "But what if this is my only film?"

Propped on a TV tray by the couch during the weeks of the phone conferencing with Hollywood operatives (I found it hard not to cast them all as villains) was a note Madonna had written to him on a card, in green felt-tip pen: "I hope you are not angry w/me for keeping the V.H.S. of Bloodhounds for so long. It was difficult to find time to watch without the peering eyes of my ever curious husband. . . . I'm sure the new editor has made many improvements and look forward to seeing them. I'm going to try & visit you on Fri. and at this time I will be in possession of a tray of RICE KRISPIE TREATS—sorry for the delay—Hi Sarah—I know you're reading this to Howard. All my love to you & Howard. OXOX. Madonna. OXOX." Howard had a connection of the heart with Madonna that broke through the barriers of celebrity. She always felt to me like his collaborator on the film, not just an actor. So a truly dark omen, a failing vital sign was his refusal to take any phone calls—including hers—for days following the hard "No" about the final cut.

Howard's condition worsened, but this time he resisted help, refusing to go to the emergency room of the hospital. I visited to try to talk him into going. No luck. He did respond to me, though,

cracking a big smile when he heard my voice at the front door. He laughed a bit when I yelled at him and told him that he was being ridiculous. But he would not reverse his stubborn decision. He could not walk at all anymore, and needed pushing in his wheelchair to the couch, where he weakly ate a bowl of Cream of Wheat.

"Why is it so hard to die?" he said.

"Because you're young and strong," I said.

The next day turned macabre, with a memorial service for Bob Applegarth, Robert Wilson's assistant, who had figured in the documentary, always fielding Bob's calls at any hour from anywhere in the world. A car was hired and Tony and Howard and the wheelchair went. Luis's memorial service had taken place during the sad and pink days of the "honeymoon phase." Bob was being buried in the midst of a crisis phase that was more like a human pileup accident on a foggy highway at night. Howard had a crying jag at the funeral, drank a couple flutes of champagne, and threw up in the back of the Town Car on the way home.

He told me about it that night on the phone. His parents were now acting as watchdogs. He decided that he did not want to see anyone. He was angry to some terminal degree, but usually agreed to talk, or whisper faintly, whenever I called.

HOWARD: I want to die but they won't let me.

BRAD: That's because we care about you. And the doctors care
 about you. That's why Barbara Starrett came over to see you.

HOWARD: Why do people care about me?

BRAD: Because something about you makes people feel good when
 they come to see you. That's an important service.

HOWARD: It's hope. I give them hope.

BRAD: That's why you got so many visitors in the hospital . . .
 because you give something to people.
HOWARD: That's why I'm a film director.
BRAD (not following exactly): Uh-huh.

Then we talked on and on, mostly waves of nothing, banging every so often into an abrupt rock of meaning sticking up out of the continuum of sounds and pauses.

HOWARD: Why do these things always happen to me?
BRAD: Howard. They don't. You've had a charmed life. Just this
 has happened. And you could still get better.
HOWARD: It's too late for me. I'm in a wheelchair. Everything is a
 struggle for me.
BRAD: But they could find something tomorrow that would kill the
 virus.
HOWARD: I'm brain-damaged.
BRAD: People with strokes regain their faculties. I don't know if it's
 different with people with brain lesions. But you might be able
 to come back.
HOWARD: But I'm crippled. And I'm so depressed. It was Bob
 Applegarth's memorial service that did it to me. I went
 berserk.
BRAD: I know. But I want to get this book to read, *When Bad
 Things Happen to Good People*, written by a rabbi.
HOWARD: I can't read.
BRAD: I'll read it to you.
HOWARD: I have a headache.
BRAD: I don't even have the book yet.

Two years had passed since I'd had the impression that Howard and I had crossed a street to the other side, and that we were living in a kind of half-light, with much of the color drained out of the landscape, in a steady rain. I had grown used to that emotional climate, made easier and sometimes even fun by being there, holding hands with Howard. That day I received the results of the HIV test that they were finally saying was sensible to take, could make a difference. It turned out that I had tested negative for the virus. I immediately felt thrown, with a loud whoosh, back to the other side of the street. Howard was not with me, and, surprisingly, I didn't know that I wanted to be left there alone, ambling on the sunnier side of the street, but without Howard next to me.

I told Howard the news the night I heard. I went over to his apartment because he was refusing to eat, swallow his pills, or get out of bed. I was trying to talk him down, down onto the ground of living. And then I told him the news, in an awkward way.

"You'll never guess what happened. I appear to be HIV negative. I mean, they say they want to do the test again, in a few months, because it doesn't make sense, but . . ."

When I told Howard, he was visibly suffused with joy. I saw his sallow skin begin to glow some. He was so happy that he laughed. Then I began to cry. So for an unreal stretch of ten minutes, without exaggeration, he was giddily laughing, and I was crying.

"What are you crying about?" he asked.

"Because I wish you weren't sick."

The disparity hurt. I would be alive, yes, but without Howard.

By the next night he had reconciled himself (because of his response to the news of my health status?) to returning to the hospital, for just one night, to have a catheter inserted in his chest, under the

collarbone, so that he would be able to receive medication at home from a Mediport machine. "Maybe the morphine will help, nothing else will," he was saying, reminding me of my promise to help him get his drugs, the medical version of heroin, when the time came. I don't think living wills were common practice at the time. He certainly didn't have one. His voice was garbled, harder to understand, like throat cancer patients speaking eerily through microphones touched to their throats, like magic wands.

"What are you thinking about?" he asked me, as I paced the room in zigzags.

"I'm wondering why the antiviral medicine isn't listed on your chart for tonight. And if Dr. Josh is going to answer the page. And whether your brother will get in touch with him. And why you don't want to see people."

"Because I can't talk."

"But people will understand that. They can just sit with you. They don't have to talk."

"It's too difficult for me to explain that I can't talk."

"I could explain for you."

A long flat line of ticking silence ensued, for about twenty minutes.

"It's such great news that you're negative. Every few hours I think about it and I feel happy."

"I wish you were negative, too."

"So do I. . . . But I fucked you for years."

"You must have been exposed to the virus after we broke up."

"Thanks God."

Then I stood there for a while with my palm on Howard's chest, near his heart. I felt a new kind of imaginary strength because of

my negative status, or, more likely, because of Howard's attitude toward my negative status. I no longer felt that I was looking into a mirror when I looked at him, seeing myself in a few seasons. Freed from my own concerns, I tried to experiment, to see if I could now pull him back across the street with me to the other side, zap him with healing energy, call down guardian angels from the walls, and through the plate-glass windows that looked out on a twinkling Greenwich Village, where, as Nurse Tony had said earlier, "All those queens are flying around."

Howard returned, for the last time, to Twenty-fourth Street. That next week he was still healthy enough for us to have what I fondly remember as our last fight—not that we actually had many racked up. We were far from George and Martha, far too beat or cool or punk of heart, even in death. The indirect cause, funnily enough, was Madonna. I was sitting bedside one night, with only Tony otherwise in the apartment. Madonna sent Howard an advance release of her new CD, *Like a Prayer*, and Howard kept telling Tony to turn up the volume, turn up the volume, until the entire apartment was filled with overwhelming sound. I was on deadline for an article and had brought along page proofs, my plan having been to keep sick Howard company while editing. Priggishly, I started complaining about the music. "Turn it off!" I yelled. "I looooove her," Howard insisted, just as loudly. "I loooove this album. It's just like her. She gave me five thooousand dollars." He was referring to a contribution Madonna made to a hospital fund. "Then I'll leave," I threatened. "Get ooooout!" he countered furiously. I did. But by the time I arrived at my own apartment, those few blocks away, I realized

what had happened and called up immediately. "I'm sorry. I love you," I said. I skipped sharing with him my insights into the linking of rage, sorrow, and frustration. "I'm sooory," he sweetly mimicked me, his syllables much elongated. "I loooove you." I was glad for the fight, for its freshening up our spirits, and its reminder of sillier, pettier, more innocent times past.

Walking into the bedroom was a jolt. When was that? That weekend, a Friday night, walking into the bedroom was a jolt. Howard was lying in a jigsaw position on the bed, with his head at an angle, body in another direction, arms splayed, oblivious to his body angles, and feeling nothing. His skin was yellow, his jaw slack, and his breathing heavy. He looked like a junky, overdosing. The silver evening light illuminating him through the window seemed much too bright, too natural for the eeriness of the scene.

He was still suffering from the dehydration of the preceding week. He had slowly been losing his ability to eat, then to swallow. I had been feeding him nights with a dropper filled with pink guava juice. He parted his lips, and I would drop in thick liquid, like feeding an injured bird. Eventually they brought a bag of liquid for intravenous.

I slept over that Friday night. It was our last night sleeping in the same bed. Howard was very quiet. Every so often the intravenous machine would sound a chime if an air bubble became trapped in its tubes. I would get up to fix it by pushing a few buttons. No longer any droning talk in the middle of the night, no demands for shifting his legs. I listened closely to the sound of his breathing, hanging on every soft exhalation.

The next morning I was awakened by a visiting nurse. I was barely out of bed, had just splashed my face with water and was on my way back into the bedroom when she hit me with the slam of news that Howard had a temperature of over 106 degrees.

"He probably won't last through the day," she said. "Is the family committed to keeping him at home?"

"What's the advantage of the hospital?"

"Distance."

We did keep him at home. His younger brother, Steve, who lived in Miami, was visiting, staying at Andy's. Both his parents were at an apartment nearby. I called them and they were quickly over. I remember his mother walking in wearing a brown trench coat and she looked, for the first time, like an old Jewish lady. She was kissing Howard over and over, cooing, "My baby, my baby," pretending to understand what the nurses were saying, but not really listening, just nodding her head in time to the sounds.

We moved Howard from the double bed into a single hospital bed. I carried him, together with Anthony—a Columbia philosophy student volunteer, a bit out of his depth. Howard was a dead weight, sagging in the middle. The rest of the day we waited. I sat by the bed, writing his obituary for the *New York Times* on a long yellow legal pad. I had spoken with film critic Steve Holden and he suggested I do the writing, and he would retouch, and sign for publication. So I haltingly started jotting down journalistic facts: Born 1954. Grew up in Great Neck, Long Island. Attended Phillips Exeter Academy, Columbia University, NYU Film School. The *Times* also wanted a snapshot I'd taken of Howard on vacation in Maine for a feature, "A Director's Race with AIDS Ends Before His Movie Opens." While I was writing, Sean and Sarah

moved his CD deck and speakers into the room. I put on John Lennon's "Imagine," remembering how Howard had disconsolately walked the streets of Paris when Lennon was assassinated, and how much he loved him. While the song was playing, rough, maudlin, yet sinuous, Howard opened his eyes and looked at me with a "This is really happening to us now, Brad, and I get why you're playing this song" look, the last full zapping I remember from those dark eyes.

He did not die that Saturday. The bag of liquids began to revive him some. He had been like a dry twig ready to snap. Now he started to open his eyes, to communicate by blinking "yes" to answer questions, though the Morse code from the operative slit of his eyes was disconcerting.

Alertness became an issue. And camps were set up. Sean, Sarah, and I were adamant that Howard should get super-shots of morphine. We knew his wishes. But his parents were behaving like parents trying to keep their kids off drugs. Especially for his mother—the mother instinct so powerful, so intent on reviving and keeping alive, was at war with what felt so clearly to me to be the reasonable tack in this situation: to start to move Howard out through the black door, gradually, and as painlessly as possible. I tried to enlist Andy to our side, so that he could use his authority as doctor. But whenever he went in to talk to his parents, he returned empty-handed. Even bumpier was the discussion of taking Howard off intravenous nutrients. "You cannot expect a mother to agree to stop feeding her child!" Elaine shouted. With Dr. Josh present, a resolution was eventually, achingly, reached: no tubes; a small dose of morphine, to ease the pain.

Monday turned into Tuesday turned into Wednesday. Each

night we would kiss Howard goodnight—amazed that someone could look greener than the night before and still be alive. Sarah was on the day shift and usually arrived at noon. That Wednesday noon, when she walked in, she was greeted by Elaine telling her that she had just missed the homecare people. "They were so wonderful!" she said, as if nothing special were going down. Sarah hurried into Howard's bedroom to find that he had an intravenous tube stuck in his arm connected to a big bag of fluid hanging over him. Elaine shot her the guilty look of a teenager who had totaled the family car. "It's just hydration, no food, just water, only water," she insisted. Then, more quietly, she confessed, "I had to." By the time I arrived that night, Howard's color had improved, making us only more conscious of the torturous blinks, the pointed reminders. "Howard, if you're in pain, blink your eyes," I repeated. "Howard, if you need more morphine, blink your eyes." He blinked definitively. He was clearly aware, and trapped, and no longer able to voice his needs.

I woke up screaming the next morning. I rarely screamed. I certainly never woke up screaming. I was fused in my half dreams in that bed with Howard, and I was in pain, and I had to get us out. I went barefoot and robed straight into my hovel of an office and called Dr. Josh. "His mother's not making any decisions," I said. Dr. Josh concurred. He ordered a bottle of morphine to be sent to the apartment and we agreed to meet there later that evening. Sarah had to read *The Waste Land* for her class the next day. She had gone back to school for a degree at Columbia. Since my dissertation was on T. S. Eliot, I volunteered to read the poem and interpret. Competing with Howard's

favorite Sleep Sound Machine tape, "Cape Cod Sunset," with waves crashing, I read aloud to Sarah and Sean from the poem, which was full of obvious ironies, including the time of year, "April is the cruelest month, breeding / Lilacs out of the dead land, mixing / Memory and desire . . ." The doorbell rang.

We froze and listened as Elaine answered. "Why, Josh, what a nice surprise!" she said, even though it was past midnight. Josh did not exactly smooth over the situation. "I'm only going to talk to Brad this evening because Brad put in the call to me," he said, as he walked into the bedroom. When she realized that I had asked him to come, she turned and glared at me, "Who died and left Brad in charge?" There were jokes about sending the bill for the evening to Brad because he had called. "I'm going to call Brad 'Mother," added Josh, gratuitously. I felt all kinds of discomfort, but also relief. And then even Elaine turned thankful that Josh was there because Howard started to suffocate on his own build-up of lung congestion. His temperature was nearly 104 degrees. He was making ominous hiccough sounds. Josh and I turned him onto his other side, revealing huge bedsores, like lakes of reddish lava floating in the thin, pale Pietà marble of his skin. I held him steady while Josh stuck a long tube down his nose and pumped out the mucus, mixed with blood. The procedure was gruesome.

JOSH: I wasn't cut out for this. Neurosurgery. Brain operations.
Migraine headaches. Not this.

Josh changed Howard to a higher-dosed bag of morphine. And he gave him two small shots of fifteen milligrams of morphine to soften the coughing, help him to sleep.

JOSH: Are you high now, Howard?

Howard blinked.

JOSH: You're aware of what's going on, but you're not feeling pain, right?

Howard blinked.

I kissed Howard on the forehead quietly. I did not even speak to him or say "Goodnight." I was drained by the effort of pushing to get him to this comfortable state, at last. I felt that something had clicked. Tired hugs were exchanged all around. Elaine was quieter than usual, but fine. Sean and Sarah and I took the elevator down with Josh. It was two a.m., and a full moon lit the street as I thanked him for coming, and then peeled off.

The next morning I wasn't thinking much about Howard. I was content for the first time that week that he was blissed on morphine. I was making phone calls. Around a quarter of twelve, I felt weary of the world. Felt funny. I switched on my answering machine to screen calls. At noon Elaine's crying voice came over the machine. "Brad, it's all over, it's all over. . . ." I rushed from the couch where I had been sitting, reading.

Howard died at 11:45 a.m. Elaine was out grocery shopping. Tony and the day nurse Louise had finished his morning grooming, hair brushed back. His temperature was nearing 107. (Josh had smelled the bacterial pneumonia on his breath the night before.) He stopped breathing while everyone was out of the room. But when

Tony came in, his heart was still pumping. Tony went to call 911. Elaine luckily walked in while his hand was still on the phone, to stop him, or two police would have shown up at the apartment.

I took a cab in a yellow haze. Walking out of the elevator, I started sobbing. Tony put his arm around me, took my coat, led me into the bedroom. Elaine was still on the phone in the next room. There was Howard. Dead. His face was stiff, noble. His black hair slicked back, skin slightly sallow. Eyes closed. He looked peaceful, but also defiant: the defiance of closed lips, stern jaw, and high forehead. The upper part of his head was the most like Howard. The lower had distortions: puffed lips that would slowly turn a waxy gray throughout the day, a second chin that formed a geological ledge beneath his real chin, never moving. I couldn't believe this was Howard, but without his soft breathing. What did it mean? I felt terribly sick to my stomach, and terribly alone without my best friend.

The rest of the day was a vigil. Waiting for Lester to arrive from Miami. Heaving crying with Elaine by the bed. Then Andy's wife, Jean, talking comforts into my ear. Elaine's friend Rhoda arrived and flew across the room to her, feet not even touching the floor. The poet John Giorno appeared by chance with a check, a contribution to the hospital fund. He was a Tibetan Buddhist and chanted over the body, in regal splendor, so that even his body odor, as I stood next to him, smelled sweet. Josh was silent, for once, except for a few cracks while filling out the death certificate. Sean and I took a break to walk down to the river, past so many yellow tulips, on as beautiful a day as I can remember: warm, breezy, and sun-dappled. It was a walk in paradise, the heaven that Howard may or may not have been finding for himself that day. We returned, and I cried with Andy, in his workaday blue suit, and we talked over the

body about retroviruses, and life: like a conversation with Howard, so abstractly intelligent, so full of thinking as joy.

Howard's father did arrive, and soon after, the men from the funeral home. When I heard their voices, I was by Howard's bed, and my heart jumped. I yelped, "No!" I felt as if they were the police coming to take Howard, as if we should hide him. They were wearing black overcoats in April. I heard Lester say to me, "Say goodbye to your friend." I bent over and kissed him on his forehead, now truly cold marble. Then others followed. We went out into the living room. Elaine's friend Rhoda and her husband, Mort, stood blocking the door so that we wouldn't see them rolling Howard out. His mother, sitting on the couch, was crying into Les's shoulder, "They're taking my baby away. They're taking my baby away." Kevin Goldfarb, Howard's high school friend, hooked on junk after Howard introduced the drug into his life, and now a mess, had shown up, without knowing. He was howling a primal howl in the corner. It was a crisis. Life was cracking apart. And then it was over. Howard was no longer in the apartment.

The morning of the funeral I was getting dressed in my gray suit, playing Fauré's *Requiem* on the record player, feeling comforted by white tulips someone left the night before in a vase on the counter. Suddenly I turned and without thinking said, "Oh, you came!" I was talking to Howard. I had this incontrovertible sensation that he was standing there—not his memory, not a ghost, but him, and that he was communicating with me again. I did not exactly see him, but I would say that he was three-dimensional.

And then he was gone. And then the chiming doorbell rang.

Sean and Sarah were downstairs. Sean was driving his beat-up white Mercedes to take us to the funeral.

We drove uptown, to a Jewish funeral home on the Upper West Side. I was pretty much out of it the entire time, as evidenced by the fact that my only clear memory is the memory of Howard in his resurrected body. But there was a family room, and there was lots of bawling, and as the mourners came, I huddled with them and we trembled together. "You finally let it get to you," said Dr. Josh. Bob Wilson walked in, tall, with his big warm hands. He flew in from Europe. I was extremely distressed without my other half.

We all huddled at the door of the family salon. Some kind of lull had been orchestrated and we were waiting in an offstage area. Elaine murmured into my ear, "Go on and have a good life. He wanted you to have a good life." They had black ribbons pinned to their clothes, cut by the rabbi as part of the ceremony. We walked out. I hadn't thought that the coffin would be there. It was. Plain dark wood, a Star of David on top. I stared as I walked by, mesmerized by the closed casket. As I shuffled into a bench, I heard Elaine saying, "I want to sit by Brad. I feel closer to Howard that way." Andy got up to speak. He was wild with crying, and trying to talk, and talking through his crying. I liked his outburst. Steve wept through memories of his big brother playing baseball.

I don't remember my talk. I only remember the microphone staring at me from the podium. The room was packed, but the only face I recall is Keith Haring's, as he stood way in the back, like Howard at Bob Applegarth's funeral, looking a bit freaked, probably. He must have felt that he was next. I typed up cues for myself on an index card, and when I look at the words now, I can imagine what I said. I summoned up our Bleecker Street apartment, with Howard's

grandmother's curved wooden chair, and plastic sheets over the windows to keep the chilly draft out, and talking with Howard about Shakespeare in front of the fireplace. About how we joked that he was a "phone queen" and had "black ear" and was a "doer," and how we joked about his "stirring up mise-en-scène." I said that nothing that I had known of him prepared me for the magnificent, indomitable man, without a trace of the victim, who was revealed, like a noble statue chipped out of a hunk of marble, over the past year: the man who was lying now in the casket in his gray Brooks Brothers suit. I had typed out the words "Walking Scene: happy," so I guess I moved on to some happy memories to relieve the sorrow and too much pretense. Then I read the lines from *Romeo and Juliet* that Bobby Kennedy had recited for his late brother at the 1964 Democratic Convention:

> *Give me my Romeo; and, when he shall die,*
> *Take him and cut him out in little stars,*
> *And he will make the face of heaven so fine*
> *That all the world will be in love with night*
> *And pay no worship to the garish sun.*

I remained as robotic and low-key as possible to keep my composure and stay on track, which only sort of worked. I had with me the poem I had written for Howard in the Bleecker Street apartment that started with his chair. I guess I had been setting it up:

> *This is for you*
> *Now that your curved wood chair*
> *Like a chair carved in Black Woods, Germany,*
> *Is gathering the silvery daylight in places . . .*

And I read the poem all the way down to the last lines, which now had extra resonance:

This is love, when it comes down to it, a bowl of porridge here,
A few words of advice on income tax loopholes there, and later,
When the swans and geese have sunk under the pink lakes of the south,
When this chair is up in final smoke, and I have not yet said it,
You and I, we will still be trying to say it in other ways,
Which is, finally, the best way, like saying Amaryllis,
When you don't mean that gorgeous hunk of fragile flower,
But mean an old girl sitting in the fertile rain, humming to death.

And then I was done.

```
Soul-mate
wooden curved chair--phone queen, black ear, listender,
                         Burroughs on Steenbeck
plastic sheets--doer, stirred up mise-en-scene
fireplace--Shakespeare discussion (April b-day) 26th)
didnt' prepare me for--magnificant, indominabable, no victim
Walking Scene: happy   Druoki Brs. suit
Bobby Kennedy at 64 Democastic Convention:
    Give me my Romeo; and when he shall die
    Take him and cut him out in little stars
    And he will make the face of heaven so fine
    That all the world will be in love with night
    And pay no worship to the garish sun.
```

———————

We were in Sean's white Mercedes driving through New Jersey. We arrived at the cemetery. Cars were backed up in a kind of holding pattern because so many funerals were scheduled that day. Finally they let us move on to our spot. I don't remember the weather. It was Howard's thirty-fifth birthday, April 30th. I stood there, waiting. I stood next to the hearse, looked in, trying to be close to Howard. His two nephews, older Aaron and younger Austin, just three, were on the floor of the funeral limo playing with toy cars. Aaron, adored by Howard, predicted by him to be very handsome someday, his surrogate son, observed me closely, briefly. I saw and felt the same laser eyes as his uncle Howard.

All the moments at the gravesite felt like an antigravity simulation. My perceptions were entirely off. I felt closer to trees than to people. Some details loomed large, while I didn't have much sense of others. Primitive feelings flowed in and out.

We carried the coffin: Lester, Andy, Steve, David Rephun, Sean, and I. It was heavy. I kept imagining the body from the deathbed inside, but without our Macy's sheets with red geometric designs over them. I was standing on the skirt of the grave somewhere, collected. Then I noticed that one of the workers over the grave, helping lower the box, had a USMC tattoo. I knew that Howard would have loved that touch. I thought of the burial scene in the porn movie *The Idol* and wished that I had been alone on my rusty bike looking down from a hill, like the mourning lover in that film.

I cast around for Howard. I had the reflex to share a look with him that would be lilting and indicate that I had thought of something funny and would tell him later as this was such an inappropriate moment to share sexual or comic thoughts and innuendoes. Then

I felt, really, his true absence. His erasure. I started a deep, mourning crying that came from some cyclonic source. It came time to shovel in the dirt. I remember saying, "I don't want to do it. I don't want to." I don't know if I was actually screaming the words, or saying them softly, or not saying them at all, but just hearing them in my head. Someone pushed a shovel handle into my hands—felt like a push, a thrust, but may not have been—and I reeled toward the hole in the ground. I shoveled the dirt almost angrily—it sounded like loud hail hitting the coffin below—and then reeled back, crying.

There was Elaine, again, next to me. She was murmuring comforts. "You know how he always used to disappear," she said. "He's up there in the sky again. He's on a trip. Like on an airplane. He's gone into the sky on a trip." Lester said, "Remember that bouncing walk? When he bounced away from us on trips and disappeared?" Howard was forever departing, in their remembering of him. Then they recited primeval Hebrew chants together, the family. It was the Kaddish, and they were chanting all the words in unison.

"Can you believe we're saying it for Howard?" Steve cried.

I was one of the last to leave the grave. I talked to Howard for a while. It was now sunny. There were flowers on the grave from Jim and Sara. The tag read, "We love you Howard wherever you are." I felt the same. But I also felt that I knew where he was. For the second time that day he was as present as he had ever been. He was hovering, while I talked with him. I was pouring out everything I had absorbed of the sensations of the day, his birthday celebration, only this time he was there but he was also a very strong bright light in an oval shape that was suspended high in the skeletal branches of a nearby tree.

After I left the cemetery that late afternoon, I never saw Howard again.

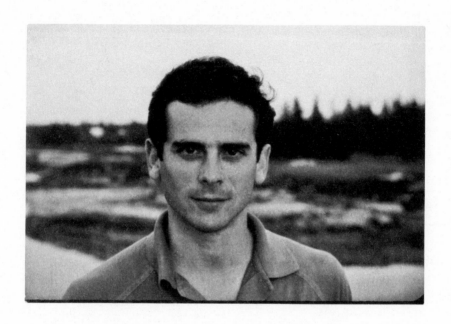

ACKNOWLEDGMENTS

———

For their help and support in writing this book I wish to thank: Jonathan Burnham, Joel Conarroe, Frederick Eberstadt, Joy Harris, Barbara Heizer, Sarah Lindemann-Komarova, and Paul Raushenbush.

BRAD GOOCH is the author of the acclaimed biography of Frank O'Hara, *City Poet,* as well as *Flannery: A Life of Flannery O'Connor,* a finalist for the National Book Critics Circle Award in biography, along with other nonfiction and three novels. The recipient of National Endowment for the Humanities and Guggenheim fellowships, he earned his PhD at Columbia University and is Professor of English at William Paterson University in New Jersey. He lives in New York City.